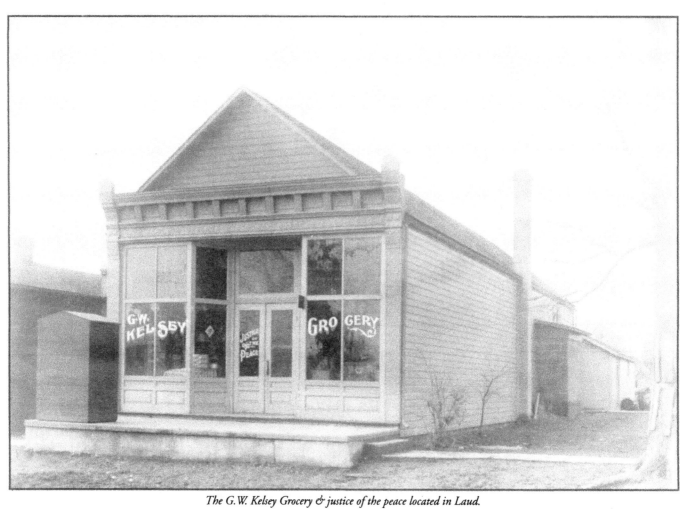

The G. W. Kelsey Grocery & justice of the peace located in Laud.

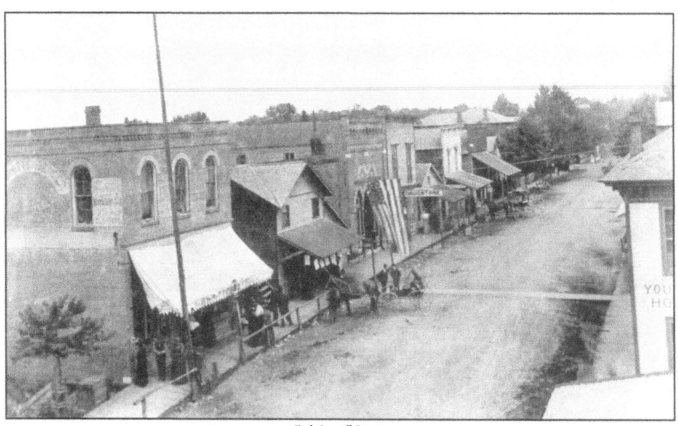

Early Larwill Street

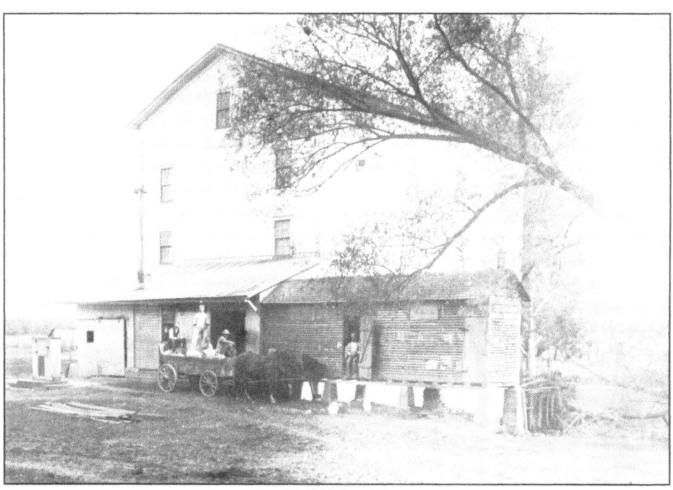

The Old Collamer Mill.

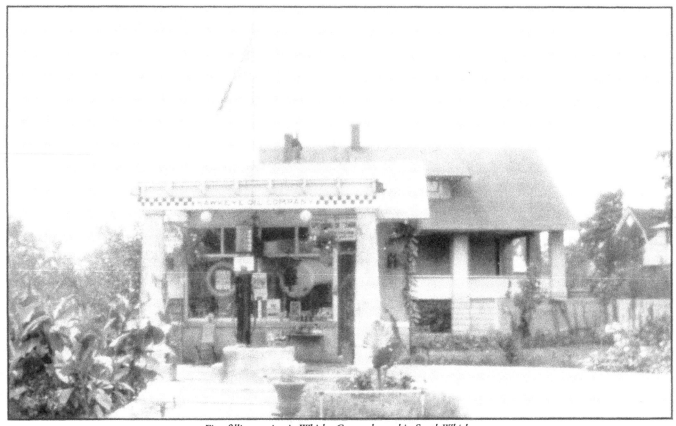

First filling station in Whitley County located in South Whitley.

WHITLEY COUNTY
1835 · 2005
PICTORIAL HISTORY

TURNER PUBLISHING COMPANY
Nashville, Tennessee

Turner Publishing Company Staff:
Randy Baumgardner, Editor
Ina F. Morse, Designer

Library of Congress Control No.
2004117476

ISBN: 978-1-68162-448-8

Limited Edition

0 9 8 7 6 5 4 3 2 1

Photo: *Creager Family Reunion at Kellis Hoard home,
Sept. 15, 1906 at Tunker. (Courtesy of Marilyn Enz McVay)*

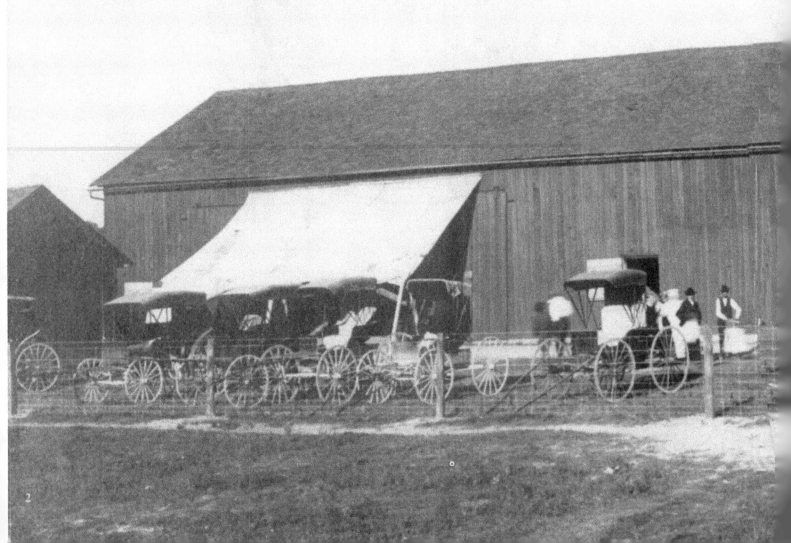

TABLE OF CONTENTS

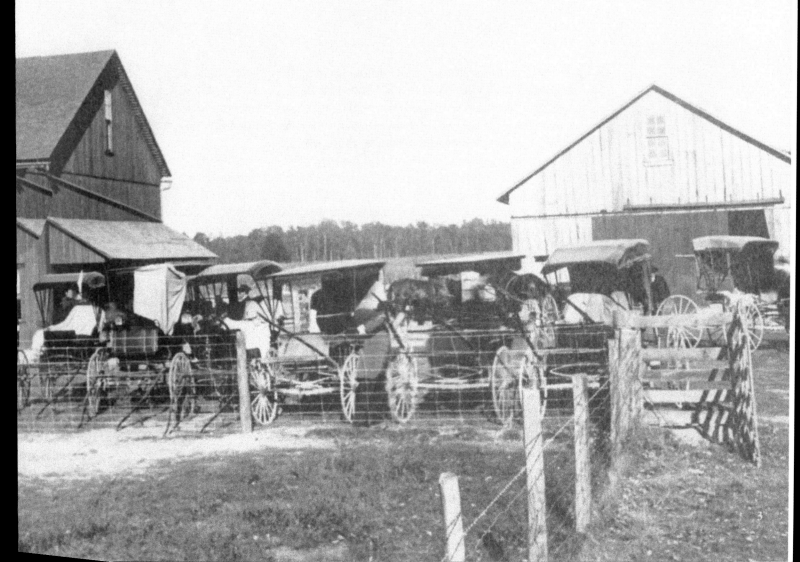

ACKNOWLEDGEMENTS

Emulating the dress of some of our forerunners are those who coordinated this pictorial book project: Back row, left to right: Beverly Henley, Ruth Kirk, Pat Reed and Susan Richey, Front row: Clark "Doc" Waterfall, Jeanette Brown and Ron Reed.

A Whitley County historical society first saw beginnings in 1899. This faded somewhat, to be reborn in 1927. The society, as we now know it, began in 1958. These motivated and talented individuals were responsible for the preservation of much of Whitley County's history. We dedicate this book to all of those hard working people who came before us.

The current board consists of the following: Jeanette Brown, President; Marie Hockemeyer, Treasurer; Beverly Henley, Correspondence Secretary; Laurel Steill, Recording Secretary; Kay Craig, Bulletin Editor; Ruth Kirk, Museum Director; Susan Richey, Museum Curator; Ron Johnson; Chuck Jones; John Marty; Marcia McNagny; William McVay; Ron Reed; Libby Reynolds; Gerald Runkle; Dan Stauffer; Dennis Warnick; Clark Waterfall; and Paul Burris.

PICTORIAL SECTION

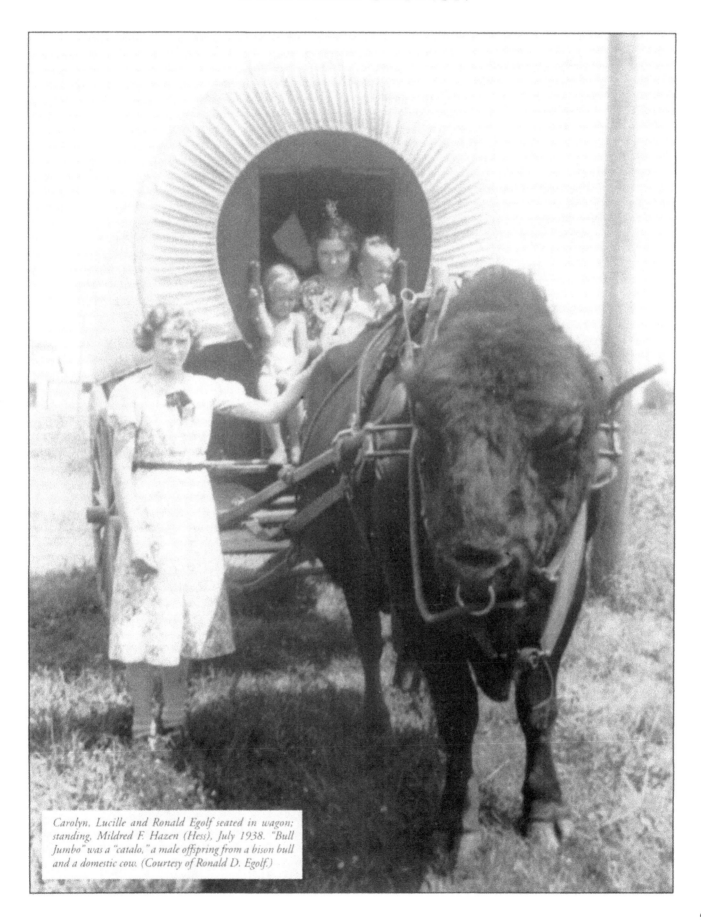

Carolyn, Lucille and Ronald Egolf seated in wagon; standing, Mildred F. Hazen (Hess), July 1938. "Bull Jumbo" was a "catalo," a male offspring from a bison bull and a domestic cow. (Courtesy of Ronald D. Egolf.)

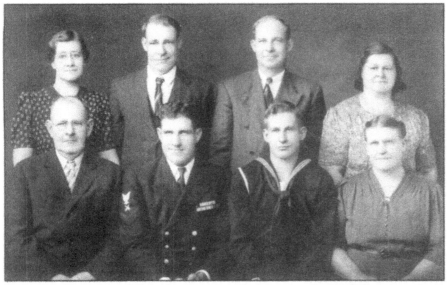

Back row: Esther Downing Hubartt, Irven Downing, Floyd Downing, Alta Breisch. Front row: Charles Downing, Owen Downing, Lloyd "Bud," Golda Uncapher Downing. (Courtesy of Cleon and Joan Downing.)

Cleon and Joan Downing married May 24, 1958. (Courtesy of Cleon and Joan Downing.)

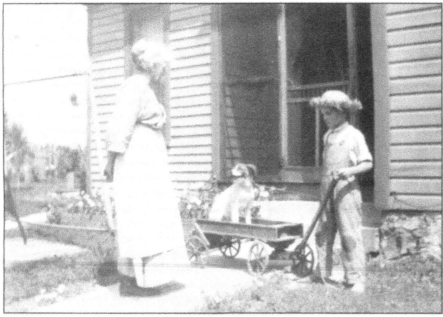

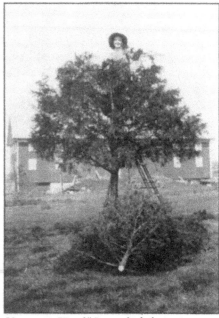

Grandma Reese and Robert.

Up a tree is "Frank" Reese which she is trimming.

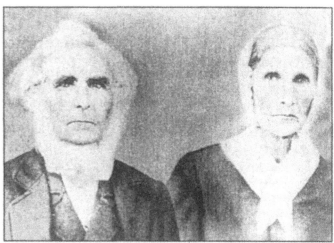

Clarence T. Grable.

Daniel Hively and Catharine Egolf Hively. (Courtesy of Ronald Egolf.)

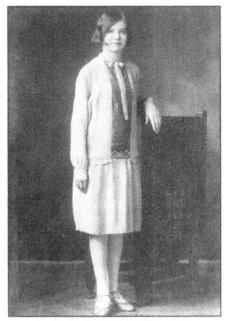

Lucille Luella Hively Egolf ca, 1929.

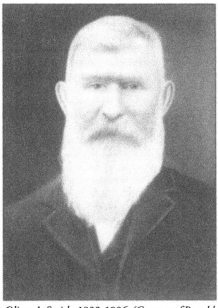

Oliver A. Smith, 1832-1906. (Courtesy of Ronald Egolf.)

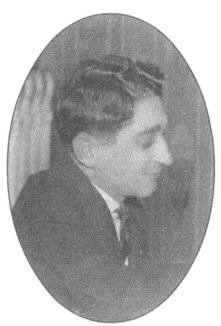

Jacob Flox, ca. 1920.

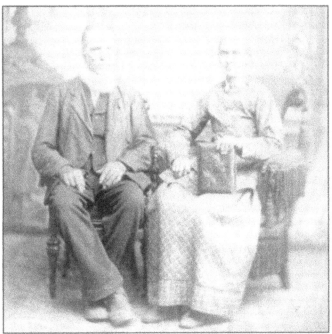

Daniel Berry (1816-1912), Hester Ann Hasty Berry (1820-1895). (Courtesy of Ronald Egolf.)

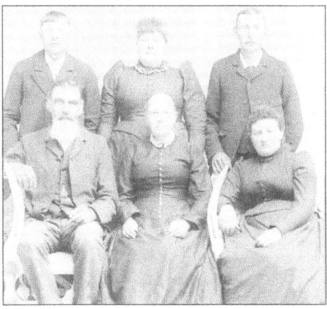

Front l-r: Cornelius Garrison (1832-1901), Catherine C. Shook Garrison (1834-1895), Mary E. Grable Garrison (1862-1926); back l-r: Charles W. Crow (1860-1940), Ida E. Garrison Crow (1866-1913), Remanzo L. Garrison (1858-1924) Union Twp. (Courtesy of Ronald Egolf.)

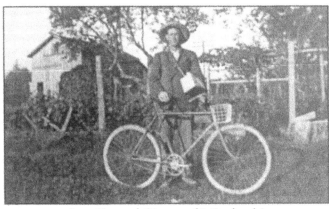

Justus Sherwood. (Courtesy of S. Cearbaugh.)

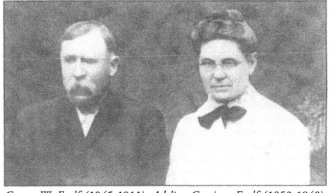

George W. Egolf (1845-1911), Adeline Garrison Egolf (1852-1940), Thorncreek Twp., Whitley County, ca. 1900. (Courtesy of Ronald Egolf.)

7

Nellie Eva Jagger Hively (1886-1968) and Benjamin Ernest Hively (1885-1960) on 50th wedding anniversary in November 1957. (Courtesy of Ronald Egolf.)

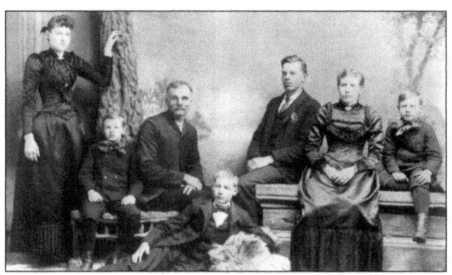

Nellie Malone Templin, Clarence, Andrew, Ernest, Otis, Josephine Brown and Chester Malone. (Courtesy of Donald Malone.)

Dorsey Elias (1860-1949) and Delilah J. (Crawford) Jagger (1865-1935). (Courtesy of Ronald Egolf.)

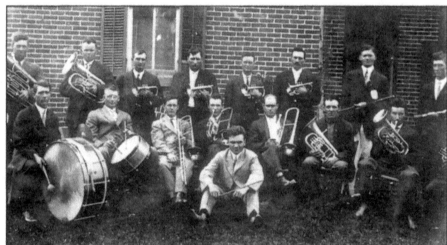

Churubusco area band? (Courtesy of Ronald Egolf.)

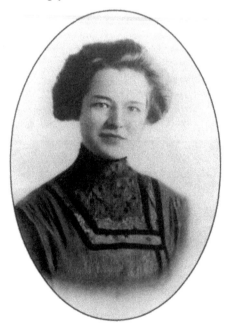

Erma (Nott) Woods (b. 1894), mother of Bonnie (Woods) Milam.

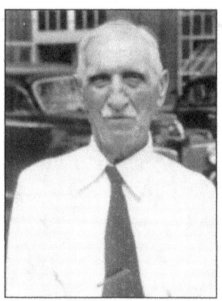

Henry Phend, September 1952. Henry was a general contractor in Columbia City from 1900 until the time of his death in 1958. (Courtesy of Rebeckah Wiseman.)

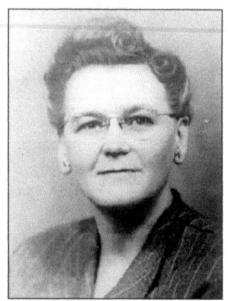

Hazlette Brubaker Phend in mid-1940s. She was the wife of Vic Phend and daughter of Charles Romaine and Maud Wise Brubaker. (Courtesy of Rebeckah Wiseman.)

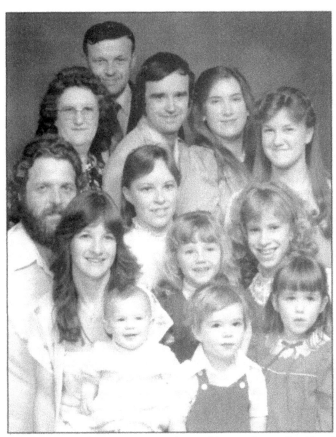

April 1986, Whitley County, IN - Robert and Patricia Dyson, David and Tammy Dyson, Lorinda Dyson, Jim and Lois (Dyson) Brandenburg, DeAnn Dyson, Dawn Dyson, Heather and Carrie Brandenburg, Dean and Christy Dyson. (Courtesy of Robert Dyson.)

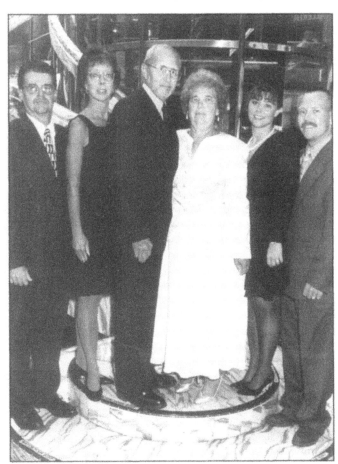

Brian and Melanie Call, Gordon and Martha Anspach, Michelle and Brian Anspach. (Courtesy of Brian Anspach.)

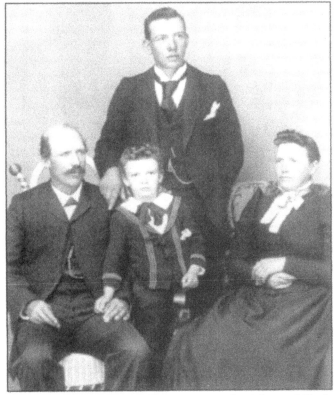

Brubaker family about 1892. William, Maurice Hale, Malissa, and Charles Romain standing in back. William and Malissa Joslin were married in 1871 and had a farm at Goose Lake in Troy Twp. (Courtesy of Rebeckah Wiseman.)

1914 from left: Great-Grandma Meyers with Irvin: Jennie Johnson Sievers and Grandma Louise Johnson with Florence. (Courtesy of Edna Bates.)

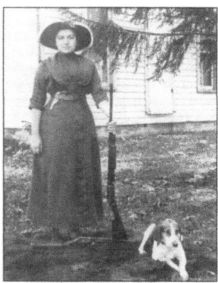

On the left is Russell and Grace Sevits and on the right is Mr. and Mrs. Frank Smith. (Courtesy of Nancy Swartz.)

Ethel Sevits and her faithful companion. (Courtesy of Nancy Swartz.)

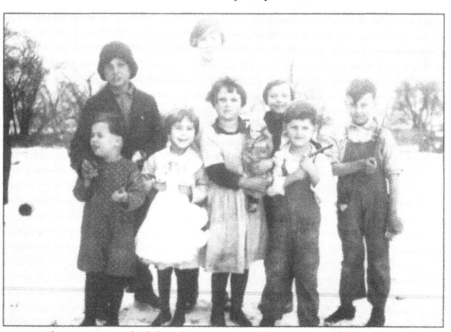

Marshall Sevits (b. 1909) and Ernest Sevits (b. 1907). (Courtesy of Nancy Swartz.)

Christmas 1925 with Clyde and Everett Seivers children. (Courtesy of Edna Bates.)

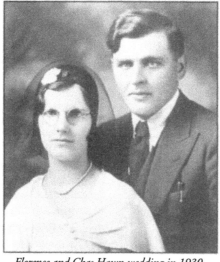

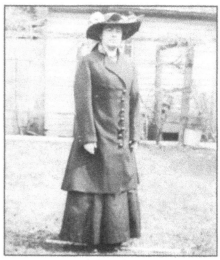

Thelma Daniel.

Florence and Chas Hawn wedding in 1930.

Zetta Clark dressed in her finest.

Kate (Moore) Johnson and son David, 1909. (Courtesy of Tom Johnson.)

George and Cora (Moore) Horner, ca. 1925. (Courtesy of Tom Johnson.)

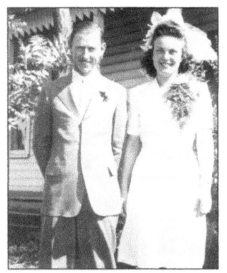

Shirley Waters and Dale Reiff wedding, 1943.

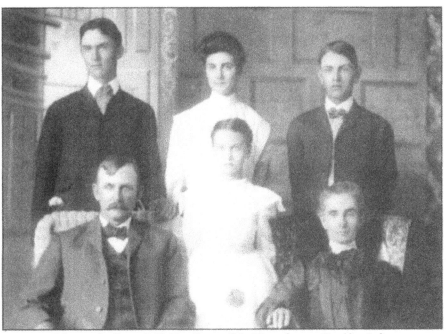

Schuman family ca. 1910. Top: Grover, Ocie, Henry; bottom: Franklin, Lydia.

Schuman family ca. 1937. Top: Adele, Walter, Edson, Ocie; bottom: Bessie, Grover.

MISS SHIRLEY WATERS AND DALE REIFF WED

Miss Shirley Waters, niece of Mr. and Mrs. Earl Karr of South Whitley, became the bride of Dale J. Reiff, son of Mr. and Mrs. Lowell Reiff, South Whitley, at 2:30 p. m. Sunday, July 18, at the couple's newly remodeled home in Cleveland township, Whitley county, with the Rev. Roger Shively reading the single ring ceremony before the archway.

The bride wore a two piece dress suit of white crepe. The jacket was accented with a tucked yoke and self trim. Her accessories were of white and she wore a small white hat trimmed with lilies and a shoulder length veil of pale blue bridal illusion. Her corsage was of red roses and bridal wreath.

The bride was attended by Mrs. Dean Hanauer, Warren township, who wore a silk bemberg dress of summer tan and white. Her accessories were of brown and white and her corsage was of red roses and blue delphinium. Dean Hanauer was best man.

Mrs. Karr, aunt of the bride, wore a navy blue and white dress and Mrs. Reiff, mother of the bridegroom, wore a brown and white dress. Both wore corsages of red roses.

A reception was held following the ceremony. A large tiered wedding cake topped with a miniature bride and bridegroom centered the bride's table. Guests were Mrs. Earl Karr, Mr. and Mrs. Lowell Reiff, Mrs. Lewis Mishler, Mr. and Mrs. Shirley Lepley, Mr. and Mrs. Lewis Reiff and family, the Rev. and Mrs. Shively and family and Mr. and Mrs. Dean Hanauer.

The bride and bridegroom both attended the South Whitley high school and will reside on a farm in Cleveland township.

11

Wise family about 1895. Harry, Sophia, Hazlette (sitting on stool), Maud, William, and Maurice. William is the son of Jacob and Malissa (Stem) Wise. Sophia is the daughter of William Hamilton and Catherine (Jones) Dunfee. William and Sophia were married in 1873 and lived in Troy Twp. (Courtesy of Rebeckah R. Wiseman.)

Marrette Scheeler.

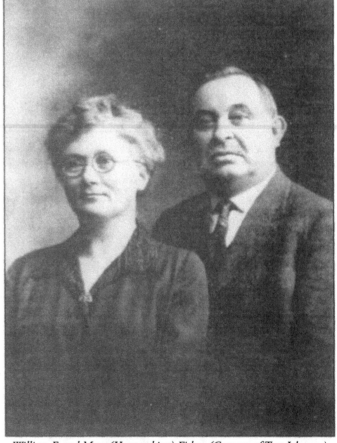

Back row: Terry Smith, Lee Fleck, David Fleck, Carolyn Vessey. Front row: Stevey Harris, Lynda Vessey, Jane Hanger, John Vessey.

William F. and Mary (Houtzenhiser) Fisher. (Courtesy of Tom Johnson.)

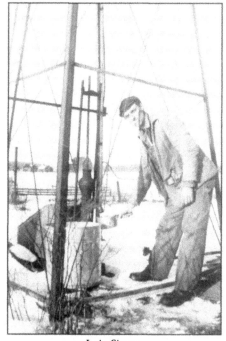

Irvin Sievers.

David Charles Johnson, son of Kate and James W. Johnson. (Courtesy of Tom Johnson.)

Elmer Dowell, 1900.

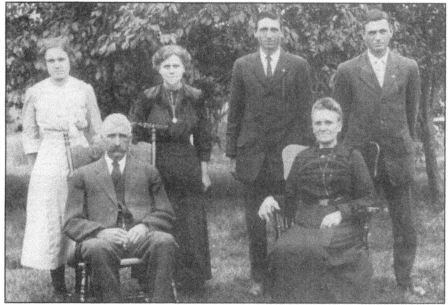

Ben Conrad family. Seated: Benjamin Franklin Conrad and wife Deliah Jane. Standing: Eldee, Erah, Fay and Fern, 1912. (Courtesy of Jane Studebaker.)

Mary Dowell.

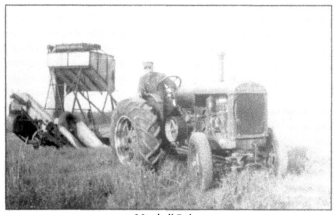

Marshall Baker.

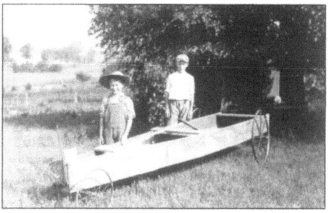

Glen Mosher and Billy Gregg with their homemade vehicle.

13

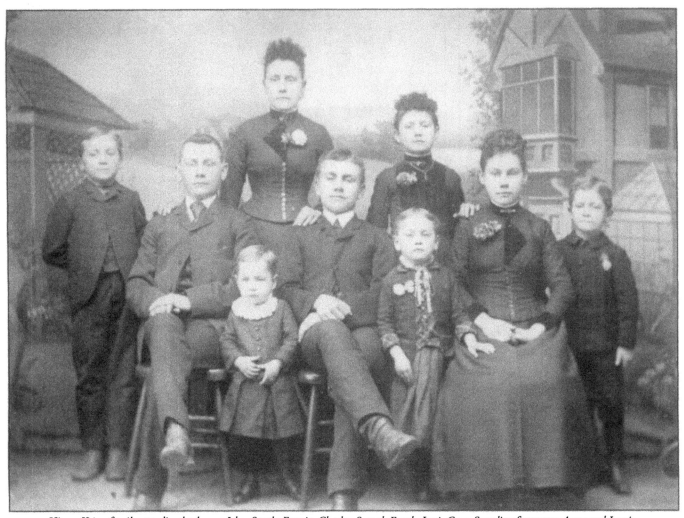

Hiram Keiser family, standing back row: John, Sarah, Fannie, Charles. Seated: Frank, Levi, Cora. Standing front row: Amos and Jennie.

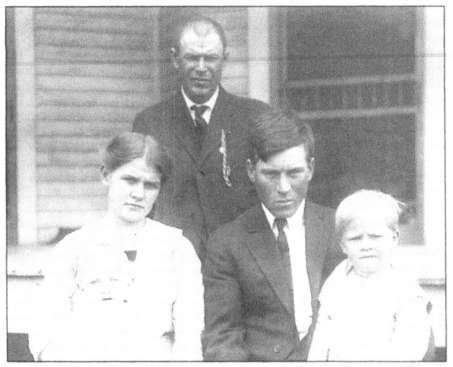

Standing: Charles Crow; seated: Hazel C. Crow holding Everett Edward and Arnie G. Egolf holding Glenn Harold. (Courtesy of Ronald Egolf.)

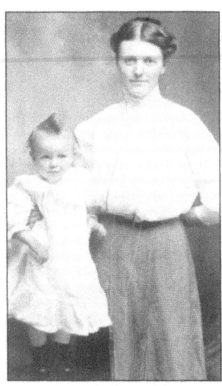

Maggie Zolman Jagger and son.

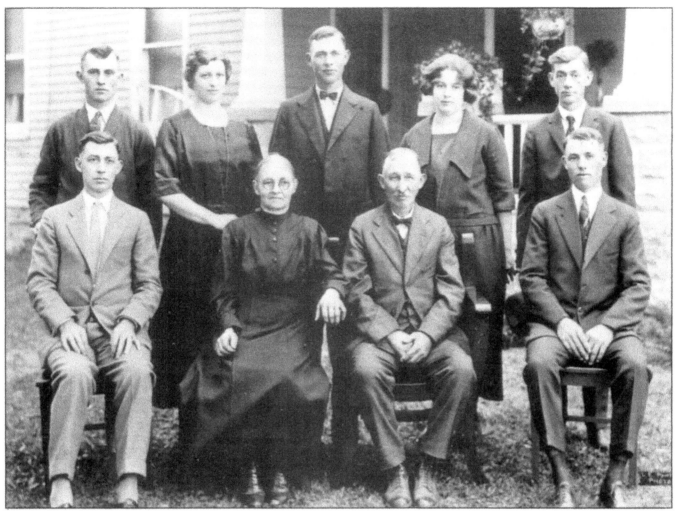

James Wesley and Sarah Jane Long Smith Family, Jefferson Twp. ca. 1925. Seated l-r: Albert, Sarah, James, Chester. Standing: William, Nora, Archie, Iva, James E. (Courtesy of Ronald Egolf.)

Ruby M. and Lorin J. Badskey, 1972. (Courtesy of Jerry Badskey.)

Gail Gregg and Jessie May Bigsbee.

15

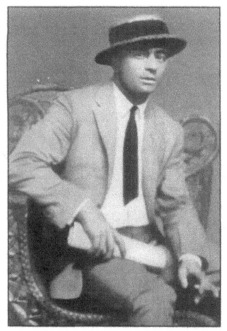

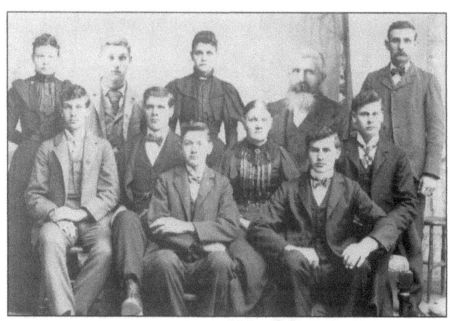

Lee Andrew Woods (b. 1891 Larwill), father of Bonnie (Woods) Milam.

Samuel and Isabell Engle Hively family ca. 1903, Thorncreek Twp., Whitley County. Front: Benjamin and Russell; 2nd row: Royal, David, Isabell and Lowell; 3rd row: Lizzie, Daniel, Margaret "Ella," Samuel and William. (Courtesy of Ronald Egolf.)

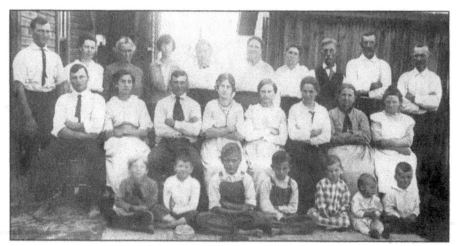

Standing: Clyde Sievers. Seated l-r: Levi Plattner, Florence and Cora. (Courtesy of LeRoy Hawn.)

Family reunion taken at August Sievers home in summer of 1918 when Carl was home on leave from Army. Back row: Clyde Sievers, Jenny Sievers, Cora Sievers, Eva Rasor, Mary Schrader, Mrs. Stalsmith, Mrs. Rasor, Mr. Stalsmith, August Sievers. Middle row: Charles Sievers, Rosa Sievers, Carl Sievers, Laura Sievers, Viola Rasor Dustin, Mrs. Charles Rasor, Laura's grandmother, _. Front: Russell Rasor, _, Omers Sievers, Walter Sievers, Florence Sievers Hawn, Elmer Sievers, Irvin Sievers.

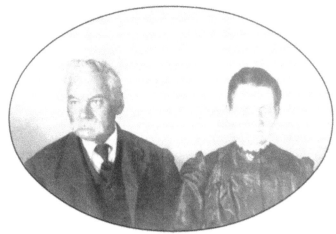

Richard and Catherine Walker.

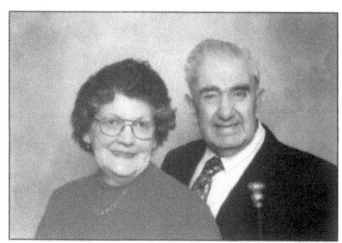

Lloyd and Juanita Hall, celebrating 50 years of marriage, June 2004.

Ralph Gates, Governor of Indiana, 1945-49.

Helene Edwards Gates, First Lady of Indiana.

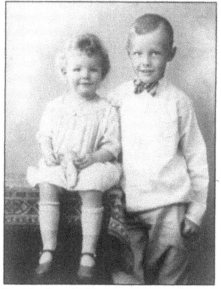

Patricia Gates McNagny, Attorney and Judge; Robert E. Gates, Attorney and Trustee of Indiana University.

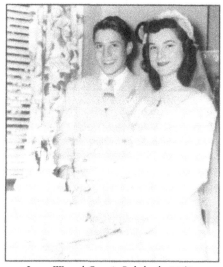

James W. and Connie Rohrbach, 1949.

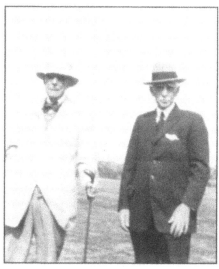

l-r: J.D. Rockefeller and S.J. Peabody

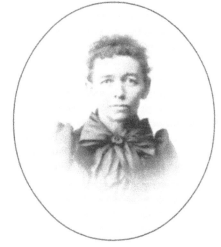

Emerilas Merriman Johnson, 1853-1916, wife of James Johnson. (Courtesy of Tom Johnson.)

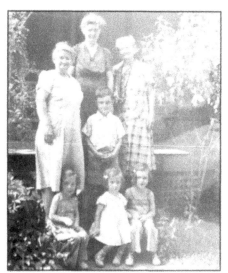

Back row: Bessie North, Helen Heath, Mary Cramer Hull. Center: Richard Heath. Bottom: Marie, Rosalie and Phyllis Heath.

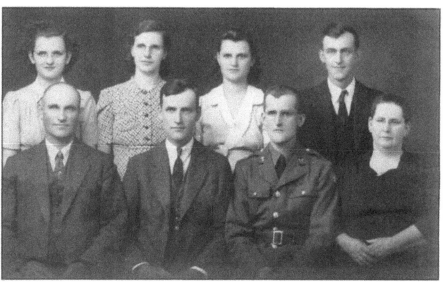

Sievers family: Front row-Clyde, Irvin, Russell and Louise; Back row-Jenny, Florence, Edna and Elmer, 1940s.

17

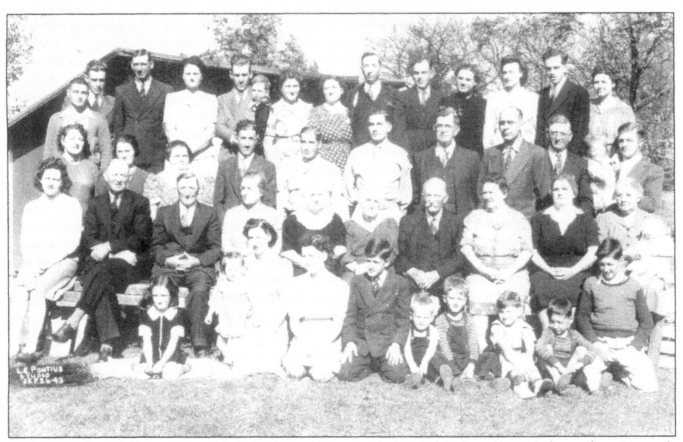

Family gathering Sept. 26, 1943 at George and Lucille Herrick home. Shower for Max Reed, Dale Bitting and Jr. Pressler home on leave. **Front on the ground:** *Sharon Lee Brown, Karen Conrad held by Jeanette Conrad, Virginia Pressler, Lee Bitting, Roger and Dick Reed, Larry Conrad, Dean and Eugene Brown.* **Seated:** *Evelyn Reed, Harlan Ott, Levi Ott, Ruth Bitting, Agnes Ott, Jane and Abraham Ott, Dica Reed, Sula Pressler, Ethel Conrad holding Maureen Herrick.* **1st row standing:** *Jane Bitting, Ruby Ott, Kessie Ott, Frank and Dale Bitting, Ralph Pressler Jr., Ray Reed, Ralph Pressler, Fay Conrad, George Herrick holding Alice Kay.* **2nd row standing:** *Don Conrad, Phil Ott, Ronald and Sara Jane Conrad, Gerald, Gail and Grace Jagger, Lavaun and Don Brown, Harry and Thelma Reed, Bette and Max Reed, Lucille Herrick. (Courtesy of Jane Studebaker.)*

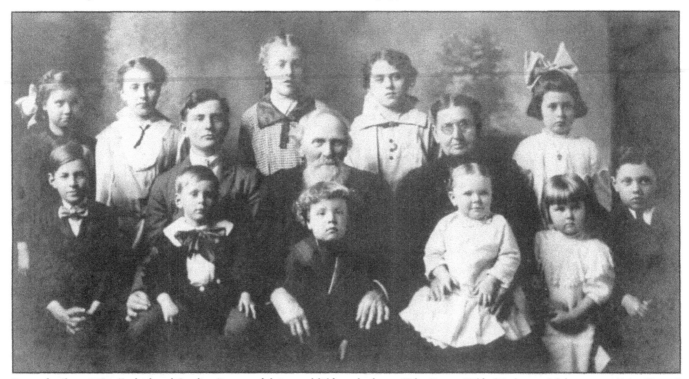

Dreyer family ca. 1913. Fredrick and Carolina Dreyer and their grandchildren - back row: Helen Dreyer, Hilda (Hockemeyer) Schoppmann, Erma (Dreyer) Rodenbeck, Leona (Dreyer) Knoblow and Lura (Dreyer) Powlen; middle row: Clarence Hockemeyer, Paul Dreyer, grandparents Fredrick and Carolina (Leucke) Dreyer, Edna Dreyer, and Carl Hockemeyer; front on laps: Theodore Hockemeyer, Clarence Dreyer and Mildred (Hockemeyer) Mensing.

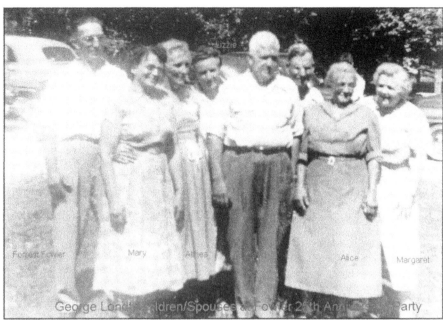

Ila May Shoemaker, 1868-1939, grew up on the Shoemaker homestead and attended the Ream School. After becoming a teacher she taught in Whitley County at the Compton, Ream, Hoffman and Laud schools, also in Nebraska and Colorado. She owned and managed an 80-acre farm west of Columbia City. (Courtesy of Bethelene Cramer.)

Children of George and Laura (Loutzenhiser) Londt. Taken the summer of 1953 at Forrest and Alice (Lonut) Fowler's family reunion in Jefferson Twp., Whitley County, IN. l-r: Forrest Fowler, husband of Alice, Mary (Londt) Graves, Althea (Londt) Kyler, Lizzie (Londt) (Croxton) Kahmeyer, David Londt, unknown-possibly John Londt, Alice (Londt) Fowler, Margaret (Londt) Bradshaw. (Courtesy of Kay A. Hilliard.)

1901 – Elizabeth Clark, John Wesley's wife.

Grable family. Back row l-r: Ed, Lester Walt, Win, Chris, Gus, Clarence. Front row l-r: Myrtie, Effie, Mary, Ella, Lonie. (Courtesy of Connie Rohrbach.)

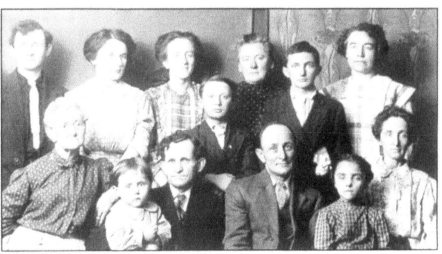

Ida (Keiser) Lower, wife of Bayless Lower and sister to Ira Gust Keiser – ca. 1885-90. (Courtesy of Ida Lower.)

l-r, top row, standing: Dale White, Lucile Kaufman, Demma White, _, _, Neil Richards, Carrie White; sitting l-r: _, Pauline White Snyder, Dr. S.R. White, _, Lola Richards Mullendore, _ gathering in Laud, IN, ca. 1909. (Courtesy of Judith Church.)

19

Elizabeth J. (Londt), Bertha C., John M., Wilfred G., Rachael A., Jesse E. Croxton. Vera M. standing in back – about 1922, Jefferson Twp., Whitley County, IN. (Courtesy of Kay Hilliard.)

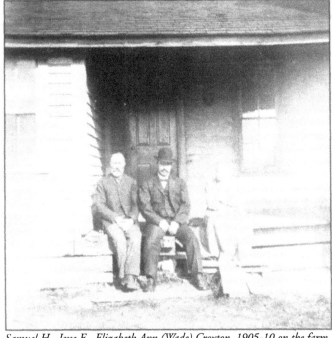

Samuel H., Jesse E., Elizabeth Ann (Wade) Croxton, 1905-10 on the farm in Jefferson Twp., Whitley County, IN. (Courtesy of Kay Hilliard.)

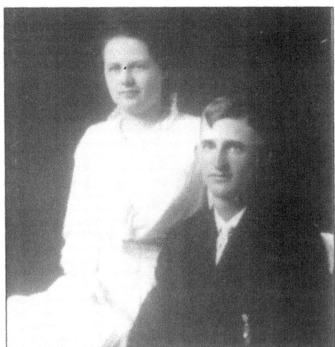

Ralph and Mabel (Taylor) Yohe.

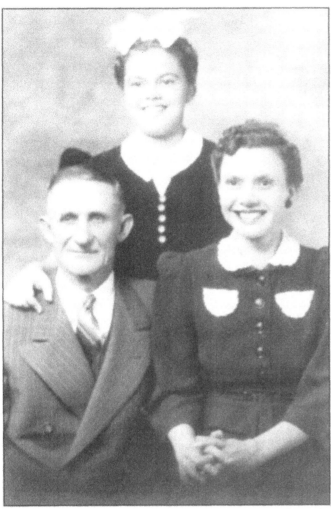

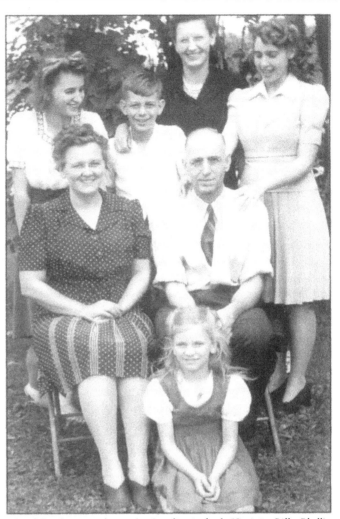

Charles Jacobs, Betty Catherine Stoffer and Jane Brubaker Stoffer Jacobs. Probably taken in the mid-1940s. They lived in South Whitley. (Courtesy of Rebeckah R. Wiseman.)

Phend family, September 1942. Standing in back: Virginia, Billy, Phyllis, Patricia. Seated are Hazlette Brubaker and Vic Phend. Sitting on ground is Shirley Ann. (Courtesy of Rebeckah R. Wiseman.)

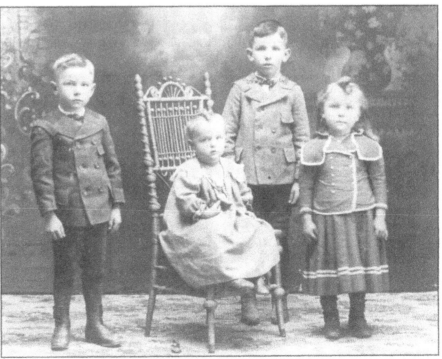

Clayton Gaff (b. 1896). (Courtesy of Jane Studebaker.)

Children of Warren and Ida Gaff. l-r: Sylvan, Clayton, Elza and Thomas. (Courtesy of Jane Studebaker.)

Susie Yarian Phend, September 1952. Susie was the wife of Henry Phend and she died in 1956. (Courtesy of Rebeckah R. Wiseman.)

Keiser family l-r: Clarence, Ray Francis, Ira Giest, John, Amos, Frank, Levi, Clarence.

The Jones family. Front: Everett holding Zachary; back: Chuck and Todd. (Courtesy of Chuck and Barb Jones.)

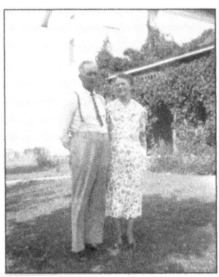

William and Rosa Gipe prior to 1918. (Courtesy of Syndey Campbell.)

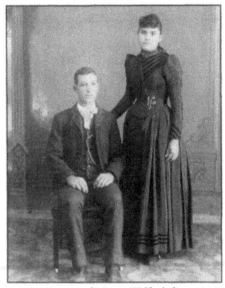

Ira Gust Keiser and Minnie Wolford about 1895.

1914 Wright Reunion, Children of Alexander and Margaret Hull Wright. Standing Left to Right: William Wright, Rosella Wright Crow, Arthur Wright. Seated Left to Right: Francis Melvin "Mel" Wright, Theodore Wright. Mel Wright worked at the Etna Grocery Store and delivered orders (including live chickens) by wagon. (Courtesy of Nola Marquardt)

1923 Eighth Grade Graduation, Etna School. Back Row: Vance Beers, Irene Heintzelman, Ilah Wright, Robert Blain. Front Row Left to Right: Chloe Vanderford, Garland Burns, Audra Gerkin, Susie Brosman. (Courtesy of Nola Marquardt)

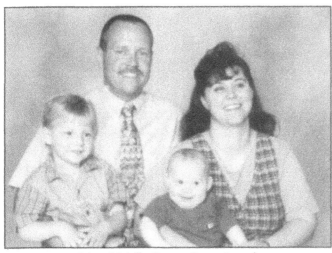

Brian, Michelle, Garrett, Carson Anspach.

Inez and Jim Waugh family: Judy, Jane, Inez, Jim holding Kent "Nub," and LeRoy. (Courtesy of Inez L. Waugh.)

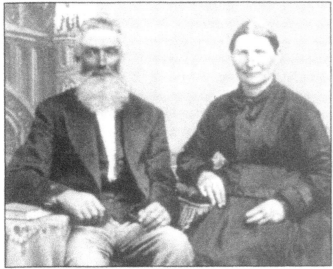

Simon Grace (b. Feb. 1, 1827 in Columbiana County, OH) married Mary (Polly) Fritz. In 1864 Simon and Mary purchased 40 acres of land in Whitley County, IN and moved here with their five children: Jeston Alonzo, John W., Mary E., Lydia S. and Simon L. (Courtesy of Dwane Grace.)

Jeston Alonzo (Lon) Grace (b. Nov. 23, 1850, Morrow County, OH), son of Simon and Mary Fritz Grace. In 1864 he moved to Whitley County, IN with his parents. He married Esther Bennett, daughter of Daniel and Mary A. Huffer Bennett on Nov. 20, 1876 in Whitley County, IN. (Courtesy of Dwane Grace.)

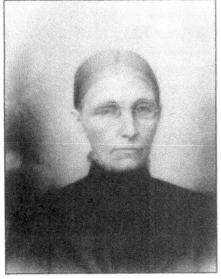

Mary "Polly" Palmer.
Mary had married Harvey before they came to Indiana along with the rest of Samuel Palmer's family. (Courtesy of Virginia Palmer.)

Harvey Orcutt.

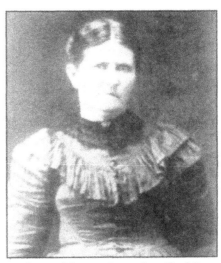

Sarah Jane (Thompson) was the wife of Oscar Palmer and daughter-in-law of Almon W. Palmer, who was the third child of Samuel and Sarah (Skinner) Palmer, early settlers of Whitley County. (Courtesy of Virginia Palmer.)

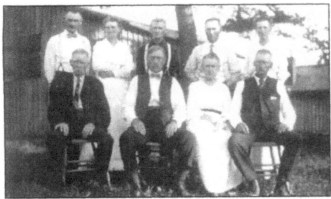

The Joseph Skinner Palmer family before 1919. Seated l-r: Newton, James, Sarah (Sade), Samuel. Standing l-r: Elmer, Catherine Marrs, Joseph, Carl, Lois Alborn (Annette had died 1907).

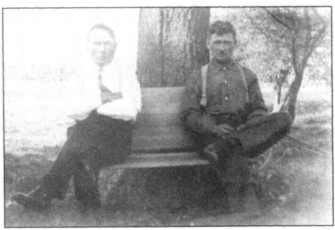

Brothers l-r: Carl and Joseph Skinner Palmer.

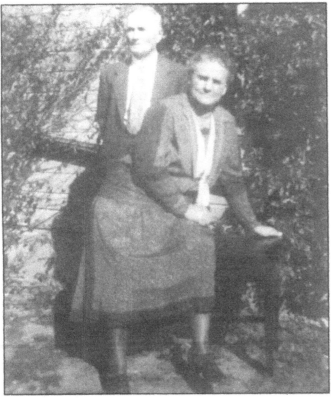

Carl Palmer and his wife Carrie (Wickliffe), parents of George, Lewis and Marion, ca. 1938. (Courtesy of Virginia Palmer.)

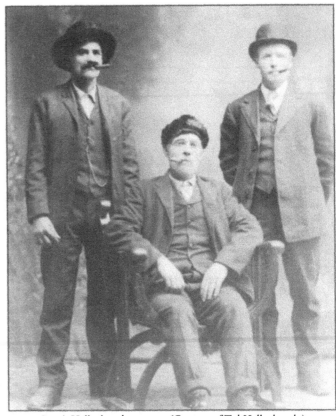

Joseph Hollenbaugh – center. (Courtesy of Ted Hollenbaugh.)

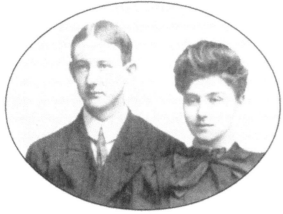

James W. Johnson and Kate Moore wedding photo, Nov. 2, 1905. (Courtesy of Tom Johnson.)

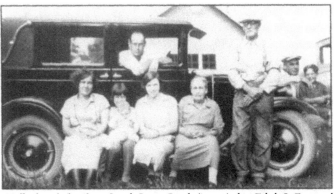

Hollenbaugh family at Laud. Lester Brock (in car); l-r: Ethel, LeEtta and Doris Brock, Edna, Altha, Joseph, Clem Hollenbaugh, Robert Brock. Joseph and Altha (Heck) Hollenbaugh are parents of Ethel and Clem. Edna (Wince) Hollenbaugh's husband Herb took the photo. (Courtesy of Linda Hollenbaugh.)

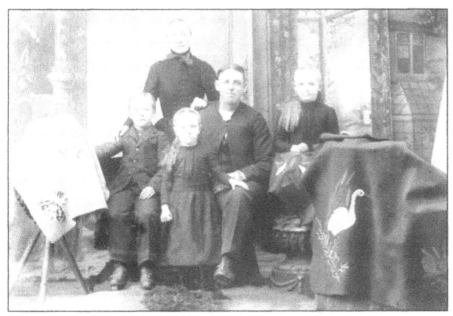

Mr. and Mrs. Lewis Mishler 60th wedding anniversary, Sept. 15, 1941.

Lewis and Barbara Mishler, son Harley A., daughter Sarah C. and a foster child, Tina Blew.

To Celebrate 60th Wedding Anniversary

Mr. and Mrs. Lewis Mishler entertained a large number of their friends and relatives at their home three miles south of here Sunday when they celebrated their sixtieth wedding anniversary. The couple held open house all day and at noon a basket dinner was enjoyed. The anniversary of the couple occurred Monday, September 15th.

A feature of the dinner was a large wedding cake decorated with the words, "Lewis and Barbara", which was a gift from their daughter, Mrs. Sarah Reiff. The couple received a large number of cards, flowers and other gifts in honor of the occasion.

More than 125 persons called at the Mishler home during the day to extend their greetings to the couple. Friends and relatives were present from Pierceton, Warsaw, North Manchester besides those from near here.

During the afternoon a program was given for which Rev. Moyne Landis of near Sidney was the principal speaker. The group was welcomed by Cyrus Senger. Other numbers on the program included a reading by Mrs. John Maple, No. Manchester, who formerly was a neighbor of the Mishlers, a prayer by Rev. Kendall of the local Church of the Brethren, a vocal duet by Rev. and Mrs. Kendall, a solo "When You and I Were Young, Barbara" by Mrs. Maple and a closing prayer by Rev. Landis.

Mr. and Mrs. Mishler stated that they enjoyed the day very much and suffered no ill effects which is of interest to a great many of their friends.

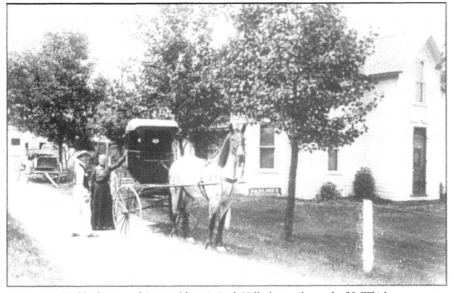

Mishler homestead (original house), Bash Hill, three miles south of S. Whitley.

Mishler home after porch was added.

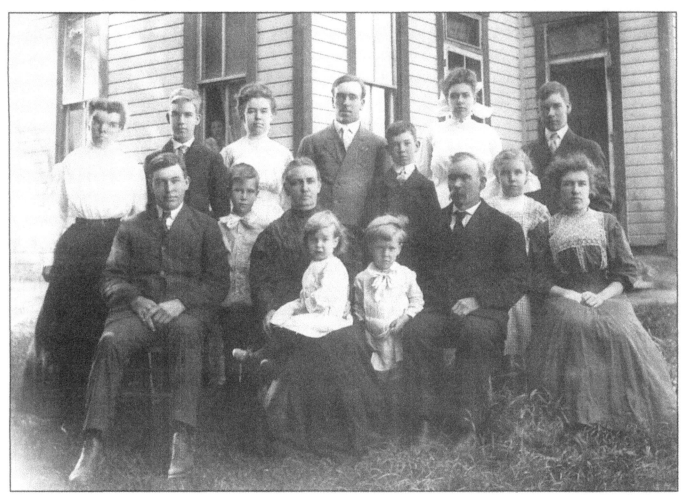

Franklin Klingaman family ca. 1910. Back l-r: Myrtle, Merle, Ethel, Ross, Edith, Allen; middle: Gaston, Dallas, Margrette; seated in front: Noel, Mary Josephine, Franklin Delorne, Maude; on lap is Kenneth and other small child is Cleon "Fritz."

Franklin and Elizabeth Klingaman family ca. 1930, l-r: Kenneth, Cleon, Edith, Maud, Margrette, Myrtle, Dallas, Walt; front: Ross, Noel, Elizabeth, Franklin, Gaston, Allen and Merle.

Elmer and Helen Heinley and Sandra Jean – 1946. (Courtesy of William E. Heinley.)

Mike McKinney – 30 years in LP gas. (Courtesy of Hollie McKinney.)

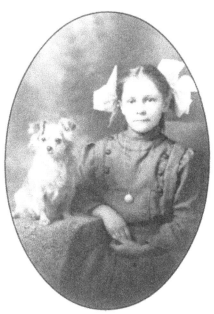

Margaret Eberhard. (Courtesy of David Keiser.)

l-r: Shelly (Yohe) Eberly and Amanda (Yohe) Hartman. (Courtesy of Anita Leach.)

Mullett family l-r: Wesley, Susie, Shawna, Braden and Dan.

Michael and Hannah (Deckard) Yohe. (Courtesy of Anita Leach.)

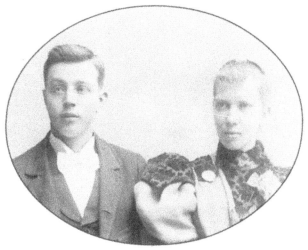

Leslie and Celestina Henrietta (Zerbe) Noble wedding photo in November 1895.

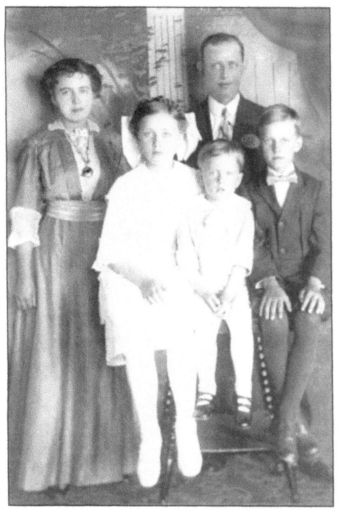

Anna L. Dreyer Hockemeyer and Christian Hockemeyer, parents of Hilda, Theodore and Clarence, ca. 1915. (Courtesy of Marie Hockemeyer.)

Joshua Barnes with nephew, Ancil. (Courtesy of J. Rawleigh.)

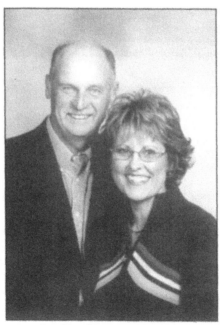

Russell and Marguerite (Mullett) Yohe married Dec. 14, 1940.

Ronald and Jane Lee (Alter) Yohe.

Twins, Alexander and Matthew Dial in 1903. (Courtesy of Hollie McKinney.)

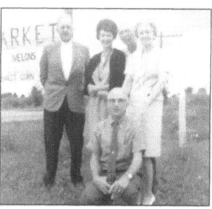

Vernon C. Jersey (1899-1984), Pauline L. Jersey (1908-1984), Roy Fanning, Madaline Dill. In front is Milton Dill. (Courtesy of Mike Hayes.)

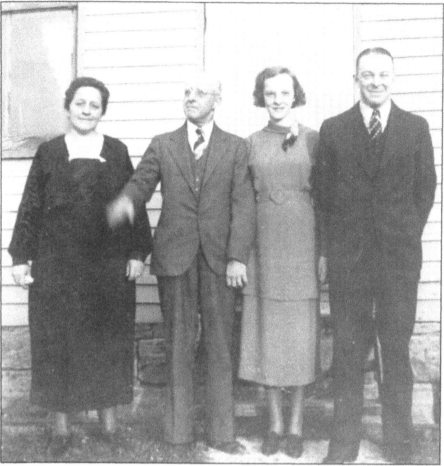

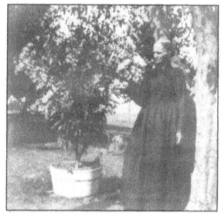

Aiden S. Warner family l-r: Carrie (Badger), Aiden S. Warner, Betty (Hanauer) Lloyd. (Courtesy of Jerry L. Badskey.)

Elizabeth (Schroeder) Mowrey. (Courtesy of Anita Leach.)

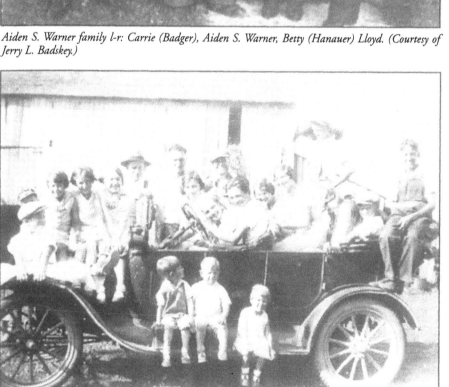

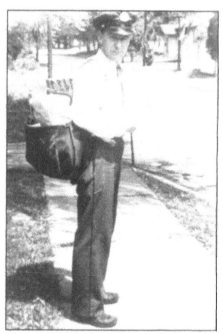

Left fender: Tom Binkley; hood of car l-r: Helen Carper, Wanda Lepley, Vernelle Binkley. Standing in rear l-r: Harry & Charles Lepley, Asher Carper; right rear fender: Guy Lepley; front seat l-r: Eileen Binkley, Edward Ulshafer, Keith Binkley, Wilbur Lepley; back seat l-r: Esther Lepley, Josephine Ulshafer, Gerald LaRue, Ralph King, _, Glen Carper; on back of car is Richard Barnes; on tool box: Richard Lepley, Teddy and Betty Carper – ca. 1931. (Courtesy of Wanda Deininger.)

Elmer Mohler is shown wearing the required uniform for city mail carriers of the late 1940s. Wool trousers, formal hats, ties and a very heavy leather mail bag. At the time "relays" were left on many front porches along the city route. It was an accepted practice and to my knowledge, no one ever touched these. (Courtesy of Vivian Mohler.)

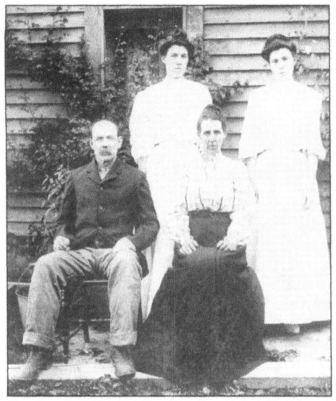

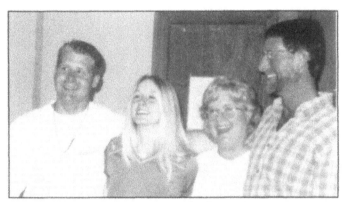

Coyle family: Derek, Jennifer, Lynn and Bruce.

Nora (Rounds) (Williamson) Nye, Alma (Rounds) Cool, Frank Rounds, Martha (Shoemaker) Rounds.

Ruby Marie (Lepley) Badskey, Dec. 6, 1929. (Courtesy of Jerry L. Badskey.)

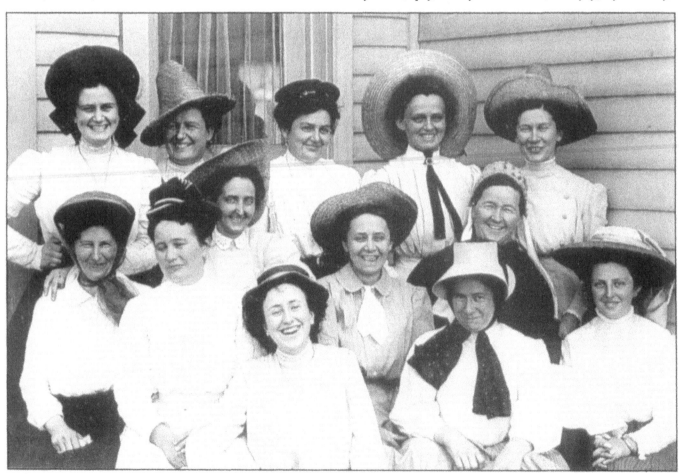

Ladies of Laud ca. 1900. Back: Ollie Vance, Chella Smith, Florence Ihrig, Edith Leppo, Edna Kaufman. Center: Ella Richards, _, Mary Chamberlin. Front: Pearl Kaufman, _, Leora Kent, Minnie Chavey, Ida Kaufman. (Courtesy of Judy Church.)

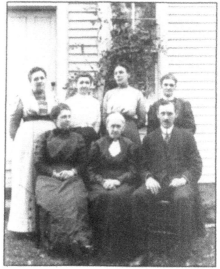

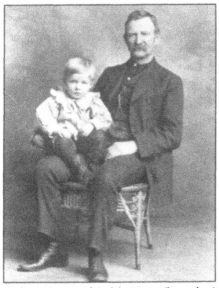

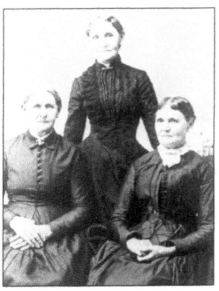

Ida Grant, Roxie Blain, Francie Templeton, Mary Ellen Kiester; seated: Della Buckels, Jane Blain and Joe Blain. (Courtesy of Donald Malone.)

Ambrose Kiester with Jackson Kiester (his nephew) on his knee. (Courtesy of Donald Malone.)

Jane Blain, Phebe Thompson, Ann Martin. (Courtesy of Donald Malone.)

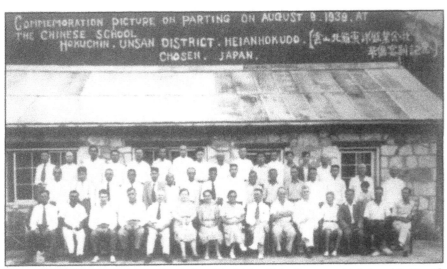

Henry Strauss, Donald Dwight Malone, John Strauss, Eugene Malone. (Courtesy of Donald Malone.)

Chosen, Japan (Korea). Front row, fourth from left, Soldan Blain; front row eighth from left, his wife Kito Blain. Leigh Hunt and his brothers recruited many young men from Whitley County to serve in different capacities. The tradition continued over the years. Soldan Blain was an engineer.

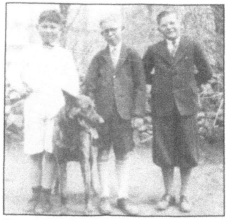

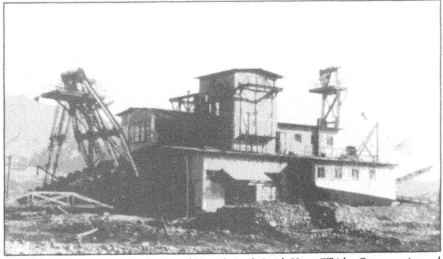

From left: John Blain, Bill Aldrich, Robert Anderson. Their families often accompanied the mine employees to Korea. John Blain, son of Soldan and Kito Blain, moved to Pukchin, Unsan Province, Korea, when he was four. The family returned to the Larwill area when he was fourteen.

Gold Mining Dredge outside Tabowie and Taracol. Leigh Smith Hunt, Whitley County native and entrepreneur, was granted a mining concession, c. 1900 in what is now North Korea to form the Oriental Consolidated Gold Mining Co.

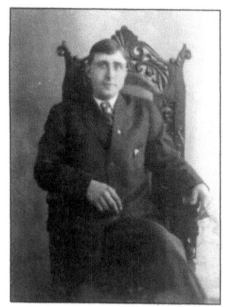

Marion Cool. (Courtesy of Marion Cool.)

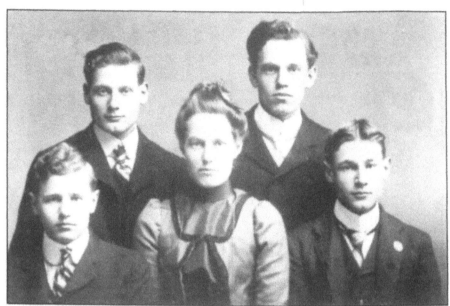

Malone: Clarence, Earnest, Nettie, Otis and Chester. (Courtesy of Donald Malone.)

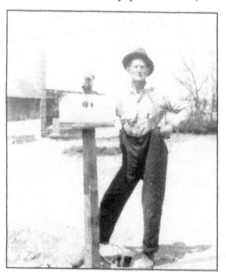

John Hoffman "Rosebud Slim" Charles Reese homestead.

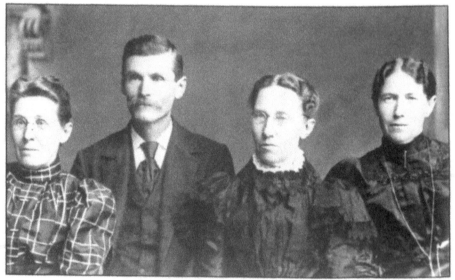

Browns: Lucinda Kepford, Acie, Martha Oliver, Josephine Malone. (Courtesy of Donald Malone.)

Joseph Shoemaker (1759-1864) was drafted into the Colonial Army of the Revolution and later served in the War of 1812 at Buffalo, NY and Black Rock. He came to Whitley County in 1856 where his son Asa homesteaded on Big Spring Creek. (Courtesy of Bethelene Cramer.)

Samuel F. and Louisa L. Shoemaker. Samuel was born in 1838 on his father Asa's homestead. He was the first white child born in Columbia Twp. Their five children were Ila, Roswell, Calvin, Nettie and Luther. (Courtesy of Bethelene Cramer.)

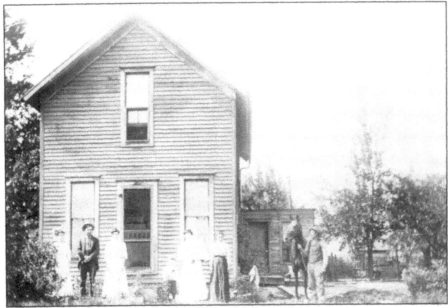

l-r: _, Marion Cool, Alma Cool, Frank Williamson, Nora Williamson holding Lucile Williamson, Martha Rounds, Frank Rounds.

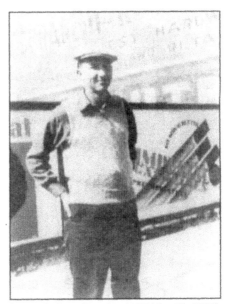

Everett R. Jones (Oct. 31, 1907-May 25, 1995), President of Churubusco State Bank for 20 years. (Courtesy of Chuck and Barb Jones.)

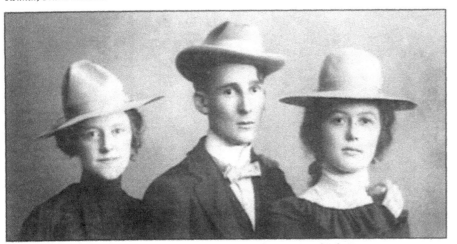

Triplets: Amelia, Wesley Jr., and Cecilia Sroufe. Courtesy of Judy Garrison.

l-r: Julia Schrader, Mary Anders on right. (Courtesy of David Keiser.)

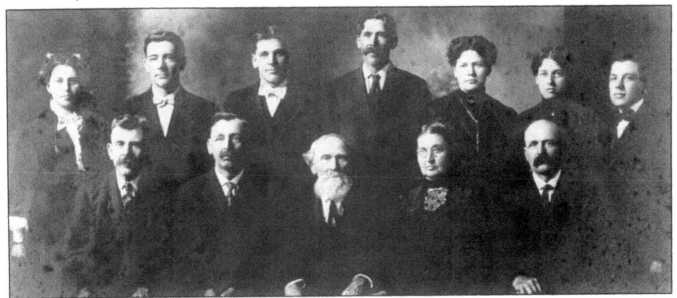

Dreyer family ca. 1913. Fredrick and Carolina Dreyer and their children. Back row: Anna (Dreyer) Hockemeyer Pook, Louis Dreyer, Carl Dreyer, Martin Dreyer, Lena (Dreyer) Hockemeyer Kehmeyer, Emelia (Dreyer) Hollman, and Fred Dreyer. Front row: August Dreyer, Henry Dreyer, parents Fredrick and Carolina (Leucke) Dreyer, and William Dreyer.

Alice (Corbin) Baker "Mother".

Marshall Baker "Father".

Dean Baker "Son".

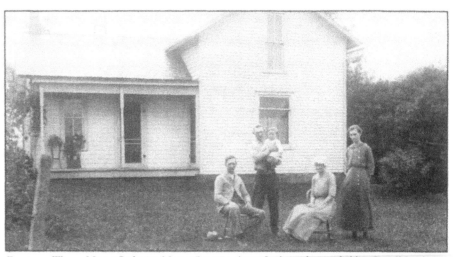

Front row: Warren Marrs, Catherine Marrs, Grace Snodgrass; back: Carl Marrs holding Russell Snodgrass. (Courtesy of Martha Engle.)

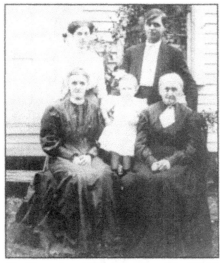

Five Generations, 1913. Front: Mary Ellen (Blain) Kiester, Della Catharine (Johnson) Van Zile, Jane Scott Blain. Back: Bessie (Kiester) Johnson, Perry Kiester.

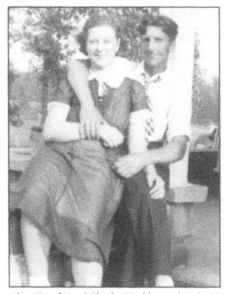

Alice (Sroufe) and Charlie Winkler, with Ruby H. Mitterling on the swing in background.

Judy Garrison and Chuck Winkler at Cock of the Walk, Nashville, TN, June 2002.

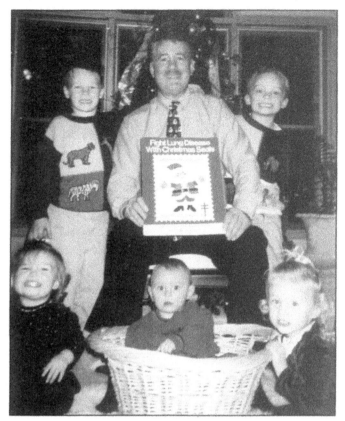

Keith Kleespie as chairman with the American Lung Association, aided by his grandchildren (clockwise): Kole Freshour, Karlie Whiteneck, Braiden Whiteneck, Klaire Freshour, and Davin Lawrence. The Kleespie family has been associated with the American Lung Association since 1913.

Members of the Columbia City Bicentennial Committee include: (front row) Davin Lawrence, Kole Freshour, (second row) Karman Whiteneck, Kari Freshour, (third row) Keith Kleespie and Terry Smith.

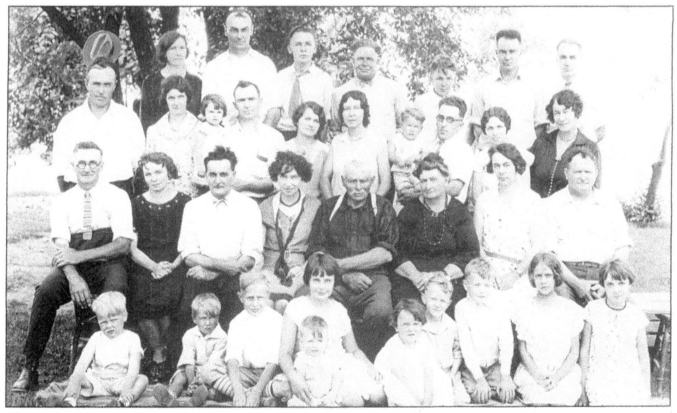

The Schrader reunion, June 15, 1930. Front row: Frederick Schrader, Willodean Schrader, Jimmy Souder (in front), Walter Schrader, Helen Kessler, and Marie Grunawalt. Second row: Frank Grunawalt, Esther Grunawalt, Arthur Shaw, Laura Shaw, Lewis Schrader, Leah Schrader, Dora Souder, and Henry Souder. Third row: Raymond Schrader, Frances Schrader, Gerald Souder is holding Betty Lou, Mary Souder, Ruth Kessler, ???, ???, and Mayme Schrader. Back row: Mrs. Myreal Schrader, Myreal Schrader, Charles Schrader, Myron Kessler, Otis Grunawalt, Claude Souder, and Charles Havens.

35

Log cabin built about 1834 at 600 E. and 1000 S. in Jefferson Township. The cabin was built by Peter Hinen when he purchased the land, and remained in the Hinen family until 2004.

Central Building, Churubusco.

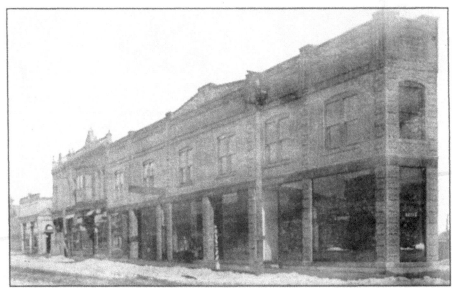

Oldest frame house in Churubusco, 321 S Main St. (C. Jones).

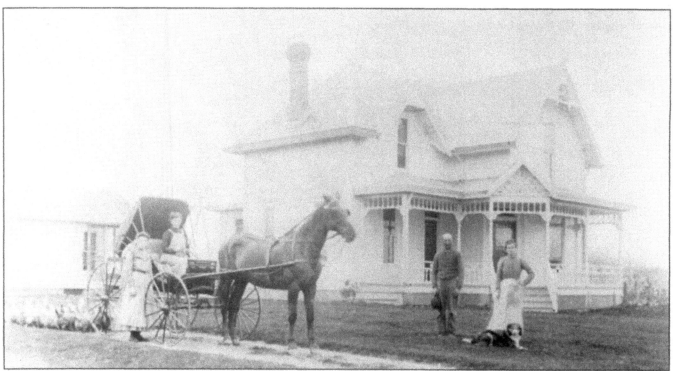

Alfred and Mary L. Grace home, E Old Trail, Columbia City. Grace daughters by buggy. This barn and house is located at 5690 E Old Trail Road, Columbia City, IN. Alfred and Mary L. Grace purchased this property in 1902. The parents are standing in the front yard. Ethyl Grace, daughter of Alfred and Mary, is seated in buggy, and her sister is standing by buggy with chickens behind her. Ethyl married Joshua Barnes and they inherited the farm in 1934.

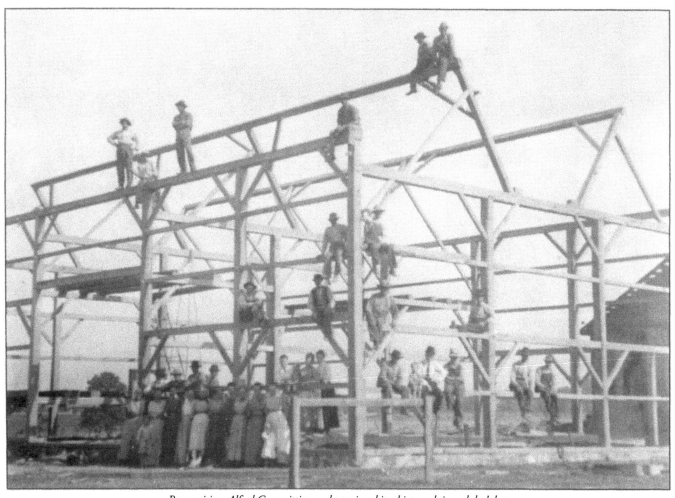

Barn raising, Alfred Grace sitting on beam in white shirt, necktie and dark hat.

Oldest brick house in Churubusco, 507 N Main St., built in 1872. (C. Jones).

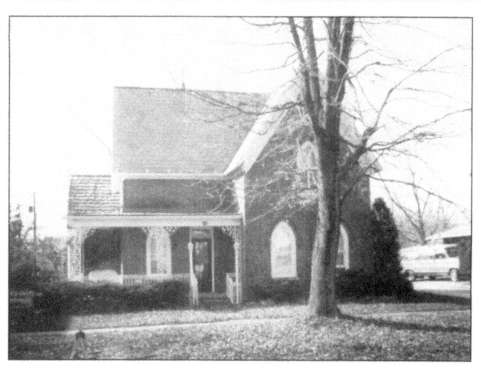

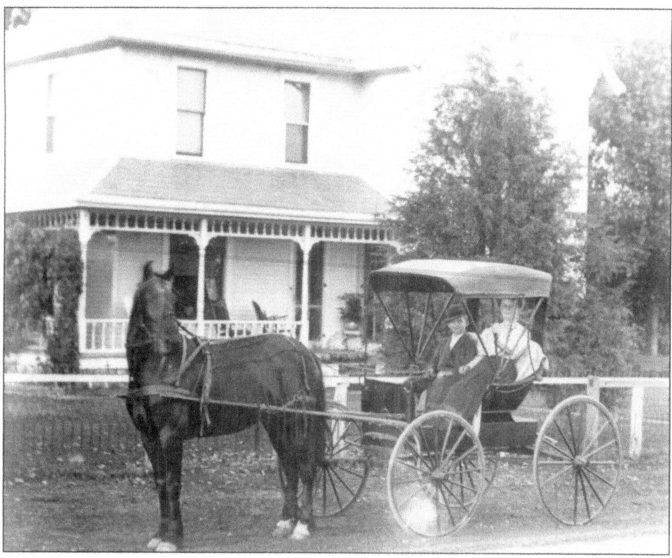

William and Clara Mowrey home, Sidney and Irene Mowrey in buggy, Illinois Rd. (now State Road 14), Jefferson Township.

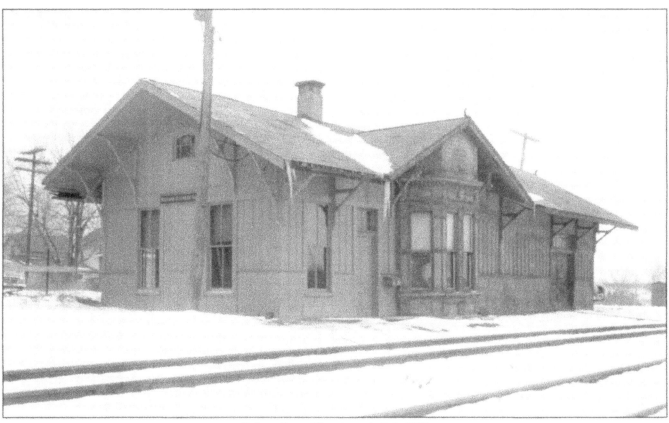

Railway Depot, Churubusco, built in 1877.

Mary Cramer's Rooming House, Churubusco.

Alfred and Kate Hathaway Homestead, N State St., South Whitley, 1967. (Courtesy of Ms. Mary K. Miller).

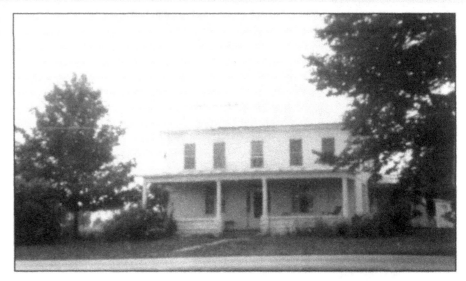

Home of Charles W. and Ida Garrison Crow, young girl is Hazel C. Crow (Egolf), Smith Township, ca. 1900. (Courtesy of Ronald D. Egolf.)

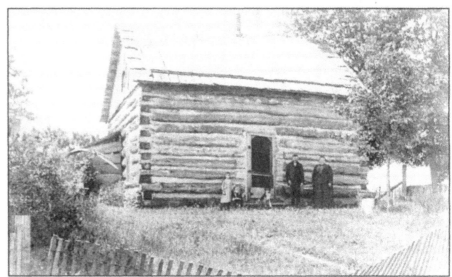

Cabins east of Shriner Lake in 1955. Laraina (Wadington) Seigel, Robbie (Robertson) Bauer, Judy (Robertson) May. (Courtesy of Laraina Seigel).

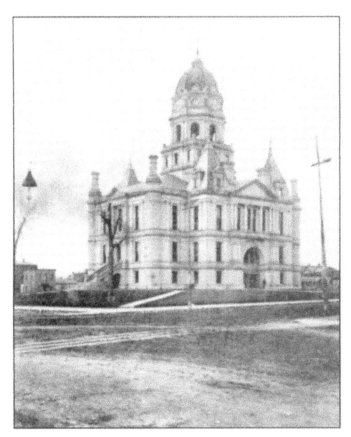

At right: Whitley County Court House, ca. 1908.

Below: Central Building, Churubusco, ca. 1910.

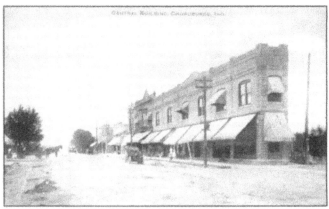

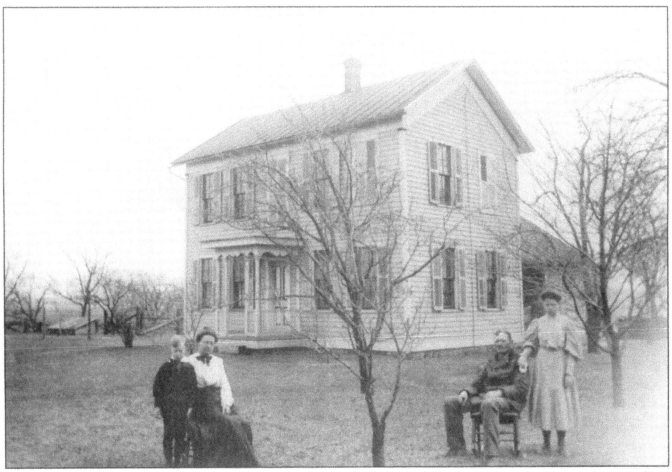

Taylor Homestead, State Road 14, Jefferson Township, 1906. L-R: Russell and Magdelena Taylor, Beal and Mable Taylor. (Courtesy of Anita Leach).

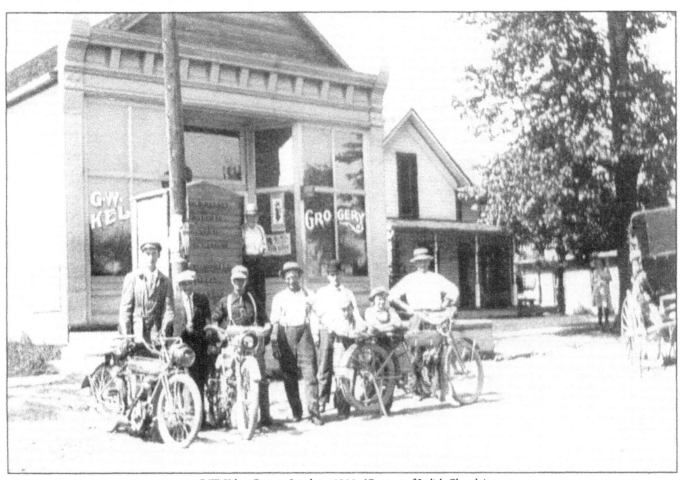

G.W. Kelsey Grocery, Laud, ca. 1900. (Courtesy of Judith Church.)

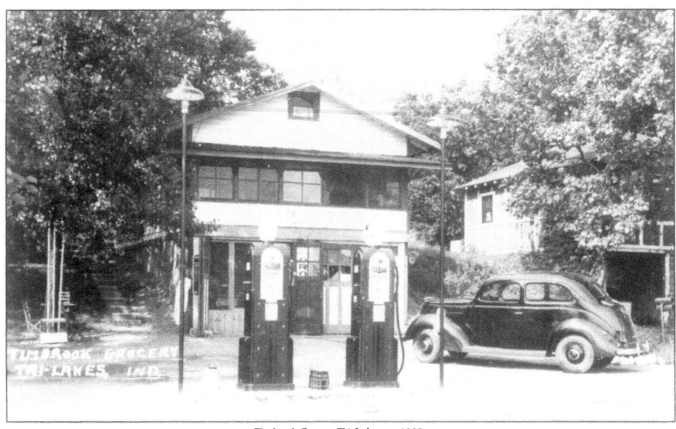

Timbrook Grocery, Tri-Lakes, ca. 1939.

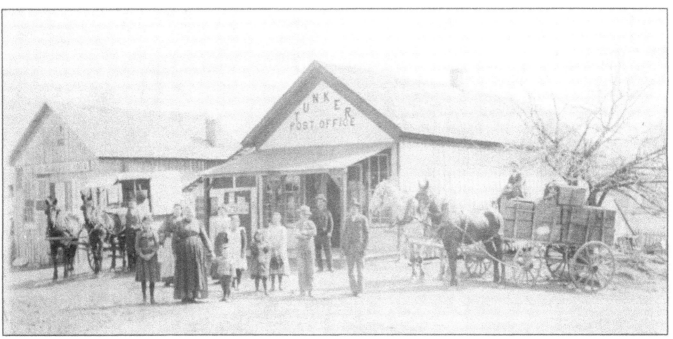

The village of Tunker's General Store and Post Office was operated by H.K. Kitch. It was destroyed in a fire in 1903. (Picture from the collection of the Whitley County Museum.) Identifications of the persons in front of the Kitch store, l-r: H.K. Kitch, unidentified girl, Mrs. Jones, in the center of group Mary Kitch and Herbert Wise, further back is Bertha Kitch, then Della Vance with Marion Kister at the end of the row and a Yontz wagon used to transport eggs and poultry.

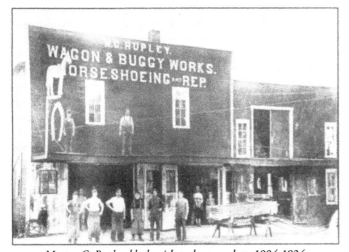

Morton G. Rupley, blacksmith and wagon shop, 1884-1934.

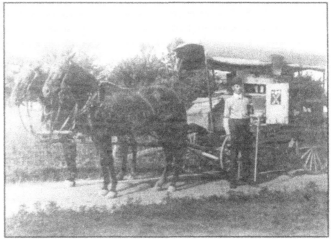

Huckster wagon.

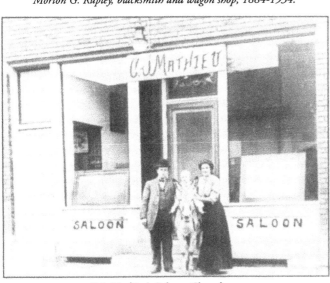

C.J. Mathieu's Saloon, Churubusco.

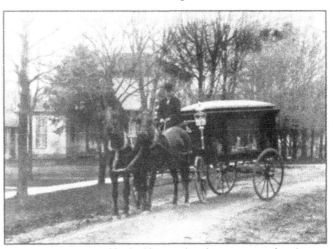

Sonday Funeral Home, oldest building in Churubusco, ca. 1870, later became Sonday & Sheets, presently Sheets and Childs. Courtesy of Chuck and Barb Jones.

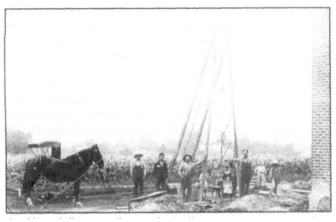

Spudding (drilling) a well at Laud Schoolhouse ca. 1910. (Courtesy of Ted Hollenbaugh.)

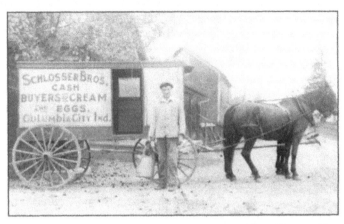

Schlosser Bros., 205 S Main St. ca. 1918. (Courtesy of Ronald D. Egolf.)

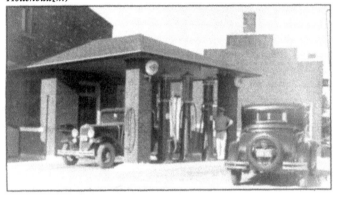

Dale Sprowl's Service Station, Churubusco. (Courtesy of Chuck and Barb Jones.)

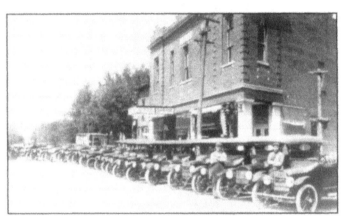

Churubusco Auto Co., 1920.

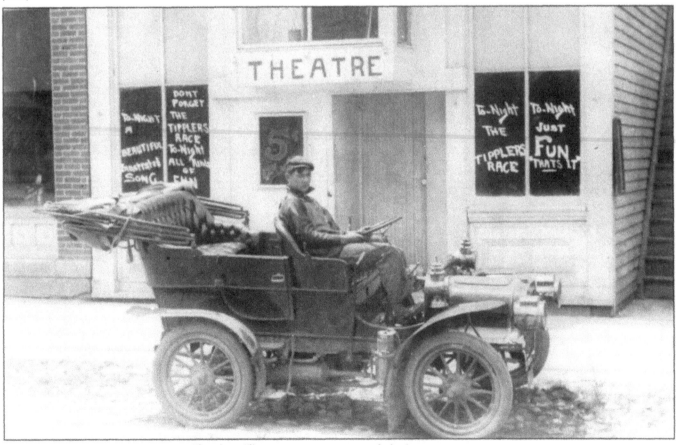

Churubusco Theater, ca. 1920. (Courtesy of Chuck and Barb Jones.)

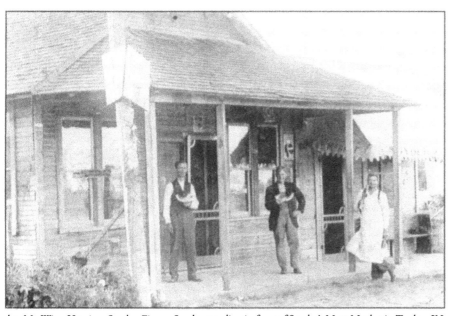

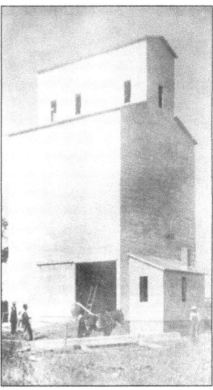

l-r: Mr. Wise, Harrison Snyder, Firmer Snyder standing in front of Snyder's Meat Market in Tunker, IN, ca. 1904. (Courtesy of Judy Church.)

South Whitley – 1911. Farmers Elevator, east side Line Street between Vandalia and Nickel Plate RR. Built in 1911, burned in 1929, rebuilt same year, burned in 1951 and rebuilt.

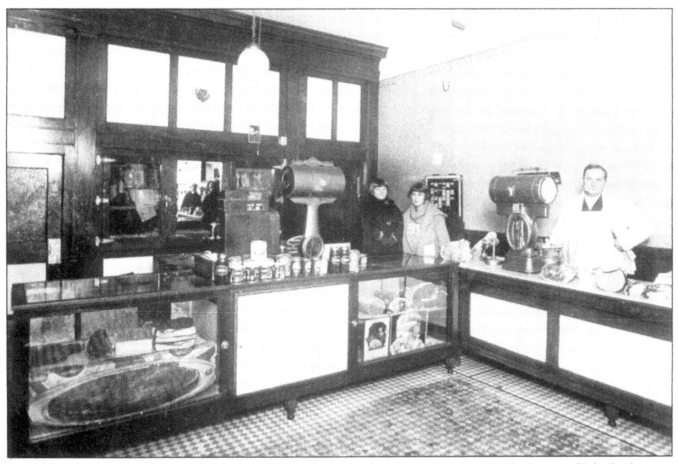

Snyder's Market, early 1920s in South Whitley; l-r: Unknown woman, Bernice Snyder Hawkins, Firmer Snyder. (Courtesy of Judy Church.)

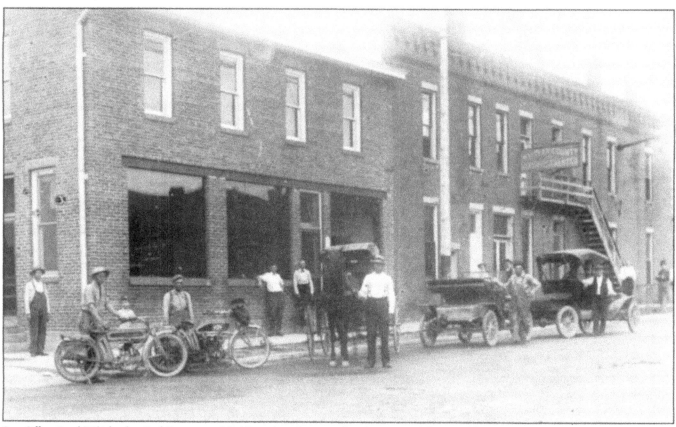

Post Office, South Whitley, l-r: Carl Swanson and Ted Daniels with motorcycles; Ike Gross with horse and buggy, Lee Merriman and Olin Harley with automobiles.

Edwards' Saw Mill, South Whitley.

Tile mill owned by John D. and Justus Sherwood, makers of drain tile, brick building blocks.

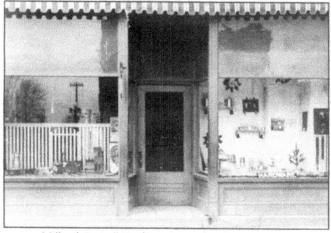

Miller & Burwell Hardware Store, Churubusco, ca. 1913.

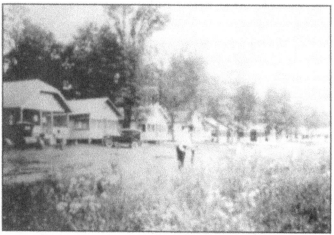

Horseshoe Park, Blue Lake, Churubusco.

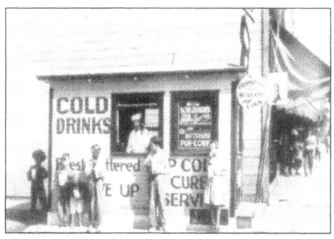

Clarence Brumbaugh and his popcorn stand at the corner of Main and Whitley streets in Churubusco. Brumbaugh ran the stand from 1930 until his death in 1942. Brumbaugh lost his eyesight as a young boy at a 4th of July picnic. Boys were playing with muzzle-loading gun caps and a piece flew into his eye. Infection set in and he later had to have both eyes removed. He attended the School for the Blind in Indianapolis, where he met his wife to be, who had lost her eyesight at an early age due to scarlet fever. The couple later moved to Churubusco.

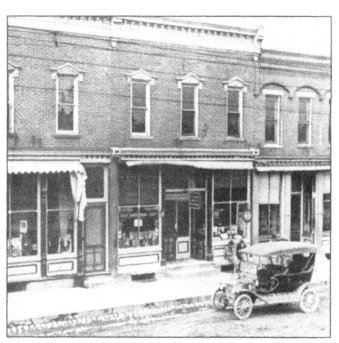

Norris Drug Store, South Whitley.

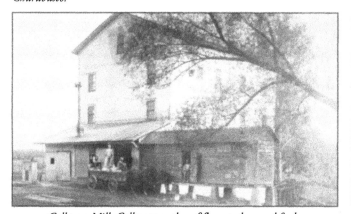

Collamer Mill, Collamer, maker of flour and ground feed.

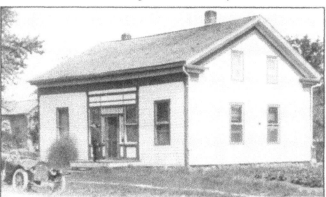

Dr. Fisher's medical office, Collamer.

Floyd Sibert's blacksmith shop, Collamer. (Courtesy of Lois Kyler.)

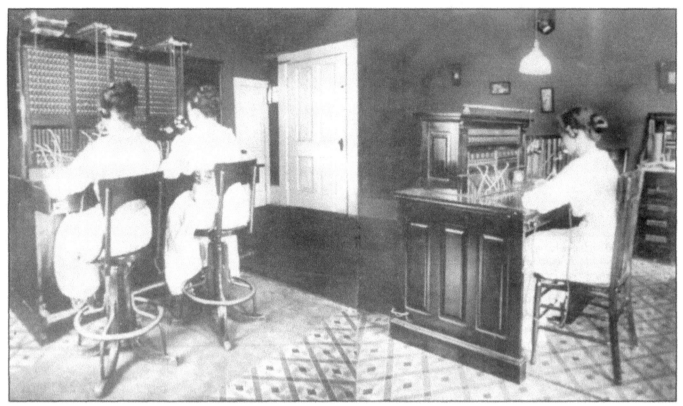

Upstairs at the South Whitley Telephone Office, corner of Front and State Streets. (Courtesy of Madge Rollins files.)

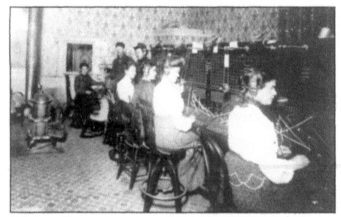

Telephone office upstairs on the northwest corner of Van Buren & Chauncey Streets, Columbia City, 1904. l-r: Bessie Adams Willets, Elle Kiester Malone, Lydia White Scott, Georgia Compton Chapman, Lulie Hufman. Linemen, Jack Rooney and Roy Thompson. (Courtesy of Donald C. Malone.)

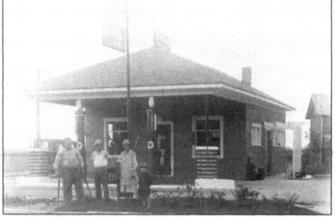

Russell Sevits filling station, southeast corner of Main and North Streets. l-r: Russell Sevits, Wyland Zumbrun, Grace Sevits, Esther Zumbrun. (Courtesy of Wyland Zumbrun.)

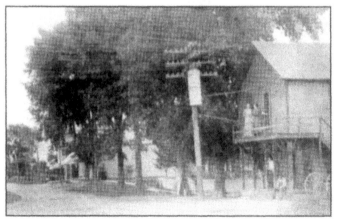

Telephone Exchange Building, Laud, IN. (Courtesy of Judith Church.)

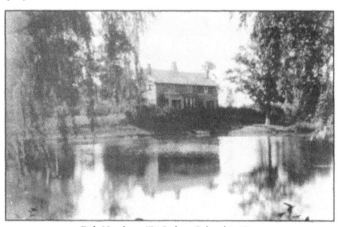

Fish Hatchery, Tri-Lakes, Columbia City.

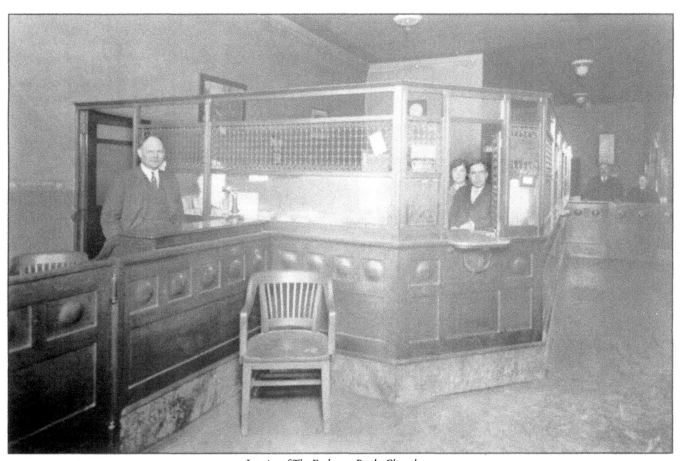

Interior of The Exchange Bank, Churubusco.

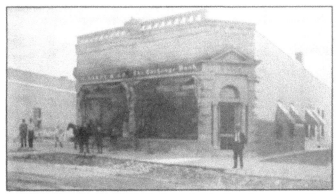

Gandy & Company and The Exchange Bank, Churubusco, ca. 1907.

Hodge's Dairy, Churubusco.

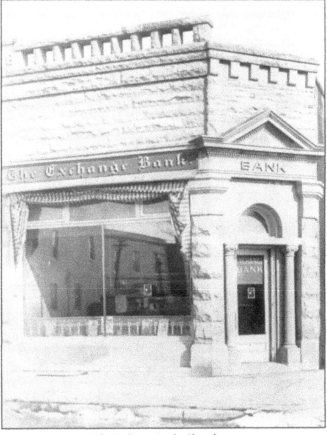

The Exchange Bank, Churubusco.

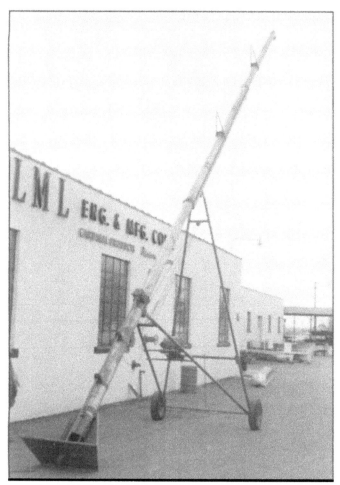

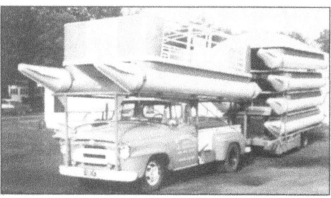

LML Corporation, Riviera Cruisers, Columbia City, 1963. (Courtesy of Jerry L. Badskey.)

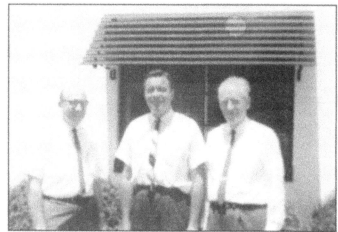

LML Corporation, South Chauncey Street, Columbia City. Note the 6" Auger Cardinal in front of the plant. (Courtesy of Jerry L. Badskey.)

l-r: Lorin Badskey, Milton V. Shubert Jr. and Lewis Reiff, owners of LML Corporation, ca. 1960s, manufacturer of Cardinal Farm Equipment and Riviera Pontoon boats.

Former Hick's Tavern, South Whitley. (Courtesy of Judith Church.)

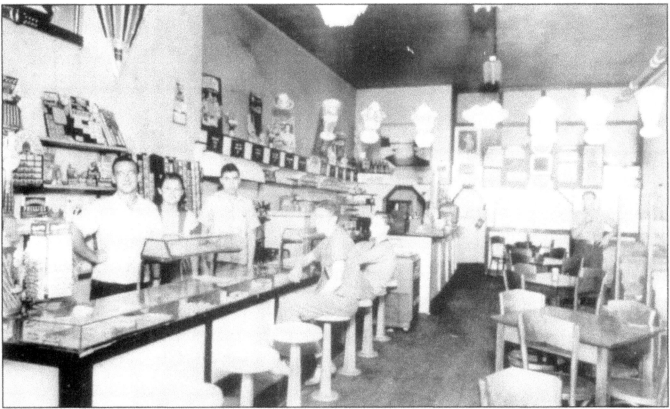

The Klondike, interior. Pictured are, from left: David Shively, Marilyn Shively, Bob Barnes, _____, and Tom Bennett. (Courtesy of M. Wright.)

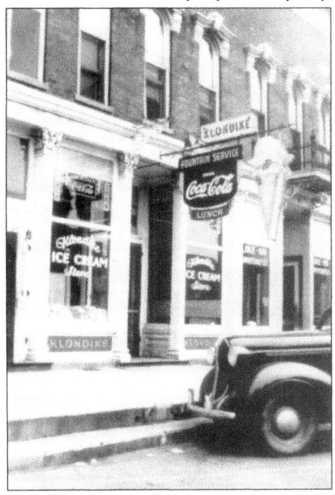

Klondike Ice Cream Store, E. Van Buren St., Columbia City.

Front and back of menu.

The menu from the Klondike Ice Cream Store.

51

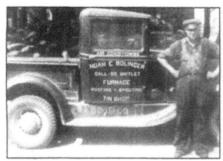

Bolinger Tin Shop, 119 State St., South Whitley –
est. 1940 by Noah Bolinger.

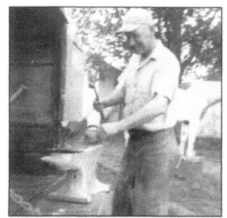

Floyd Siberts, Whitley County blacksmith, July
1961. (Courtesy of Bobbieann Lawrence.)

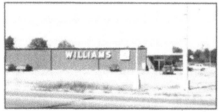

Williams Grocery, N. Main St., Columbia City,
August 1970. (Courtesy of Marilyn Wright.)

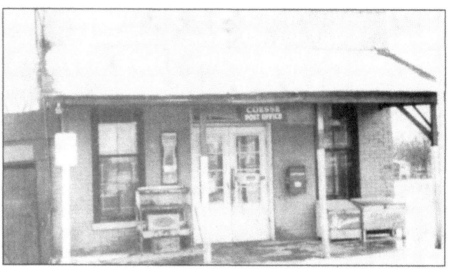

The Old General Store – Coesse.

Schultz Bros. Co. 5 & 10, W. Van Buren St., Columbia City, August 1970. (Courtesy of Marilyn
Wright.)

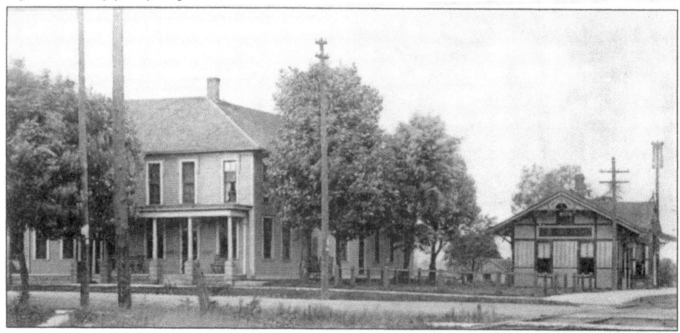

Hotel and Depot, Churubusco, ca. 1967.

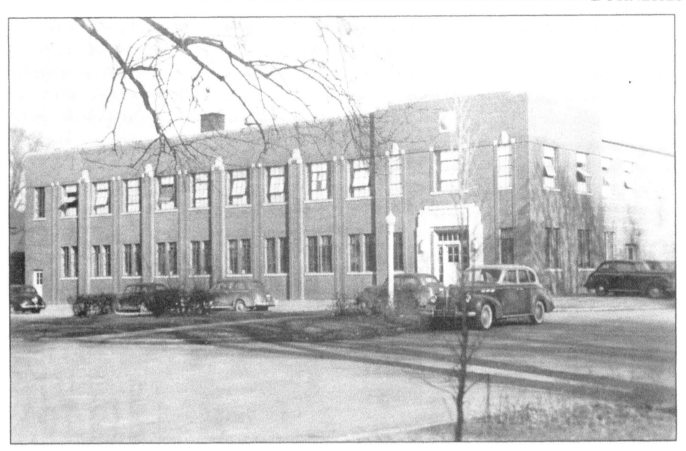

Blue Bell-Globe Manufacturing Co., S. Whitley St., Columbia City.

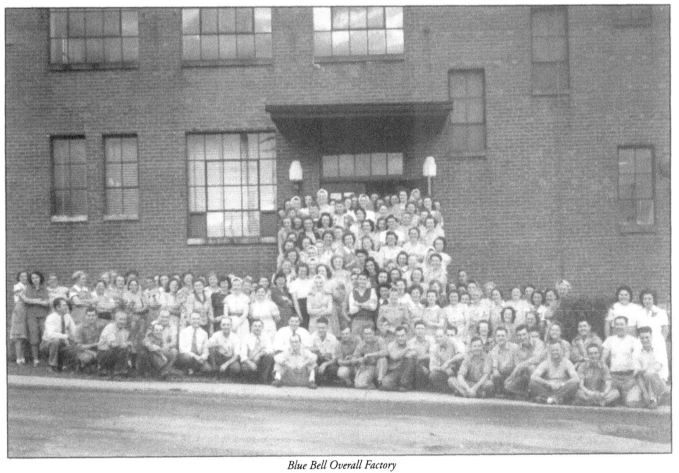

Blue Bell Overall Factory

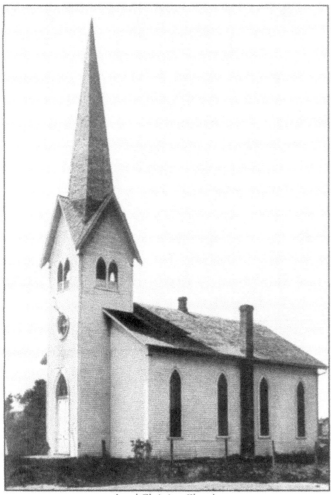

Laud Christian Church.

Laud Christian Church, ca. 1938. Pictured are l-r in front: Lucile Kaufman, Demma White, and the little girl is Judy Snyder. Back: _, Max Kaufman, Thora Mullett, _, Mayola Tschantz, Pauline Snyder, Carrie White, Alma Mullett, _. (Courtesy of Judith Church.)

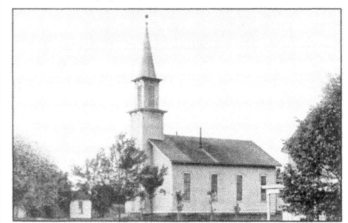

U.B. Church, Churubusco.

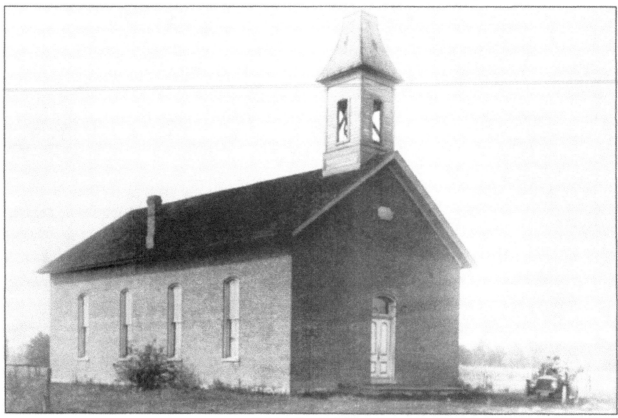

Christian Church, Collamer.

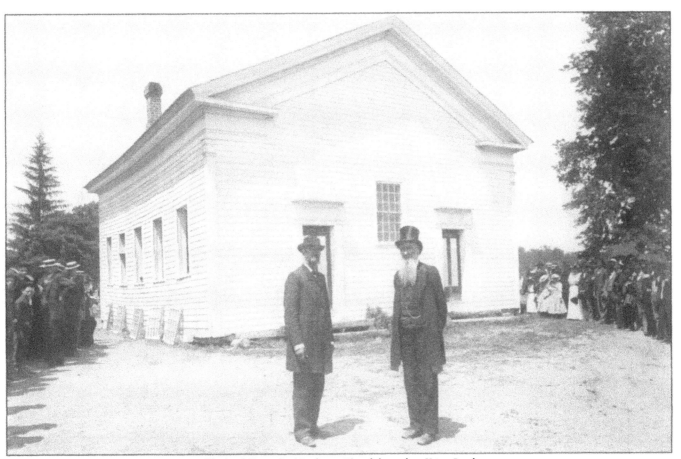

Eberhard Evangelical Lutheran Church located on Keiser Road.

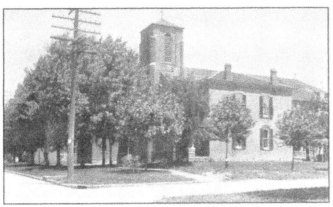

St. Paul's Catholic Church and parsonage, Columbia City, ca. 1917.

First Methodist Church, Churubusco.

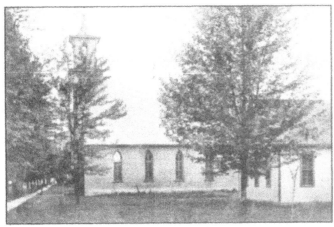

M. E. Church, Churubusco.

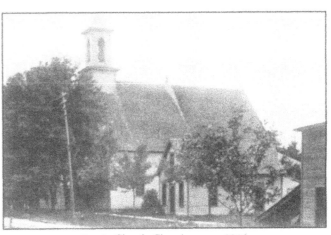

Baptist Church, Churubusco, ca. 1916.

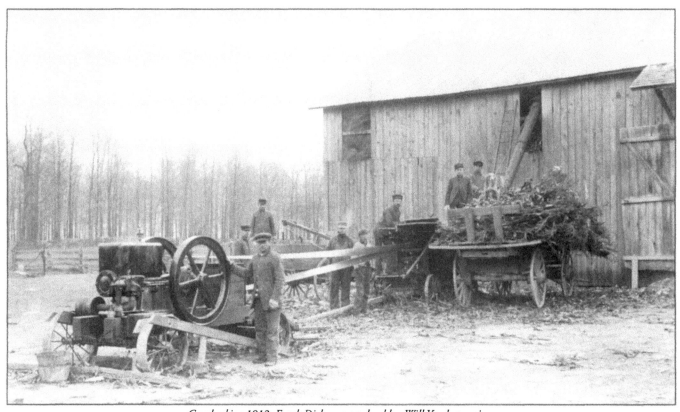

Cornhusking 1912. Frank Dickerson on shredder; Will Yagel at engine.

Butchering day at Frank and Emma Dickerson farm, l-r: Andrew Gaerte, Frank Dickerson and Will Yagel.

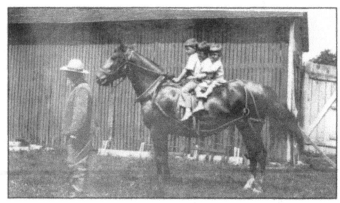

George W. Lawrence leading three grandsons on Blackie, George Lewis, Harvey Sylvester and David Frederick, ca. 1911. (Courtesy of Bobbieann Lawrence.)

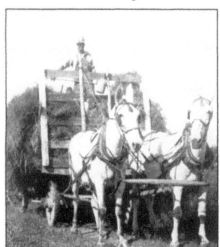

Harvey S. Lawrence with his first set of mules, ca. 1937.

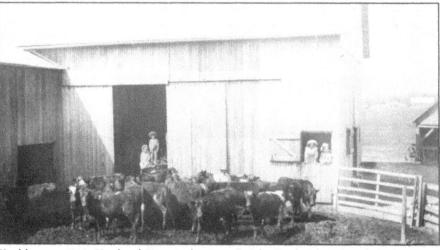

Yagel barn ca. 1910. Hazel and Pappy in driveway, Grandpa Yagel with cattle, Ada Dickerson and Grandma Yagel in doorway.

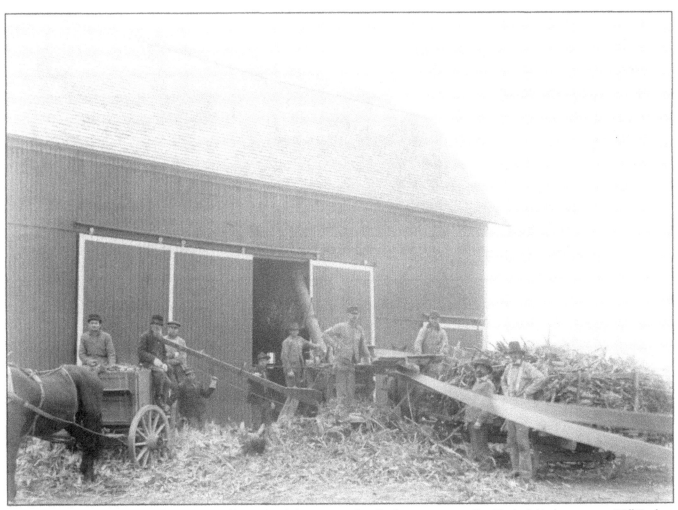

Corn shredding on the Adam Yagel farm (late owned by Merle Kyler) ca. 1910. Adam Yagel on grain wagon, Alva Hartley behind ear conveyer, Will Yagel on back of shredder and Frank Dickerson on front of shredder. Rest unknown.

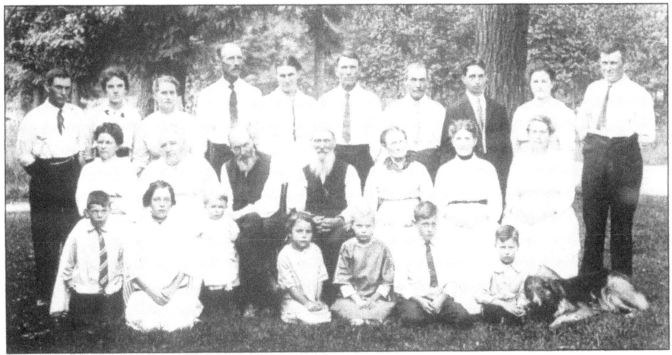

Yagel Reunion 1915, back row: William Yagel, Ada (Gaerte) Dickerson, Emma (Walker) Dickerson, Frank Dickerson, Jennie (Reese) Sheeler, Al Sheeler, Lewis Yagel, Emzy Yagel, Elva Yagel, Truman Kyler. 2nd row: Lela (Hartley) Yagel, Eliza (Martin) Yagel, Henry Yagel, Adam Yagel, Catherine (Yagel) Walker, Maria (Yagel) Allen, Lula (Walker) Kyler. Front row: Vern Yagel, Hazel Yagel, Hubert Yagel, _, _, Merle Kyler, Garland Dueeler? and Shep the dog.

Bonnie and Glenn R. Martin farm, N. Etna Rd. Columbia City. The farm has been in the Martin family since 1836. (Courtesy of Glenn R. Martin.)

Bonnie and Glenn Martin with the 1848 deed for the Martin farm in Etna-Troy Twp., signed by President James K. Polk. (Courtesy of Glenn R. Martin.)

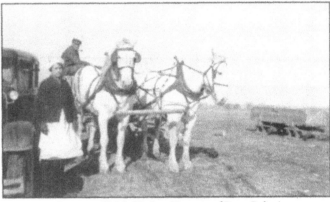

Repairing the corn picker, l-r: Helen Goble, Grover Baker, Marshall Baker. (Courtesy of Dean Baker.)

Grover and Mabel Baker. (Courtesy of Dean Baker.)

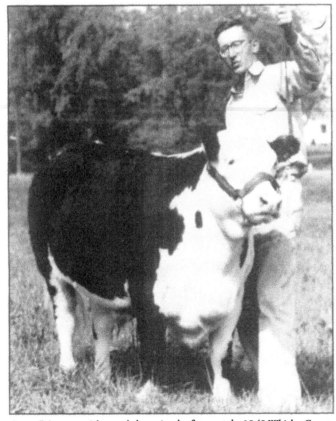

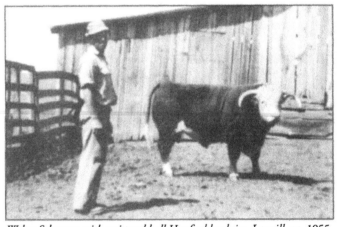

Walter Schuman with registered bull Hereford herd sire, Larwill, ca. 1955.

Larry Schuman with grand champion beef steer at the 1949 Whitley County 4-H Fair.

Merle W. Kyler.

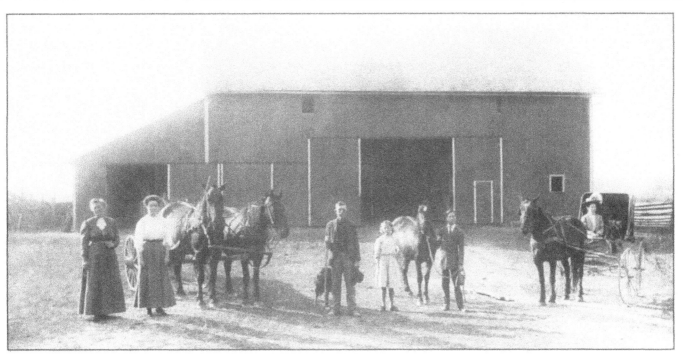

James A. Waugh barn on Airport Rd. L-R: Grandma Waugh (Mrs. James A.), Letha Waugh, James A. Waugh, Margaret Waugh Ott, Kenneth Waugh, Mirth Waugh.

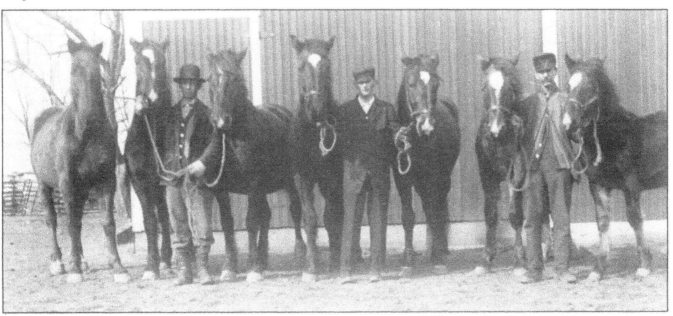

Harley Marrs, Carl Marrs, and their father Warren Marrs at the Marrs farm.

Gaff family onion field which produced 890 bushels per acre, ca. 1912; l-r: Alpheus, Clayton, Elzia, Warren, Thomas and Sylvan Gaff. Sherman and Blanche Gaff in front. (Courtesy of Jane Studebaker.)

Onion Field near Collins, ca. 1915. (Courtesy of Ronald D. Egolf.)

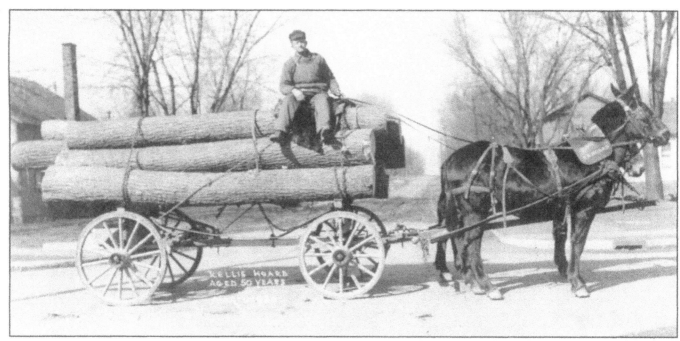

Kellis Hoard hauling logs to town from Homeland Farm, Washington Twp., ca. 1920.

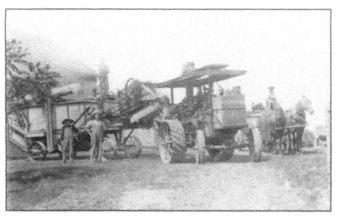

Huber steam engine and thrashing machine. (Picture donated to Whitley County Historical Society by Ronald Egolf.)

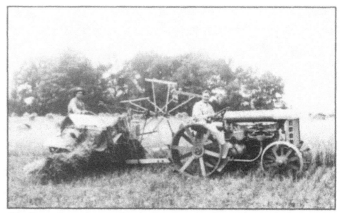

Binding wheat sheaves for shocks. (Picture donated to Whitley County Historical Society by Ronald Egolf.)

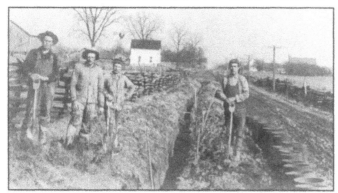

Ditch Diggers in Jefferson Township; l-r: Chester Hollenbaugh, Marion Zent, Homer Hollenbaugh, Clement Hollenbaugh. On back of picture in Homer Hollenbaugh's handwriting: "…at the ditch that we were working on all winter. This picture was taken along the road. This is a good picture according to the position. We had to stand facing the sun. The one boy next the tile is Uncle Joe's third boy Clement and the one next to me is Marion Zent, Mollie's man, and the other is Chester H. This ditch is 245 rds. long it started in the woods that you see between the house and barn. It started with 15 inch tile 122 rds. The rest are 10 inch on the main line you can see part of the main." (Courtesy of Linda Hollenbaugh.)

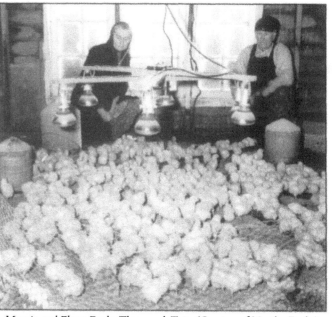

Mazzie and Elmer Engle, Thorncreek Twp. (Courtesy of Martha Engle.)

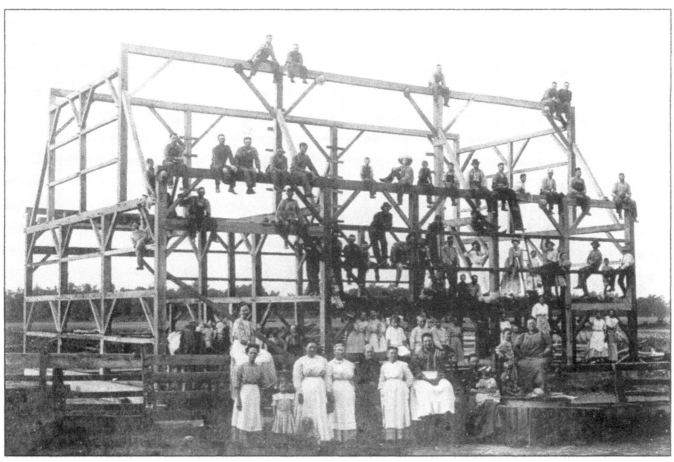

Barn Raising on John Lefever Farm, Jefferson Twp., Whitley County. Third from left top tier is Lester Crowell; 2nd row 1st from left is Herbert Hollenbaugh, 3rd is Chester Hollenbaugh, rest unknown. Courtesy of Linda E. Hollenbaugh.

Lewis Mishler, Moline Tractor dealer, delivering a new tractor.

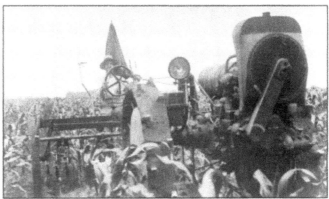

Lewis Mishler cultivating corn.

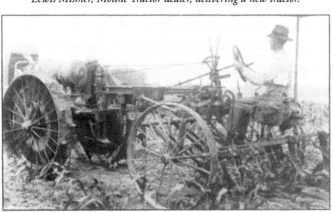

Lewis Mishler cultivating corn.

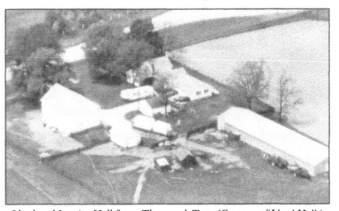

Lloyd and Juanita Hall farm, Thorncreek Twp. (Courtesy of Lloyd Hall.)

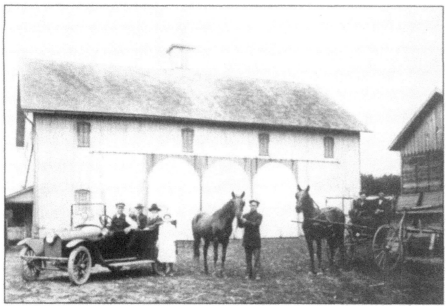

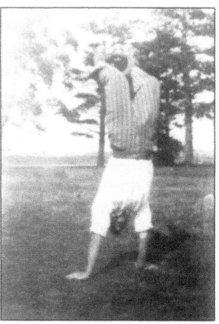

Noah and Nettie Shively farm, Thorncreek Twp., ca. 1908. In the new Briscoe car, Icie Shively Gross, Ilo McCoy. Driver is Noah Shively. Backseat: Helen McCoy, John Smith, Daniel Zumbrun, Ethel Shively Jagger (standing), Murray Shively holding his horse. In the buggy, Esli Shively and David McCoy. (Courtesy of Marilyn Wright.)

Guess who! Lewis Palmer walking on his hands as he often did when going to bring the cows in for milking, ca. 1930-33. (Courtesy of Virginia Palmer.)

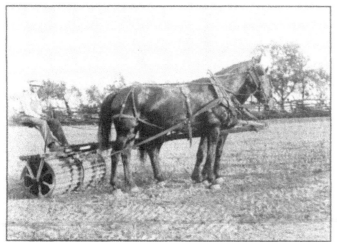

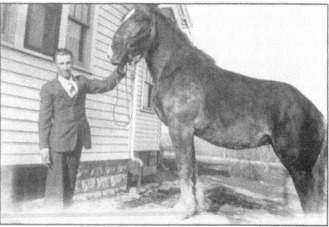

Esli Shively driving a horse-drawn roller. (Courtesy of Marilyn Wright.)

Clarence Raichart with registered Belgian mare, Raber Rd. Jefferson Twp., ca. 1935. (Courtesy of Linda Hollenbaugh.)

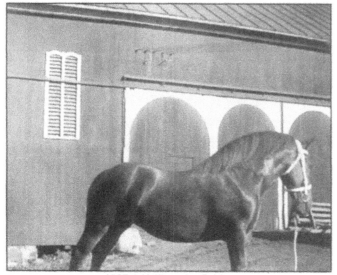

1937 4-H Champion Belgian.

2100 lb. Belgian Stallion.

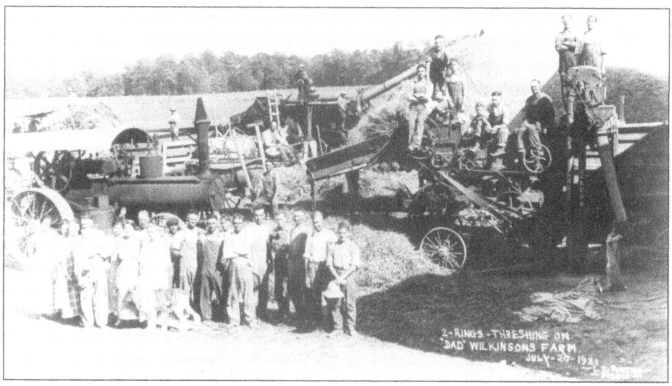

Wilkinson Farm Etna-Troy Twp. Threshing July 20, 1921. Standing in front Mina (Frank) Shaffer, Mildred Harshman (Joe) Wilkinson, Grace Hufty, Sylvester Wilkinson, Blanche Harshman (Carper) Hathaway, Lorena (Johnson) Cornelius, Martin Galloway, Dora Cornelius (George) Harshman, Harold Monroe, Joseph Wilkinson, Archie Kern, Homer Brusman, John Rowe, Glen Galloway, Harry Wolfe, Jake Stricker, George Harshman, Everett Smith. Back l-r: Arlo Orcutt, Homer Correll, _, William Wilkinson, Alvernis Wilkinson, Harl Burns, _, _, Howard, Knouff, Everett Lynn, Charley Shaffer, Albert Shaffer, Thomas Wayne Wilkinson, Frank Orcutt, _, Willard Wilkinson. (Courtesy of Galen Wilkinson.)

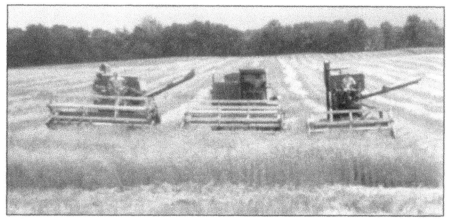

Elmer Heinley, outstanding in his field, 2000. (Courtesy of William E. Heinley.)

Galen Wilkinson farm, 1980, combining wheat are Monte Wilkinson, Rex Wilkinson and Larry Wilkinson.

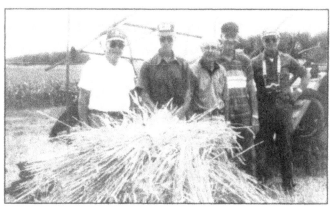

Helen Heinley in the truck patch, 2000. (Courtesy of William E. Heinley.)

Galen Wilkinson Farm, 1998, five brothers cutting wheat for threshing at Whitley County 4-H fair; l-r: Galen, Max, Dayne, Carroll and Larry Wilkinson.

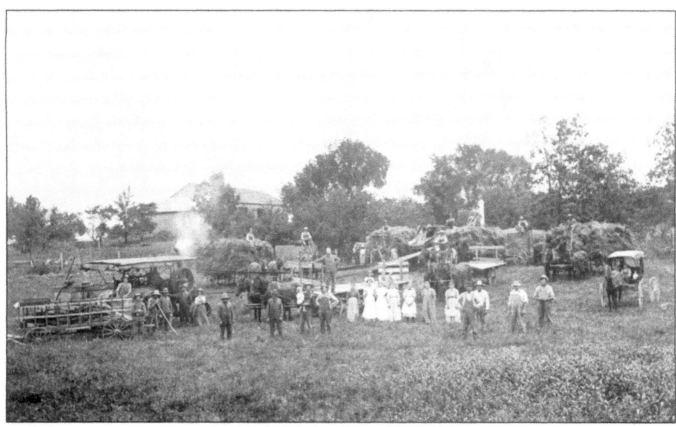

Studebaker family threshing. (Courtesy of Jane Studebaker.)

Farm of H. Junior Studebaker (early 50s to 1988), Union Twp., 2393 E. Mowrey Rd., owned by Brent Schrader.

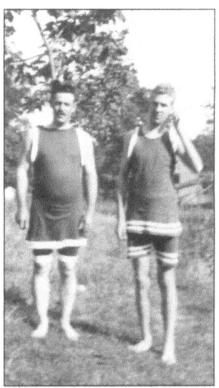

George and LeRoy Clark.

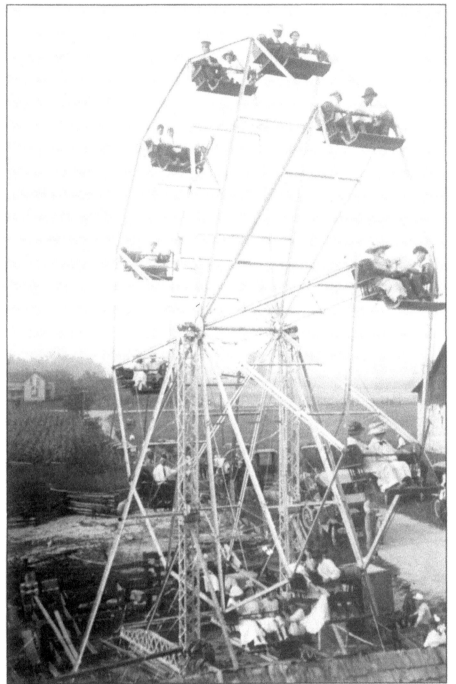

Onion Day, Collins, Farris Wheel. (Courtesy of Phyllis Tracey.)

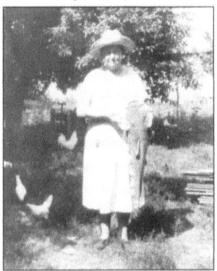

Grandma Kline and her big catch in 1930.
(Courtesy of Edna E. Bates.)

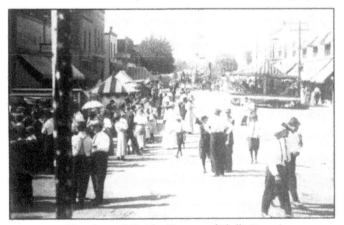

Churubusco, S.E. side. (Courtesy of Phyllis Tracey.)

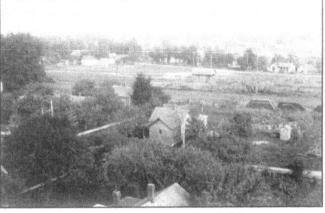

Harvest Jubilee, Churubusco. (Courtesy of Phyllis Tracey.)

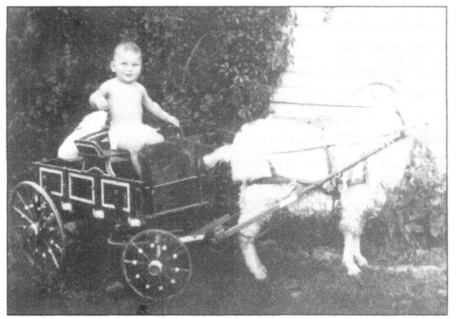

Dan Daniel, 1930.

Ralph Meinika and son Dick with their pet racoons.

Coon Hunters – Hollenbaugh brothers: Chester, Herbert, Clement and Joe. (Courtesy of Ted Hollenbaugh.)

Choella Jane Brubaker, daughter of C.R. and Maud (Wise) Brubaker, probably about 1910. (Courtesy of Rebeckah R. Wiseman.)

Thelma Daniel, Eileen Lillich, Lucy Jones, Mary Pontius, Mary Harrison.

St. Camp Whitley, 1946. Front row: Mary Lois Goble, Jean Lee Mullendore, Joan Heinley; back row: Madalyn O'Doud, Bernice Carver, Julie Crouch.

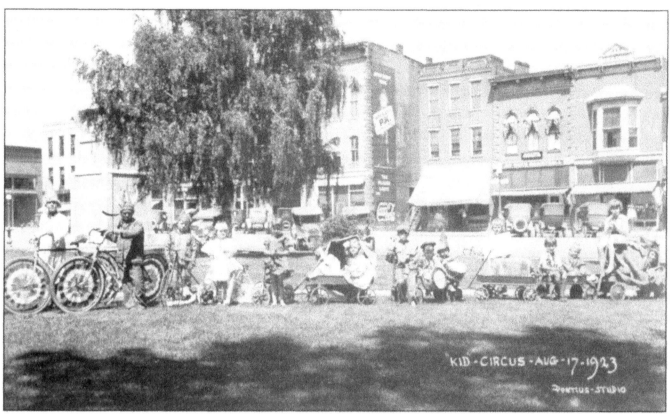

Kid Circus, Courthouse Square, 1923. Second Indian, Carl Waterfall, first drummer, Clark Waterfall.

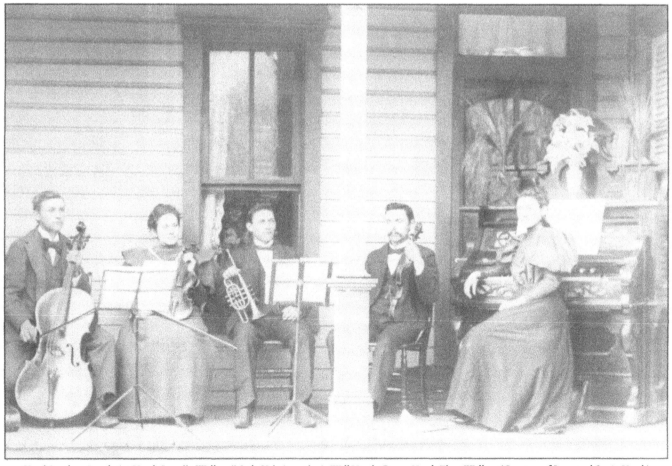

Yagel Brothers Band: Art Yagel, Louella Walker (Merle Kyler's mother), Will Yagel, George Yagel, Flora Walker. (Courtesy of Jerry and Sonja Yagel.)

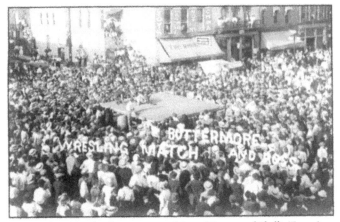

Wrestling Match – Buttermore and Ross. (Courtesy of Phyllis Tracey.)

"Pleasant View Four" Gospel Quartet from Pleasant View Church of the Brethren located five miles south of South Whitley, 1945-54; l-r: Herb Gilmer (tenor), Preston Gregory (lead), Floyd Bollinger (baritone), Dale Reiff (bass).

1966 South Whitley High School prom. Steve Reiff and Doris Draper.

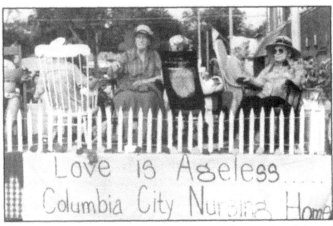

Columbia City Nursing Home float, 1989 Old Settlers Parade. Edith Yagel far right in rocker and Helen Loe next to her.

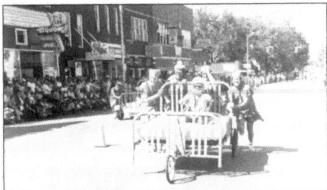

Bed Race Festival, South Whitley.

Bed Race Festival, South Whitley.

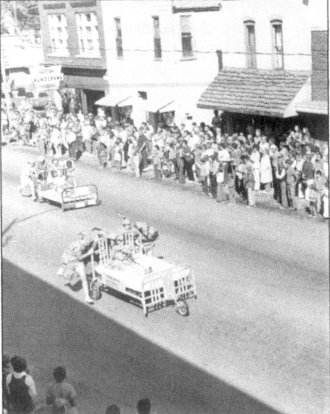

Bed Race Festival, South Whitley.

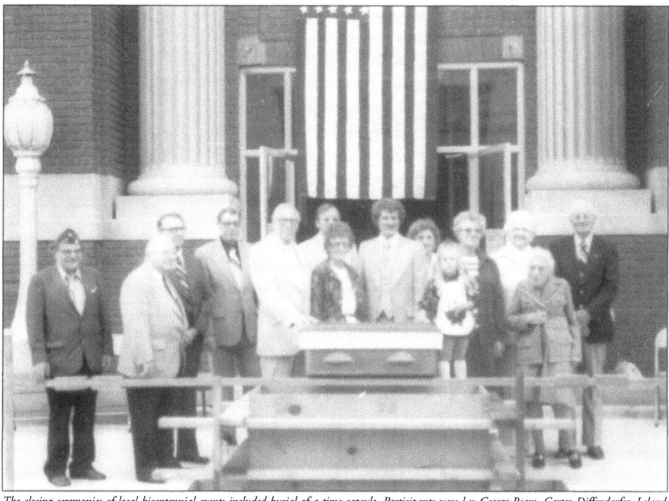

The closing ceremonies of local bicentennial events included burial of a time capsule. Participants were l-r: George Ream, Carter Diffendarfer, Leland Williams, Robert Walker, Rev. Graham Kleespie, Terry Smith, Cornelia Kleespie, Keith Kleespie, Hattie Whitman, Kari Kleespie, Bernice Carver, Lenore Enz, Hester Adams, Carl Enz.

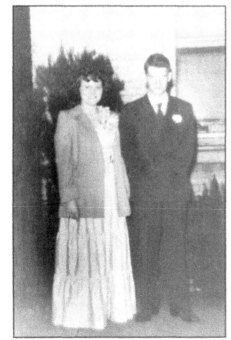

Don and Joann Platt 1949 Jr.-Sr. Prom.

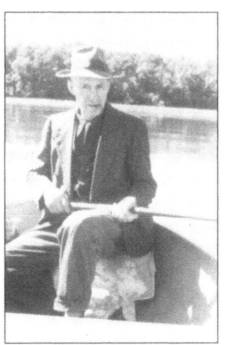

Ira C. Cornelius fishing on Wilson Lake.

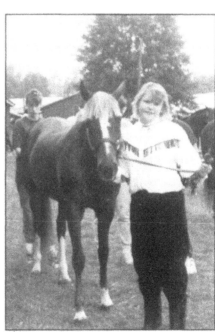

Holly McKinney, 1992 4-H Fair. (Courtesy of Holly McKinney.)

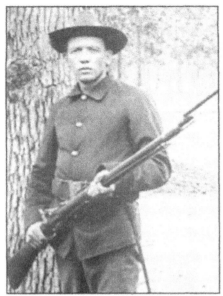

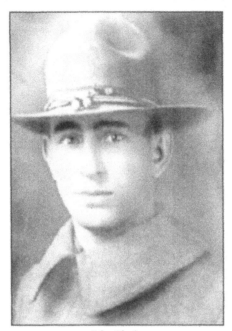

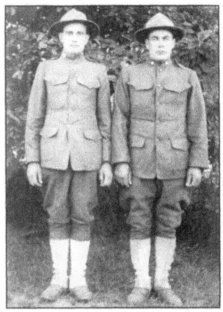

Charles Romaine Brubaker. Mess Sergeant in Spanish American War. This photo was taken in 1899 in Cuba. (Courtesy of Rebeckah R. Wiseman.)

John Black.

Herbert Hollenbaugh on right. (Courtesy of Ted Hollenbaugh.)

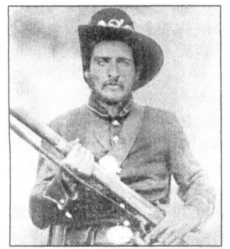

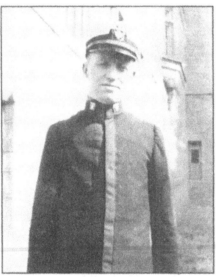

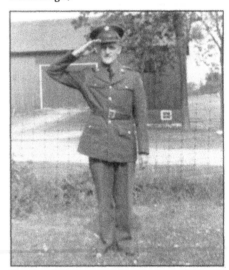

Rolland Victor "Vic" Phend. Sergeant in WWI, 1919. Vic was the son of Henry and Susie Phend. (Courtesy of Rebeckah R. Wiseman.)

Ralph F. Gates. (Courtesy of Pat McNagny.)

Pvt. Russel E. Sievers, 1942. (Courtesy of Edna E. Bates.)

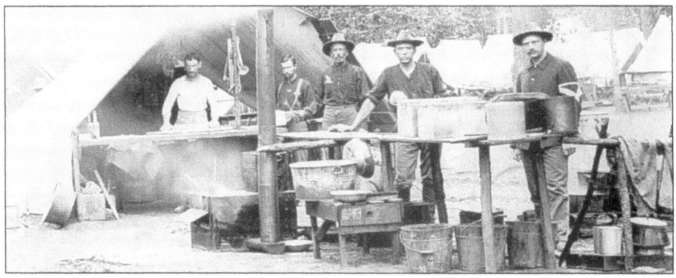

In camp at Mantanzas, Cuba. Charles Romaine Brubaker (2nd from left) was a mess sergeant in Co. K 160th IN Volunteer Infantry. (Courtesy of Rebeckah R. Wiseman.)

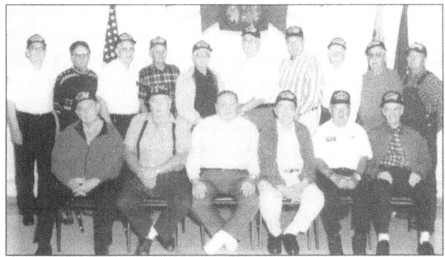

Korean War Community Awareness Committee of Whitley County 2002. Front row: Jack Binkley, Charles Treece, Roger Treece, Anthony Treece, Jim Shaw, Paul Gates. Back row: Donald York, Dick Schuman, Jack Schrader, Chester Ferrell, John Fries, Gerald O. Boyd, Dean Ramsey, John Slabaugh, Charles Pulley, Donald Berkshire. Not shown: Robert Cornmesser, Alvin Freeman, Frank Frey.

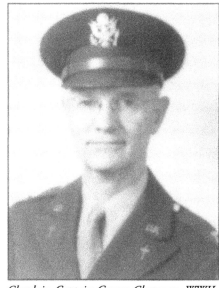

Chaplain Captain Grover Chapman, WWII, 1945. (Courtesy of Charles and Margaret Smith.)

Leatherneck Coffee Club of Whitley County, 2003. (A-L) from left: John Adams (not pictured, Gerald O. Boyd, Barry Yeakle, Charles Carroll, Ken Cearbaugh, Ronald Dean Egolf, Frank Fahl, Tom Fahl, Chester L. Ferrell (Deceased Aug. 22, 2003), Kenneth Foster, Phil Fry, E.A. Gebhart, Michael Gingher, Dave Hanie, Kevin L. Jagger, Lyle LaFever (not pictured), Don Lewis, Grant Loy, George Lutz.

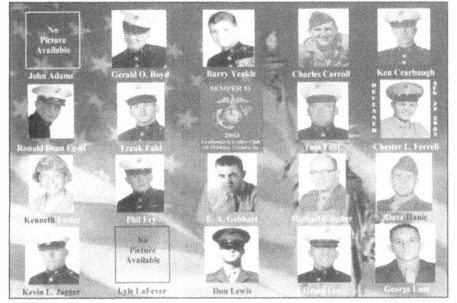

Leatherneck Coffee Club of Whitley County, 2003 (M-Z), from left: Henry Mackey, Jason McKown, Eugene Ness, Joe M. Pittenger Jr., Don Porter, James A. Price, Fred Rathke, Dave Reed, Rob Reed (not pictured), John Richards, Gene E. Rohrer, Donald Rondeau (not pictured), Jack Schrader, Richard Tierney, Anthony Treece, Roger Treece, Jerome Wellman, Ray L. Wilson, Lyn Zumbrum (not pictured).

Future Farmers of America, Whitko High School, 1975-76. (Courtesy of Bill McVay.)

Adult Farmer Class, 1960, South Whitley High School. Joe Metzger conducted the classes from the late 1940s until 1957 and Bill McVay from 1959-1980s. (Courtesy of Bill McVay.)

BPOE (Elks) 50 year members, ca. 1955. Front row: Rob McNagny, Norris Essinger, Louis Daniel, Ralph Widdefield. Back row: Harry Bollinger, Jim Brown, Bud Grant, Jim Adams, Jack Peabody, John Lillich.

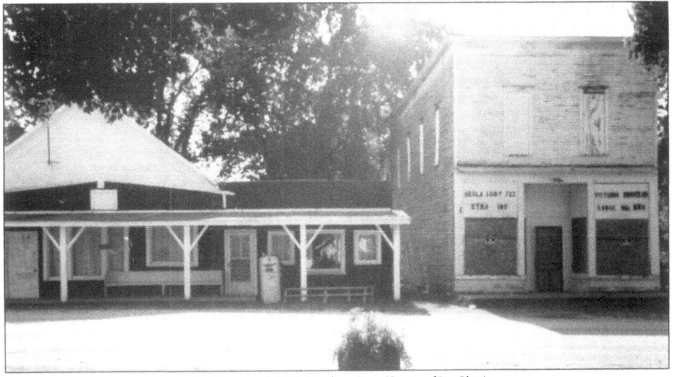

Ever's Grocery and old Hecla Lodge at Etna. (Courtesy of Don Platt.)

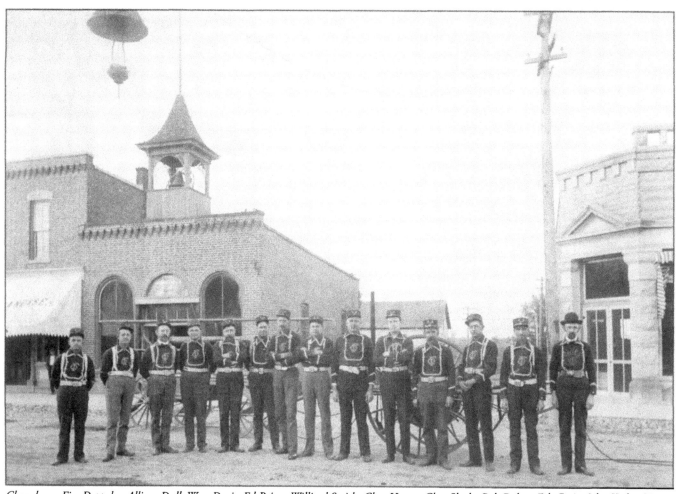

Churubusco Fire Dept. l-r: Allison Dull, Wm. Davis, Ed Briggs, Williard Smith, Chas Harter, Chas Slagle, Bob Dolan, Eck Craig, John Keeler, Homer Cutter, John Easley, Frank Heff, Dora Ackley, F.P. Loudy. (Courtesy of Opal G. Johnston.)

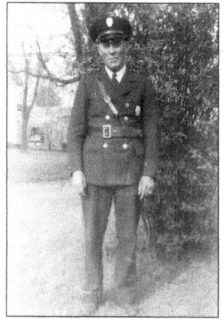

Arnie Gilbert Egolf, 1889-1962, Security Officer at Weatherhead Products 1943-44. (Courtesy of Ronald D. Egolf.)

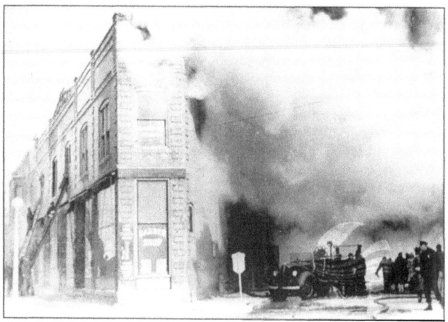

Central Building Fire in Churubusco; Fort Wayne sent pumper No. 6 to help fight the fire. Three were hurt including two Fort Wayne Firemen, Captain Henry Goeglein and his brother-in-law Harry Prange, Feb. 12, 1944.

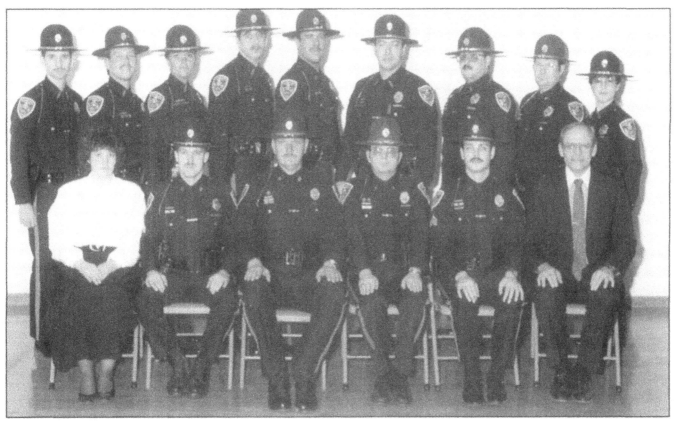

Police Department, Columbia City, 1994. Front row: Chris Weigold, Doug Eber, Larry Creech, Ron Glassley, Shad Hunter, Mayor Jim Teghtmeyer. Back row: William Simpson, Brian Anspach, Geri Davis, Scott Cover, Rick Carroll, James Acres, Jeff Mishler, Peter Yorg, Linda Herron.

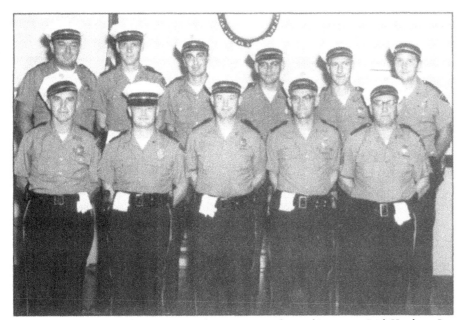

Police Department, Columbia City ca. 1964. Front row: Paul "Dutch" Forrester, Dick Hyndman Ron Egolf, John North, Lee Gross. Back row: Bill Creech (Dispatcher), Dick Smith, Russell Wolfe Jr., Fred Snyder, Cecil Huntley, Gordon Anspach.

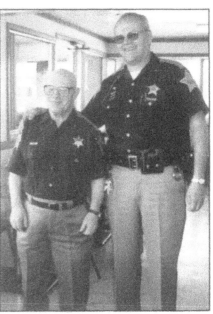

Whitley County Sheriff Mike Schrader (right) and Churubusco's famous citizen John Kreiger. CNN did a show about Johnny in 1999.

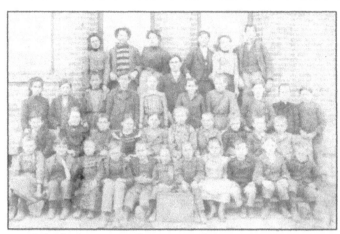

Fair Oak School 1901-02, Jefferson Twp., Whitley County. **Front row:** Kitty Jerome, Gus Hines, Gail Robbins, _, Charles Flickinger, Hazel Chapman, Ethel Chapman, _, Donald Thrasher, Nate Shroyer, Herbert Hollenbaugh. **Row 2:** Charles Siffles, Edith Paine, Walter Hart, Beatrice Robbins, _, _ Robbins, Clement Hollenbaugh, Hazel Smith, Charles Robbins, Arthur Razor. **Row 3:** Alta Flickinger, Plen Jerome, _, John Hines, _, (teacher) M.S. Domer, Walter Flickinger, _ Robbins, _, _ Robbins, _. **Row 4:** _, Cleveland Freck, _ Flickinger, _, Edith Hollenbaugh, Logan Freck. (Courtesy of Linda E. Hollenbaugh.)

Quick School, northeast corner of Raber Rd. and 400 south, Union Township, ca. 1890. Luluela Walker, middle row, far right. Flora Walker, middle row, third from right. (Courtesy of Larry Hawn.)

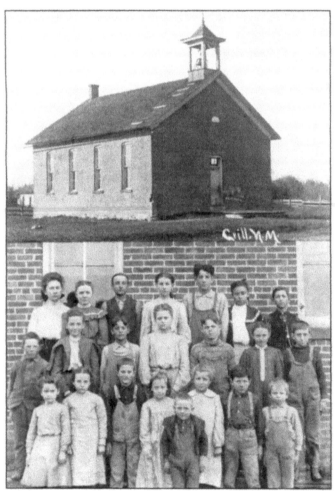

Groundhog School, District 9, Jefferson Twp., ca. 1903. Back row, far right: Jesse Chase Nichols.

Washington Center School, Oct. 5, 1905. (Courtesy of Amy Abbott.)

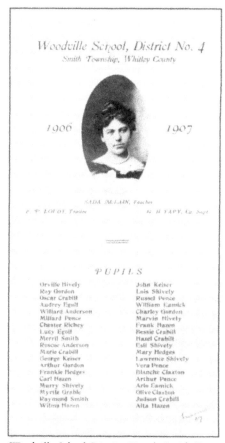

Woodville School, District No. 4
Smith Township, Whitley County

1906 1907

SADA McLAIN, *Teacher*

PUPILS

Orville Hively	John Keiser
Roy Gordon	Lois Shively
Oscar Crabill	Russel Pence
Audrey Egolf	William Eamick
Willard Anderson	Charley Gordon
Millard Pence	Marvin Hively
Chester Richey	Frank Hazen
Lucy Egolf	Bessie Crabill
Merril Smith	Hazel Crabill
Roscoe Anderson	Esli Shively
Marie Crabill	Mary Hedges
George Keiser	Lawrence Shively
Arthur Gordon	Vera Pence
Frankie Hedges	Blanche Claxton
Carl Hazen	Arthur Pence
Murry Shively	Arlo Eamick
Myrtle Grable	Olive Claxton
Raymond Smith	Judson Crabill
Wilma Hazen	Alta Hazen

Washington Center School, ca. 1908. Elva Kimmell, far left, third row from top. (Courtesy of Harry Bollinger.)

Woodville School District No. 4, Smith Twp., Whitley County. Sada McLain, teacher 1906-07. Pupils: Orville Hively, Roy Gordon, Oscar Crabill, Audrey Egolf, Willard Anderson, Millard Pence, Chester Richey, Lucy Egolf, Merril Smith, Roscoe Anderson, Marie Crabill, George Keiser, Arthur Gordon, Frankie Hedges, Carl Hazen, Murry Shively, Myrtle Grable, Raymond Smith, Wilma Hazen, John Keiser, Lois Shively, Russel Pence, William Eamick, Charley Gordon, Marvin Hively, Frank Hazen, Bessie Crabill, Hazel Crabill, Esli Shively, Mary Hedges, Lawrence Shively, Vera Pence, Blanche Claxton, Arthur Pence, Arlo Eamick, Olive Claxton, Judson Crabill, Alta Hazen.

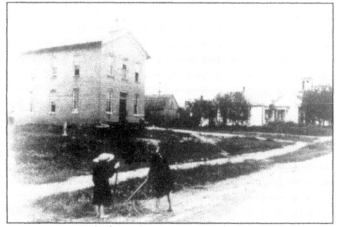

First school in Collamer. (Courtesy of Lois Kyler.)

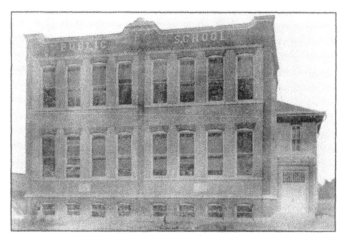

Churubusco School, ca. 1910.

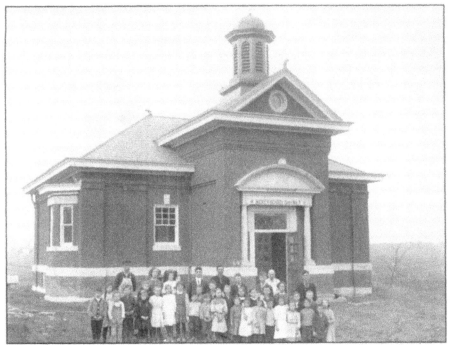

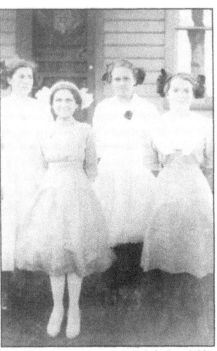

Smith Twp. Whitley County. Helen Egolf Shively and Hildreth Egolf More, twins in second row (white collars on dark dresses). (Courtesy of Marilyn Wright.)

In their graduation dresses, 1912: Sula Ott, Goldie Garrison, Eldee Conrad, Ruth Ott.

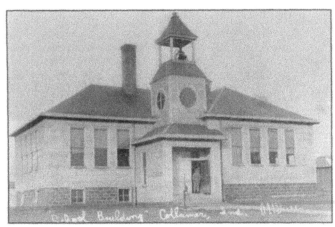

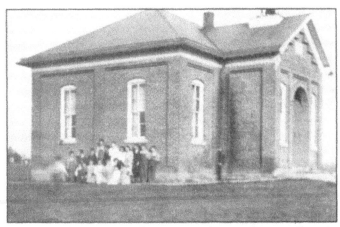

Collamer School, 1913.

Tracy School, District 8, Washington Twp. (Courtesy of Harry Bollinger.)

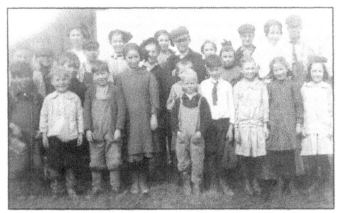

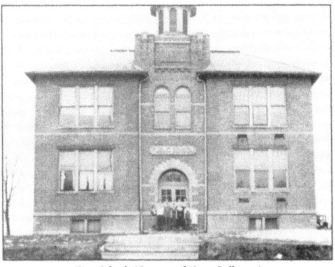

Postcard. On the back is written "Jane Brubaker April 3, 1914 My School. Wyland Herrold Teacher" Jane would have been 11 years old in 1914. I think she is the 3rd person from the right in the back row, with the white bow on top of her head. This probably would have been the old Scott School since she lived at Goose Lake at the time. (Courtesy of Rebeckah R. Wiseman.)

Etna School. (Courtesy of Harry Bollinger.)

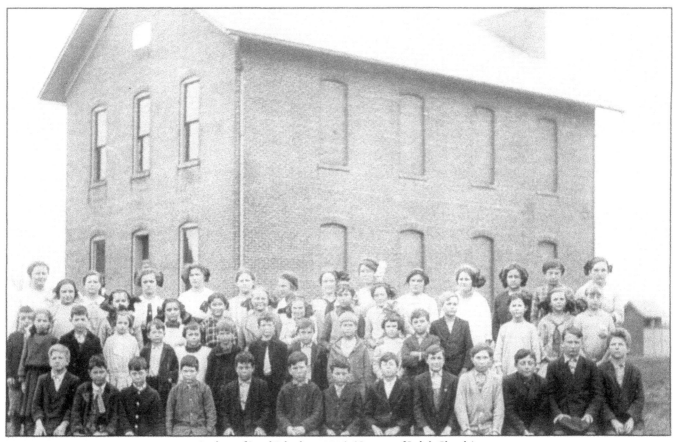

Students of Laud School, ca. 1914. (Courtesy of Judith Church.)

Schrader School, Columbia Township, ca. 1915. **Back row:** *Russell Rasor, Clemmett Ritenouer, Robert Anders, Carl Kneller, Walter Keiser, Helen Shearer, Samuel Schrader, Walter Sievers, Verda Cox, Russell Schrader, Roland Schrader, Mildred Ramsey.* **Center:** *Frances Schrader, Florence Sievers, Berneda Schnetzler, Florence Schrader, Alice Ritenouer, Ella Hurd, Florence Kerch, Melba Hartman, Iva Decker.* **Front:** *Lloyd Kerch, Stanley Hurd, Irvin Sievers, Alex (last name unknown), Robert Smith, Edward Anders, Elmer Sievers, Henry Sievers, Norman Shearer, Martin Schnetzler.*

Churubusco 8th Grade, April 28, 1916. **First row:** *Charlotte Diller, Bertha Richards.* **Second row:** *Headley Deminy.* **Third row:** *Julia Hull, Kenneth Jones, Harold Christopher, Lois Deems.* **Fourth row:** *Abbie Hilbig, Thelma Smith, Emily Dominy, Glenn Lehman. Teacher Frank Read.*

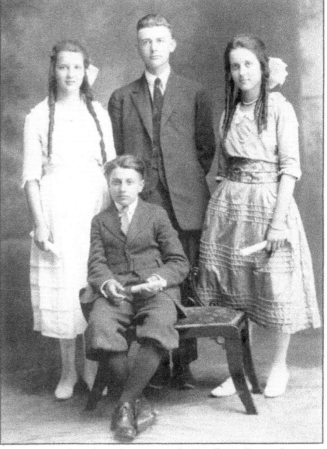

Maple Grove 8th grade graduates, 1921, l-r: Rozella Kneller, teacher Harry R. Bollinger, Stella Cusick. Sitting is Roy Sheets. (Courtesy of Harry Bollinger.)

CCHS Class of 1916. First Reunion after 45 years. Old Settlers Day Aug. 17, 1961. **1st row l-r:** Irene Leininger Schultz, Carrie Wetzel Timmons, Laura Keirn Metzger, Mary Bechtold Rhoads, Cleo Coyle Adams, Herbert J. Ihrig as faculty guest, Vernice Carter Mosher, Velma Whiteleather Moeller, Katherine Waterfall Kirschner. **2nd row l-r:** Nell VanVoorst, Marie Friskney, Mary Faust Strouse, Edith Jackson Fleckenstein, Naomi Estlick Gerkin, Ernest Gerkin, Bernice Briggs Lockhard, Louis Rhoads Goble, Esther Brown Inks, Ernest Erne, Mildred Crawford Barnes, Clara Colchin Miller. **3rd row l-r:** Gail E. Lancaster, Dr. Robert Fagan, Merle M. Fisher, Rex Ball, Ralph J. Meyers, Leeman S. Baker, Phil McNear, Mark Terman, Clarence A. Feist, George Burns.

Maple Grove School (Poor Hook) Washington Twp. - District 1, 1920-21, Whitley County. Harry R. Bollinger who lived in Washington Twp. and graduated from Washington Center High School in the spring of 1920 went to Manchester College soon after school was out and took educational courses to be able to teach in the fall. J. Lee Emery was the Trustee for Washington Twp. and he hired Harry R. Bollinger for the 1920-21 school year in the one-room school house at Maple Grove referred to as "Poor Hook." There were 31 students on the roll at the school for the year of 1920-21. (Courtesy of Harry Bollinger.)

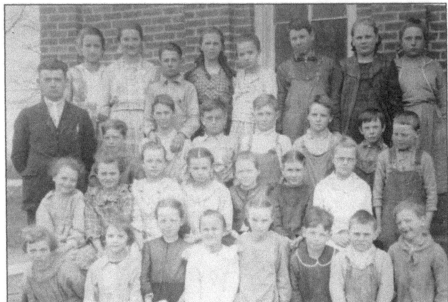

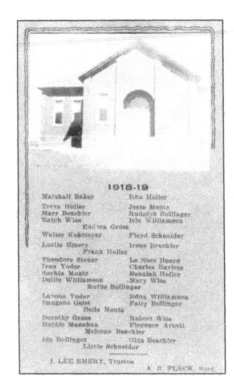

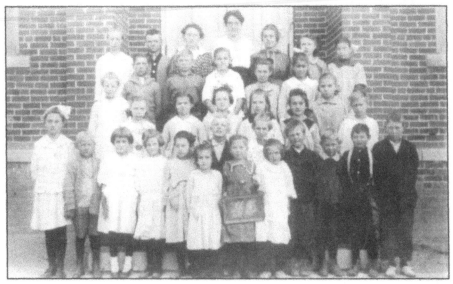

1918-19. Marshall Baker, Treva Holler, Mary Beachler, Ralph Wise, Eudora Gross, Walter Kehmeyer, Lucile Emery, Frank Holler, Theodore Stoner, Ivon Yoder, Sophia Montz, Dollie Williamson, Rufus Bollinger, Lavona Yoder, Imogene Geist, Della Montz, Dorothy Gross, Burnie Monahan, Melzene Beachler, Ida Bollinger, Lizzie Schneider, Itha Holler, Jesse Montz, Rudolph Bollinger, Icle Williamson, Floyd Schneider, Irene Beachler, Le Nore Hoard, Charles Bayless, Mary Wise, Edna Williamson, Fairy Bollinger, Robert Wise, Florence Arnett, Olga Beachler. (Courtesy of Harry Bollinger.)

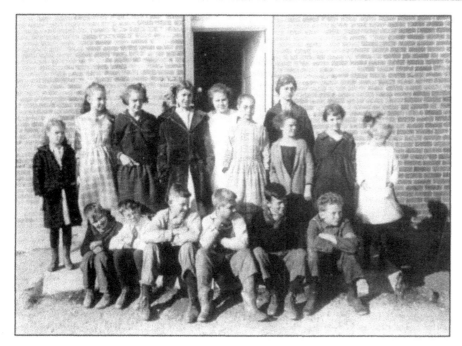

Huffman School, Columbia Twp. **2nd row:** *Esther Blanchard, Kathryn Long, Marie Anderson, Tina Hawn, Wanda McNabb, Mary Dennison, Vineta and Dorothy Long, Mary Miner.* **1st row:** *Evertt Anderson, Bonnel Mosher, Harold Kyler, Don Hawn, Gail Harris, Kenneth Morrow. Teacher Blanche M. Stickler. (Courtesy of Blanche Stickler.)*

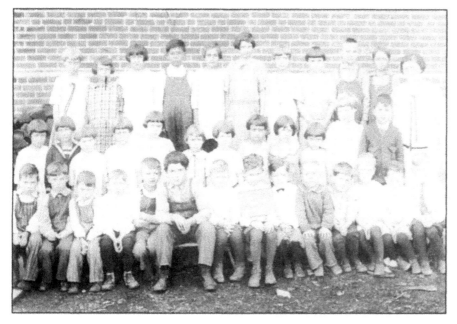

Etna School 1924-25 Teacher Mrs. Ralph Evans. **1st row l-r:** *Dale Beers, Dan Sauers, Orvas Beers, Bennie Herr, Ralph Shroufe, Roy Vanderford, Joe Orcutt, George Baugher, Robert Estlick, Ralph Cooperrider, Charles Gray, Jack Boggess, Max Heintzelman, Max Wolfe.* **2nd row:** *Geneva Miller, Emiline Thorn, Wilma Wolfe, Imogene Wolfe, May Millard, Mary McConnell, Glenndora Beers, Peggy Beezley, Billie Goodrich, Martha Miller, Helen Myers, Thagus Burns, Mrs. Evans.* **3rd Row:** *Doris Bennett, Edith Gradeless, _ Gradeless, Jimmy Blain, Leota Grabil, Ardith Firestone, Mary VanCuren, Katherine Rowe, Marion Palmer, Clarence Winebrenner.*

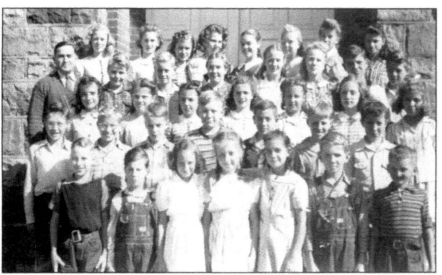

South Whitley Grade School **(Begin)** *Pollyanna Mink, Flossie Stidham, Helen Hollman, Mary Jane Landis, Betty Stoffer, Dorothy Wagner, Helen Cook, Bonnie Knapp, Cyrus D. Senger, Jerry Carey, Lester Culp, Edna Ritenour, Alice Sanson, Mary K. Hathaway, Dean Neher, Robert Comstock, Lois Myers, Rhoda Heindselman.* **(Back Row)** *Joan Brandenburg, Mae Joy, Betty Snyder, Donna Krieg, Velma Schipper, Max Bishop, Richard Johnson, Richard Howard, Bennie Max Bauman, Leo Senger, Rex King, Robert Lancaster, Billy Rhoades, John V. Kreider, Barbara VanHouten, Norma June Arnold, Helen Wright, Arden Neher, Keith Kreider. (Courtesy of Mary K. Miller.)*

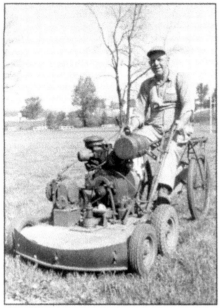

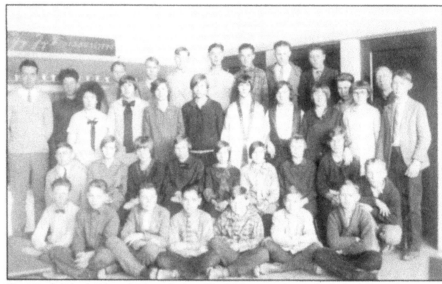

Jake Ness, Columbia City High School Janitor ca. 1950.

Troy Grade School, 7th and 8th grade class. "Buz" Mertz, teacher and principal. From bottom 2nd row: _, Doris Haimbough, Fancheon Gilbert, Bernice Orcutt, _, _, _, last boy kneeling is Lewis Palmer. 3rd row: unknown. 4th row: teacher, _, _, _, Ferman Orcutt, rest unknown. (Courtesy of Virginia Palmer.)

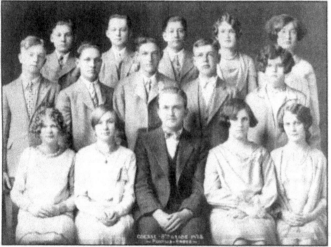

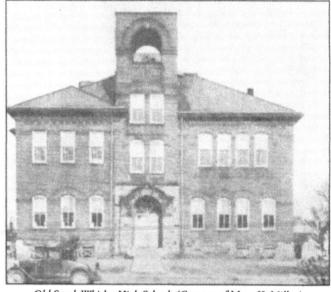

Coesse 8th Grade, 1928. Back row: Robert McClain, Cletus Sott, Maurice Rouch, Eileen Leininger, _ Bennett. Middle row: Garth Tucker, Ford Ruckman, Glen Walters, Robert Johnson, Glois Schrader. Front row: Louise Judd, Opal Humbarger, Paul Harding, Florence Sievers, Helen Grant.

Old South Whitley High School. (Courtesy of Mary K. Miller.)

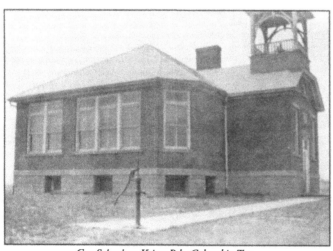

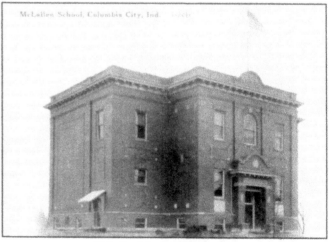

Cox School on Keiser Rd., Columbia Twp.

McLallen School, Columbia City.

Tracey School. Back row l-r: Juanita Reed (Hoover), Ben Richards, Gertrude Clark, Matthew Davenriner, Ialene Davenriner, Gerald Beck, Eunice Ervine. Front row: John Wesley Reed (holding the slate). Teacher Harry Bollinger. (Courtesy of Harry Bollinger.)

Tracy School, Washington Township, 8th grade graduates, 1923. Teacher, center back is Harry R. Bollinger; boy is Edison Dial. (Courtesy of Harry Bollinger.)

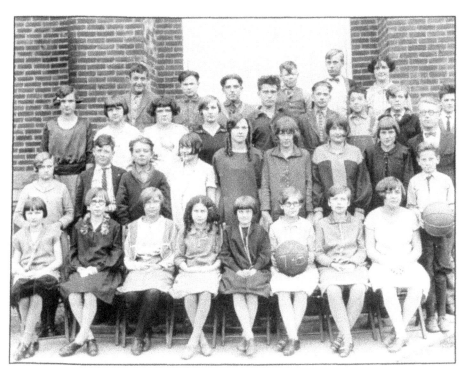

*Washington Center School, 7th and 8th grades, ca. 1929. **Front row**, second from left, Hennig?; third, Mildred Thomas; fourth, Treva Juillerat; sixth, Chella Howenstein; seventh, Myra Lickey; eighth, Vera Goble. **Second row**, first from left, Cyral Bryant; second, Scott Stickler; fifth, Freda Rupley; sixth, Monica McClain; seventh, Lenore Smith; eighth, Ruth Bays. **Third row**, second from left, Edna Dryer; third, Magdalene Dryer; fourth, Miriam Howenstein; sixth, Arnold Goble. **Back row**, third from left, Goble?; fifth, Ted Hockemeyer.*

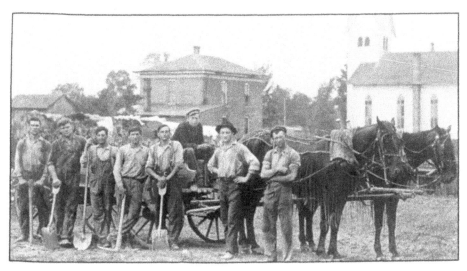

Digging the Laud School basement ca. 1910. Tom White, Ben Swing, Ora Goodyear, Jesse Nichols, Lyman Goodyear, Arthur Rasor, Sam Zent, Tom Hartley. (Courtesy of Ted Hollenbaugh.)

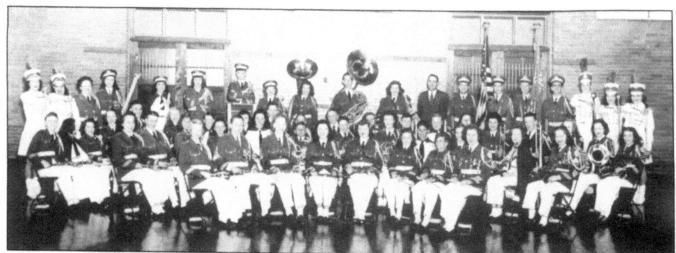

1st row l-r: Pollyanna Mink, Joe Freund, Catherine Kehler, Suzanne L. Brun, Iris Hiles, Ruth Ann Kinsey, Nancy Ziegler, Helen Hollman. *2nd row:* Georgia Faye Able, Norman Fricke, Sharon Wilson, Nancy Quinn, Nellie Newell, Danny Harshman, Jimmy Dean Arnold, Alice Sanson, Junior Ulshafer, JoAnne Huffman, Dottie Davis, Norma June Arnold. *3rd row:* George Fleck, Elizabeth Pflieger, Bonnie Badskey, Carleen Kehler, Garald Wallace, Betty Clark, Donnie Davis, Martha Myers, Max Bishop, Jimmy Beard, Glen Auer, Donna Jean Krieder, Roger Wallace, Danny Mink, Alyce Jean Parker, Bonnie Knapp, Bill Kelley, Mary Kathryn Hathaway, Fancheon Sanson, Maxine Stands. **Back row:** Betty Snyder, Helen Wright, Mrs. Geist, Rosalie Bauman, Lillian Short, Helen Cook, Dick Walters, Betty Ziegler, Ardythe North, Howard Reisher, Edna Ritenour, Mr. Howenstine, Dick Beard, Jim Bollinger, Charles Eaten Lancaster, Roger Thomson, Velma Schipper, Pat Johnson. South Whitley High School Band. (Courtesy of Ms. Mary K. Miller)

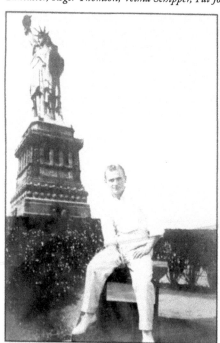

Lewis Palmer, having graduated from the three year high school at Etna and then the fourth year at Columbia City High School went on to work his way through DePauw University. During a couple of those summers he worked as a guide at the Statue of Liberty. At that time there was some reconstruction going on in the Statue. This made it possible for Lewis, a gymnast, to crawl out through a window onto the head of Miss Liberty where he fulfilled his dream of doing a headstand on the head of the Statue of Liberty! Unfortunately his friend who was to make a picture of the event, missed his mark. When the film was developed it was a picture of Ellis Island. (Courtesy of Virginia Palmer.)

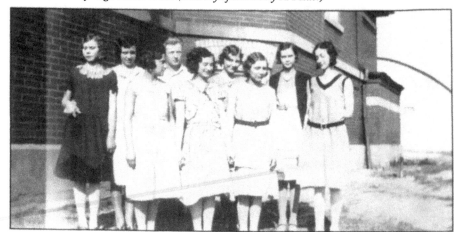

Jefferson Center Senior Class of 1932. Pictured: Leona Ferrell, Evelyn Nichols, Vivian Roth, Loyd Hartley, Beatrice Kaufman, Hilda Shipley, Evelyn Pequinot, Eloise Johnson, Edith Thomas. (Courtesy of Bobbieann Lawrence.)

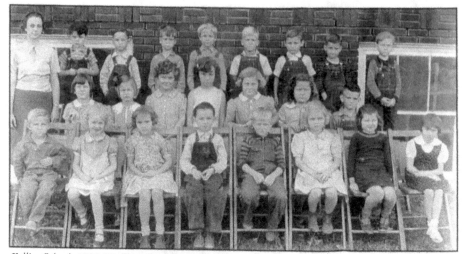

Collins School, 1938-39. **Top row:** Harrold D., Jimmy Yant, John Fulk, Robert Earns, Delbert Cripe, Emmett P., Steve Carter, Roger L. **Middle row:** Charles J., Doris M., Jackie Crabell, Mary Pressler, Kitty Carter, Bonnie Carter, Richard Hull. **Bottom row:** Roger Kelly, Jane Walker, Phyliss Hazen, Lournce D., Bobbie Harrold, N.J. Walker, Arlene Hayney, Nancy Dick.

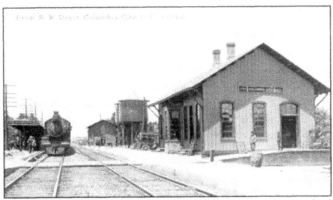

Pennsylvania Rail Road Depot, Columbia City ca. 1930. (Courtesy of Ted Hollenbaugh.)

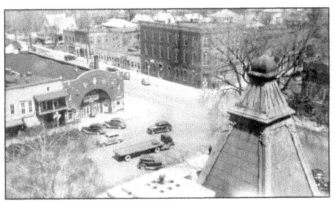

Northeast corner of Main and VanBuren Streets, Columbia City, taken from the courthouse. (Courtesy of Sydney Campbell.)

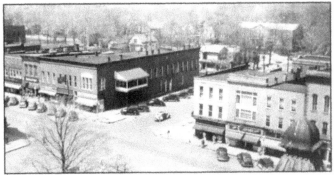

Corner of Chauncey and VanBuren Streets, Columbia City looking northwest. (Courtesy of Sydney Campbell.)

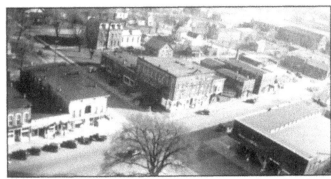

Southeast corner of Main and Market Streets, looking southeast from the top of the courthouse.

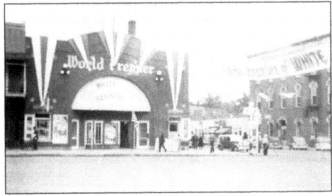

Columbia Theater, White Banners Premier, 1938. (Courtesy of Sydney Campbell.)

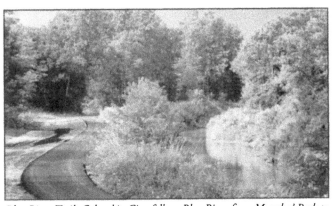

Blue River Trail, Columbia City, follows Blue River from Morsches' Park to State Road 9.

Sherwood's Pond, Thorncreek Twp.

Home place where Justus Sherwood was born and raised.

85

South Whitley. (Courtesy of South Whitley-Cleveland Twp. Public Library.)

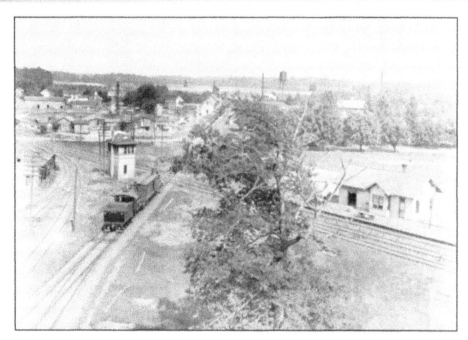

Eel River Bridge, South Whitley, built 1935. (Courtesy of South Whitley-Cleveland Twp. Public Library.)

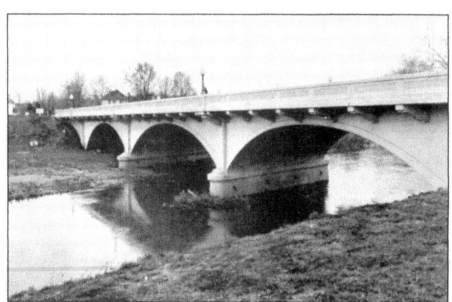

South Whitley, Main Street. (Courtesy of South Whitley-Cleveland Twp. Public Library.)

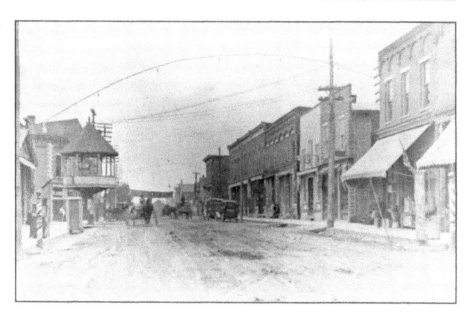

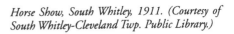

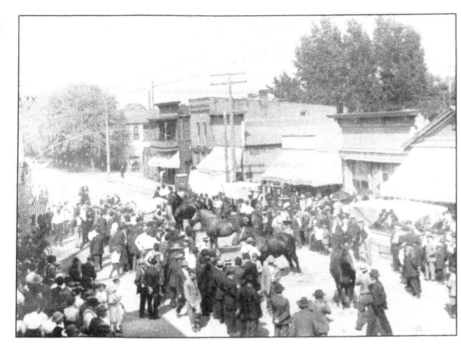

Horse Show, South Whitley, 1911. (Courtesy of South Whitley-Cleveland Twp. Public Library.)

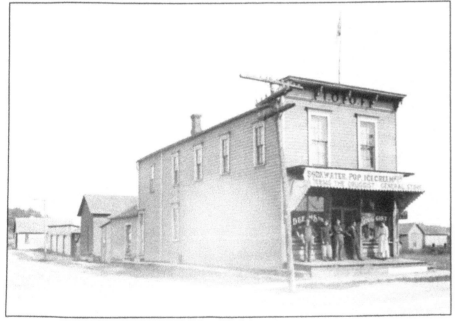

Laud General Store operated by Warren and Callie Deems, ca. 1922. (Courtesy of Ted Hollenbaugh.)

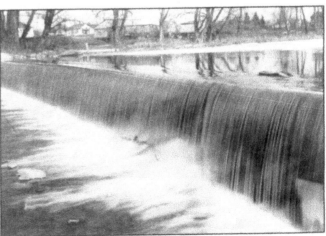

Collamer Flour Mill and Tavern. (Courtesy of Lois Kyler.)

Collamer Dam, Cleveland Twp. (Courtesy of Lois Kyler.)

Mulberry St., Churubusco.

West Whitley Street, Churubusco, ca. 1910

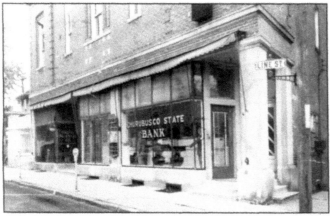

Churubusco State Bank and Truth Printing Company, ca. 1950. (Courtesy of Chuck Jones.)

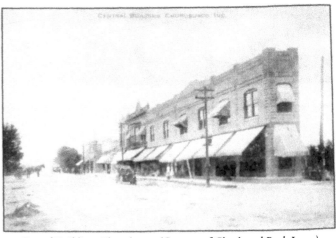

Central Building, Churubusco. (Courtesy of Chuck and Barb Jones.)

North Main Street, Churubusco.

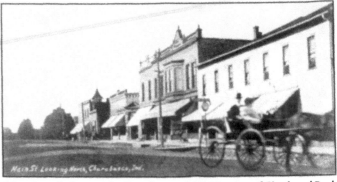

Main Street looking north, Churubusco, 1909. (Courtesy of Chuck and Barb Jones.)

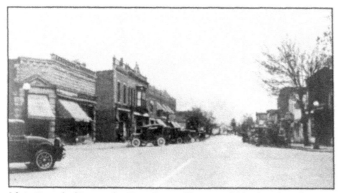

Main Street looking south, Churubusco. (Courtesy of Chuck and Barb Jones.)

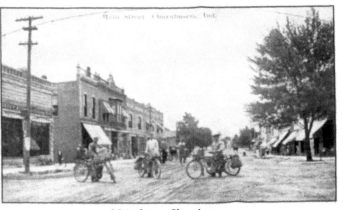

Main Street, Churubusco.

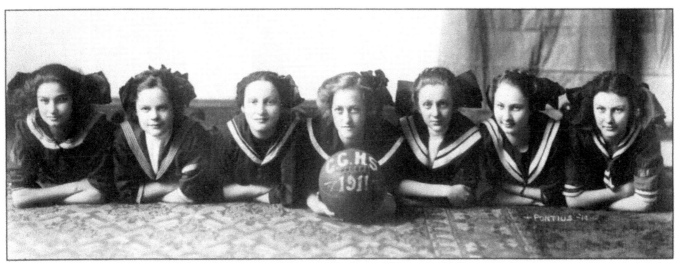

CCHS Basketball team of 1911. They had just lost a big game. They were all crying and Edgar said, "Well you might have lost the game but you had the best hair bows there! L-R: Thelma Strouse Dainel, Lucy Jones, Irene Apfelbaum, Margaret Baker Myers, Mary Harrison Eyanson, Aileen Lillich Shea, Aileen Roney.

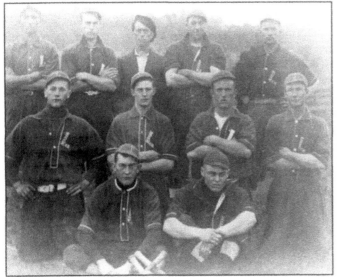

Laud Baseball Team. Bottom row, right: Edison White. Middle row, right: Ott Ward. Back row, left: Jesse Nichols, others unknown.

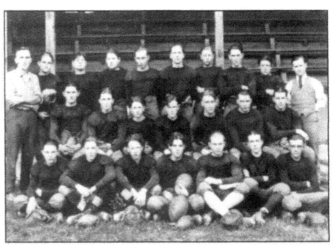

Columbia City High School Football Team, 1923. Those identified: Front row: 1. Paul Sheets; 2. Bob Clugston; 3. Donald Dwight Malone. Middle row: 5. Hobb Galvin; 6. Harry "Dusty" Rhodes. Back row: 1. Coach; 2. Blain Shang; 3. Dick Kissinger; 4 Walter Weick, 10. Principal. (Courtsey of Donald Malone.)

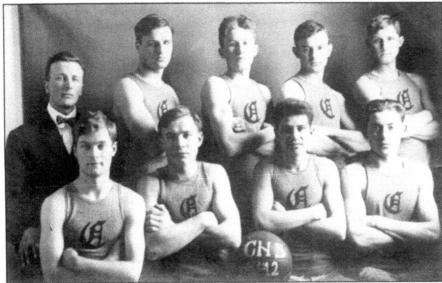

Churubusco High School Basketball Team, 1911-1912. Front row: _, Guy Thompson, Jay Levi "Kink" Sefton, Russell Downey. Back row: _, _, Amasa Fogel, Jim Fulk, Daniel Barnhart.

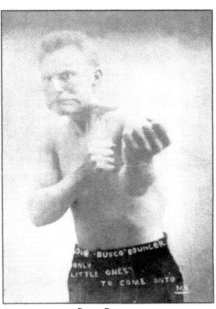

Busco Bouncer.

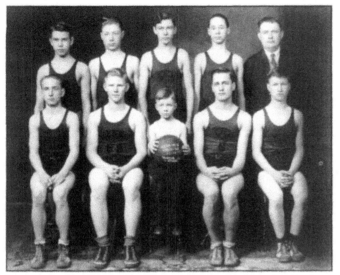

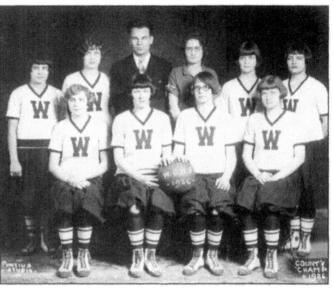

Etna High School, 1935. Sitting: Wendell Blain, Robert Waugh, Harry Bollinger Jr. (mascot), Russell Perkins, Nathan Gause. Standing l-r: Ralph DePoy, Claude Myers, Robert Bowlby, Grant Osborn, Coach Harry Bollinger. (Courtsey of Harry Bollinger.)

Washington Center High School Basketball Team, Whitley County Girls Basketball Champions, 1926. Second from left in front row is LeNore Hoard Enz.

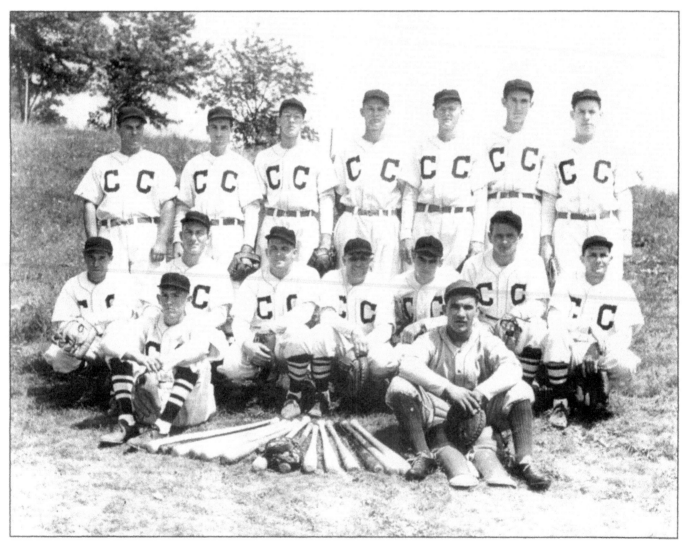

Columbia City Baseball Team. Seated in front: Nate Roberts, Pete Redman; kneeling: Foster, Bill Bloom, Stanley Mullendore, Willard Phillips, Emmett Bowie, Clarence Fahl, Theo Gawthrop; standing: _, Marshall Schinbeckler, George Bloom, Eddie Berwert, Bob Overdeer, Virgil Deutsch, Delbert Ballard. (Courtesy of Millie Mullendore.)

Russell, Grace, Ernest and Marshall Sevits going for a nice Sunday drive.

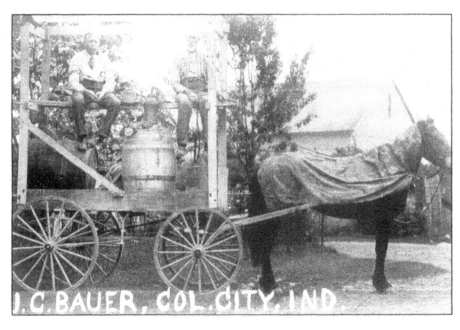

Elisha Swan is the man on the right. (Courtesy of Judith Church.)

Green and Snyder Meat Market in South Whitley, 1900-18. Market deliveries were made in a horse-drawn delivery wagon. (Courtesy of Judith Church.)

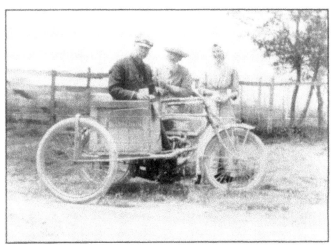

Ted Daniels U.S. mail carrier in the early 1900s. George Hanauer (center), Rose Hanauer, wife of A.A. Hanauer. (Courtesy of Jerry L. Badskey.)

In front of Dr. Whites office located below the telephone exchange in Laud; l-r: Carrie White, Dr. S.R. White; in second car is Dale R. White, Pauline White, Demma White and Bess Greenfield. (Courtesy of Judith Church.)

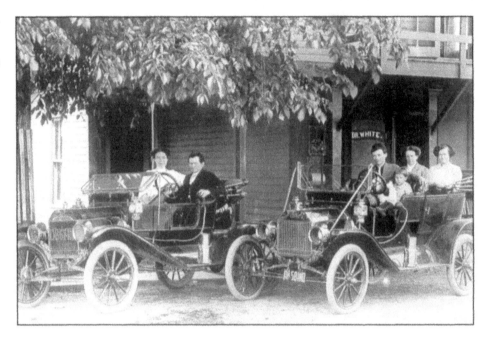

Orlo McCoy chicken truck in Churubusco.

1914 Ford car of Lewis Mishler.

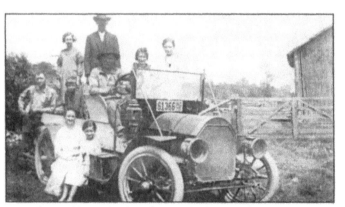

1915 The Harshbarger family in their Overland car. Emanuel, Henry, Goldie, Bess, Dora and Sam Smith.

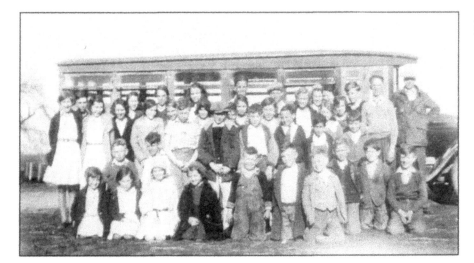

1931-32 bus driver Ray Hively and his charges at Thorncreek Center School.

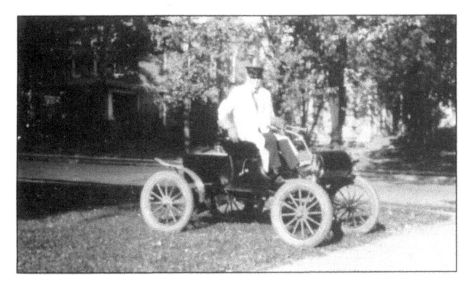

Simon J. Peabody in one of the first automobiles in Columbia City.

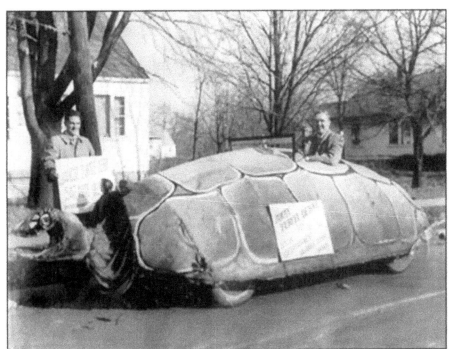

"Oscar" Churubusco's famous turtle car.

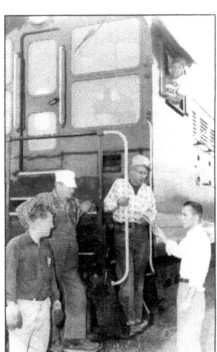

The last train through Churubusco.

Galen Wilkinson checks out the Ten Millionth Model-T made by Henry Ford, on display at the Whitley County Museum on its way from New York to San Francisco, 1999.

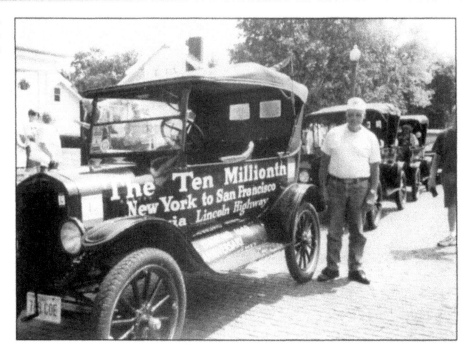

Don Platt's pulling tractor.

H. Junior Studebaker on his restored Farmall 450 tractor, (Courtsey of H. Jr. and Jane Studebaker.)

BLUE RIVER COMMUNITY CHURCH

Based on accounts written by Bernice Riley Davidson and Nellie Riley Raber,
edited by Brian W. Secor, and updated by Bob Brittain.

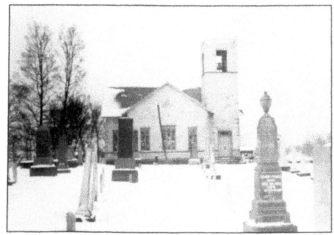

The Blue River Community Church, circa 1930s.

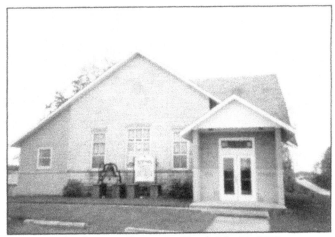

The Blue River Community Church, May 11, 2003.

Establishing farms and homes on land near the Blue River in Smith and Thorncreek Townships in the 1830s, the families of Nathaniel Gradeless, George Pence, James Riley, Joseph Waugh, and Samuel Smith also built a church when Methodist Circuit Rider Samuel Smith organized a congregation at Blue River.

In 1847, Joseph Waugh gave land for a church site. Their log church was so small that quarterly meetings were held on the south bank of Blue River in Waugh's beech grove. These meetings were times for spiritual revival and Christian fellowship. Frequently an ox would be roasted and the ladies would make rivels for those in attendance.

Services continued at the log church until 1872 when a new frame church was erected at Fuller's Corner and named the Salem Methodist Episcopal Church. The Free Methodists wanted to buy the Blue River site in 1875 but were rebuffed.

Levi Waugh, son of Joseph, in an effort to resolve the problem, deeded a strip of land beside the original plot to the Free Methodists where they erected a church. Trustees included Albert DeMoney, Richard Wade, William Bloom, William Davis and Asa Carter

By 1900, both the Salem and the Blue River Churches became inadequate. The Free Methodist congregation dwindled so that the church was only used for funerals.

In 1909, Charles and Samuel Riley, grandsons of the Riley pioneers, suggested uniting the congregations into one church at the Blue River site. With the consent of the Wabash District Superintendent, they purchased the land and existing building.

The heavy frame building was utilized for the new church by turning it a quarter turn from the original north-south position to an east-west orientation. An addition was built on the north side for the Sunday school. The foundation is of solid cement and the base to the water table is of rock-faced cement blocks on colored mortar. The men of the congregation did much of the construction work. The women of the church provided meals for the workers. At last, in 1911, the church was completed and the dedication was held on October 1, 1911. The Board of Trustees and the Building Committee included Willis Rhoads, Elmer DeMoney, James Jones, W. Alonzo Smith, Ira Pontius, and David Pence.

America's economic depression brought problems to the church at Blue River. The roof leaked badly and the bell tower began to rot, forcing the removal of the bell. The furnace failed, and it was expensive to replace. One Methodist District Superintendent suggested that the church be closed, and the congregation should attend The Methodist Church in Columbia City. That suggestion rallied the congregation and funds were raised for a new furnace which was soon installed. As the depression ebbed and World War II ended, new families moved into the community increasing church membership.

By 1950, more Sunday school space was needed. The men excavated the remainder of the basement area adding classroom and dining space. In the mid-1950s an organ was purchased, a building fund started, and the furnace was replaced with a modern oil-burning system.

In 1969 the EUB Church and the Methodist Church merged creating the United Methodist Church. This national church merger created changes for the Blue River congregation. Shortly after the merger, the Blue River Church, the Collins Methodist Church, and the St. John's EUB Church were assigned the same pastor. The Blue River Church and St John's were consolidated to form St. Matthews United Methodist Church. A considerable remnant of the Blue River congregation felt a great loss of the pioneer church.

For three years, this group met each Sunday at the home of Charles and Mildred Hess. The group organized as the Blue River Community Church and in 1974 purchased the Blue River building for $6,000 from the Methodist Church.

The congregation at Blue River began again in the footsteps of the pioneers who built the first church in the 1840s. United by a love for the Lord and generations of friendship, the congregation began restoring the church building and continuing Christian witnessing.

In the 1980s, the 1910 church bell was returned to the Blue River Church. The bell had been stored in barns and even stolen once. Mike, Kendall, and Dennis Jagger built a brick foundation, repainted the bell and placed it in the brick framework that became part of the foundation plantings. The parking lot that once served as a place to hitch horses is now a modern paved parking lot.

Today, the church helps support three missionaries: Alice Payne, formerly a medical missionary to Bangladesh, and now serving as an assistant to a church planting team in Chicago caring for a critically ill child; Barbara Tooley, who teaches in an Ecuadorian Christian School; and Jon and Robin Coules, a former pastor and his wife, serve a church planting ministry in France.

Blue River's ministries include weekly Sunday services, a women's circle, support for many local needs, and other special services. A Christmas Eve service brings families together for a special time, and near Memorial Day lives of departed pioneers, friends, and neighbors are celebrated with a program to decorate the cemetery. A Homecoming celebration complete with homemade chili and delicious desserts takes place in October.

Since 1973, church pastors include Gerritt Den Hartog, Ronald Scharfe, Philip Blake, John Talley, John Coules, Ronald Scharfe for a second term, and the current pastor, Brian W. Secor.

Today's congregation serves the Lord with special loving hearts from its church home on the banks of the Blue River.

COLUMBIA CITY UNITED METHODIST CHURCH

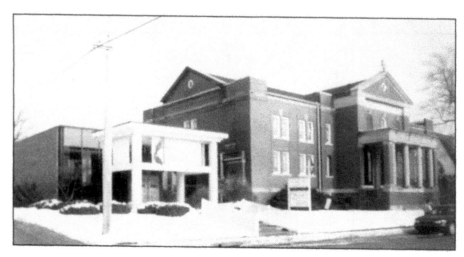

(Courtesy of Joyce Lawrence.)

Columbia City United Methodist Church

The congregation, now known as the Columbia City United Methodist Church has a history which spans 164 years. In 1840 a Methodist class consisting of 10 persons was organized in the town of Columbia. It was the first religious organization in the village and was presided over by Samuel Smith, a local Methodist preacher. The first church was built in 1848 on South Line Street and served the congregation until 1878. By then a new house of worship had been erected at the corner of Chauncey and Jackson Streets, In 1912 that building was razed and the present sanctuary, erected on the same site was occupied in May 1914. The educational unit, Wesley Hall, was consecrated in November 1960. This church, which had earlier adopted the name Trinity Methodist Church, became Trinity United Methodist Church as a result of the merger with the Evangelical United Brethren denomination in 1968.

The United Brethren in Christ Church, later known as First Evangelical United Brethren Church, was organized in 1880 by the Rev. W.M. Bell, a native of the county who later became a bishop of the church. The first home for this congregation was on Hanna Street and served until 1902 when a new church building was erected at the corner of Chauncey and Market Streets, That church was completely rebuilt and re-dedicated in December 1926. Extensive remodeling and redecorating of the sanctuary was done in 1953 and again in 1966. In 1968 following the denominational merger the church took the name Christ United Methodist Church.

On May 24, 1970 Christ United Methodist Church and Trinity United Methodist Church merged into one congregation called Columbia City United Methodist Church. The congregation was housed in the former Trinity Church. In 1971 a new parsonage was purchased at the corner of Park and Shinneman Streets, and the old parsonage became a center for youth activities until October 1978, when the demolition of the old parsonage was begun in order to make room for a new Narthex, Office, and Classroom addition, On January 6, 1979 ground was broken for the addition and the congregation moved their Sunday morning worship services across Chauncey Street to the First Presbyterian Church for the six months duration of the Sanctuary remodeling, On February 24, 1980 the consecration of the new addition was held.

During the ensuing years, membership and attendance climbed and more space was again needed to fill the needs of new programs and classes. Land was obtained from the Gates family. Primary classrooms and offices wing and a multipurpose plus adult classrooms wing were built. The move to the new building was made in February 2003.

The church is located north of Parkview Whitley Hospital at 605 North Forest Parkway, It is between North St. and U.S. 30. In time a wing with a sanctuary is to be added.

To learn more about programs and times of services, call 260-244-7671, between 8:00-4:00.

SOUTH WHITLEY UNITED METHODIST CHURCH

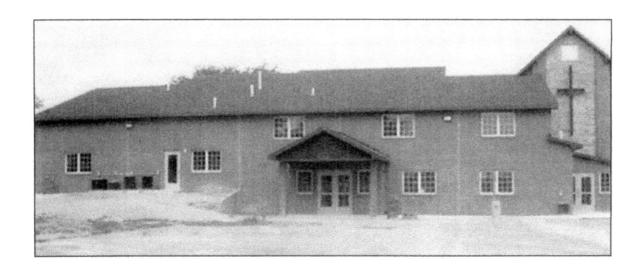

The United Methodist Church of South Whitley was formed April 9, 1967, according to a previous plan of union for the Evangelical United Brethren and Methodist Churches, with Rev. Ross Cook, Evangelical United Brethren Pastor, as its minister. A yoked ministry had been in effect since the death of Rev. James Glebe, Methodist Church pastor in August 1966. The two churches united a year before the general uniting conference in Texas in April 1968.

After holding separate services in both churches until a beautiful new building was constructed just south of South Whitley, east on State Road 14, both congregations, together, entered their new church home for the first combined service November 24, 1968. A consecration service was held on April 27, 1969.

The two previously occupied church buildings and the Methodist parsonage were sold, the Methodist property to the Church of God for $18,000, while the Evangelical United Brethren building was purchased and razed to form the foundation for a home by Floyd Bollinger. The building and lot were sold for $3,100, and the parsonage on South Water Street retained.

The site for the church was bought by the Evangelical United Brethren Church from Mr. and Mrs. J. Homer Studebaker in September 1962 for $7,500, a plot of five acres. Both churches approved the site, and members of the building committee were of the united congregations. The church was built by D and C Construction Co. at a cost of $255,000.

The original floor area for the building was 10,582 square feet. The seating capacity of the sanctuary is 315 with capability of overflow. In 1982 an enlarged narthex was added and a youth room to increase the usable space by 1,750 square feet. Inside the sanctuary you will find eight beautiful stained glass memorial panes that were place there in 1985. A new "A" frame roof replaced the built-up roof of the educational wing in 1986.

In 1977 the church purchased a plot of land, about one and one-half acres adjoining its property on the west side, for $26,500 and razed the buildings there in 1985. A new parsonage was built on this site in 1990. In January of 2004 construction began on a new 4,000 square foot addition. The new addition, which houses new offices and classrooms, was completed by W.J. Carey Construction Co. in September 2004 at a cost of $530,000.

The church, which numbers over 280 in membership, is very active in supporting many different missions projects locally and around the world.

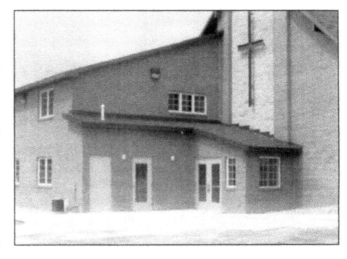

ST. CATHARINE CATHOLIC CHURCH

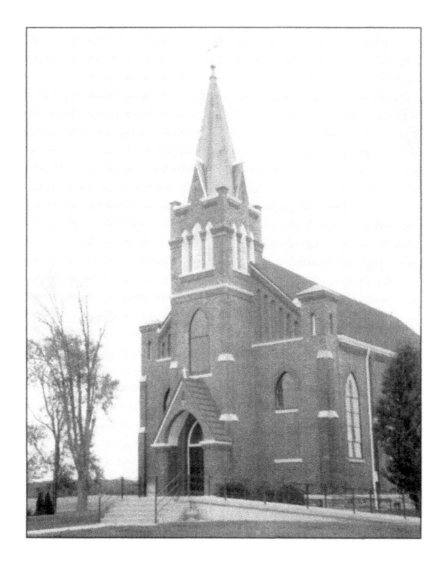

St. Catharine Catholic Church is named after St. Catharine of Alexandria. The rural Whitley County church, halfway between Columbia City and Huntington, Indiana, at 9989 S. State Road 9, is 150 years old. The pioneer Nix family immigrated to this place between 1845 and 1847. As early as 1848, Mass was celebrated in the home of Mr. and Mrs. Jacob Nix. In 1850, a hewn log church was erected in the "Forest-Primeval," three-quarters of a mile southwest of its present site, the first church organized in Washington Township. It had about 10 members. The church burned down in 1868 and then services were held in a schoolhouse near the site of the old church. Their cemetery was located nearby.

Mr. and Mrs. George Bauer donated two acres for a new brick church and cemetery on the present site. The cornerstone of that structure was laid on July 19, 1869.

Two vocations came from the parish: Francis Koch ordained in May 1902 and in August 1938, Kathleen Bauer professed final vows as a Holy Cross sister.

The priest moved to live in Roanoke in 1924. In December of 1930, the Nix School, on the southwest corner of the intersection was purchased from Washington Township to be used for parish functions. In the early 1940s the cemetery was moved front its original site to the present location. In 1948 a cement block building was constructed and the school building sold.

On September 9, 1990, the parish celebrated its 140th anniversary with retired Bishop William McManus. Starting October 1993, a religious education program resumed being held again at St. Catharine's.

Pastors Serving The Parish

1850-1881, Fathers M. Faller, A. Schippert, F. Fuchs, J. Meyer, H. Schaefer, T. Vanderpoel, W. Woeste, and C. Seeberger; 1881-83, C. Miller; 1883-84, F. Lambert; 1884-89, P. Guethoff, 1889-95, E. Boccard; 1895-1905, B. Soengen; 1905-10, J. Beidermann; 1910-16, P. Schmitt; 1916-18, L. Faurotte; 1918-25, J. Roederer; 1925-29, J. Steger; 1929-38, F. McAuliffer; 1938-41, Shanley, Cap; 1941-46, C. Koors; 1946-47, F. Westendorf; 1947-50, J. Roesler; 1950-56, M. Bodinger; 1956, C. Zurawiec; 1956-64, J. Hayes; 1964-71, R. Smith; 1971-74, E.J. Miller; 1974-78, A. Mueller; 3 mos., J. Pfister; 1979-82, B. England; 1982-94, D. Durkin; 1994-98, P. Widmann; 1998, K. Sarrazine.

EBERHARD EVANGELICAL LUTHERAN CHURCH

Eberhard Evangelical Lutheran Church located on Keiser Road, midway between South Whitley and Columbia City is named for George Eberhard Sr. (born in 1806) who came to the area in 1852 with his wife Catherine, purchased 2,300 acres of land to raise cattle, and along with a group of other farmers, recognized the need for a church nearby. Eberhard had previously started a church near his home in Stark County, Ohio, where he had also established and run a distillery. Worship and Sunday School classes were begun in the Eberhards' home, and by June of 1853, with the help of the first pastor, the Reverend Philip Baker, the Evangelical Lutheran and German Reformed Church was established. George and Catherine Eberhard donated land for a building and cemetery and gave one seventh of the money needed to build the first building.

The name of the church was changed to Eberhard Evangelical Lutheran Church on March 24, 1863.

After fourteen years of service, Pastor Baker left, and the Rev. John Kissel was elected as his successor. Since the children of this era were being educated in English, the church began holding services in English as well as German.

By January of 1892, the congregation recognized the need for a new building, and the cornerstone of the current sanctuary was laid June 20, 1892. The building was dedicated in 1894 and was recognized as the finest country church structure in Whitley County.

In 1959 members dismantled a farm wagon, reassembled it inside, and built a scaffolding on it so that they could replace the decorative metal ceiling of the sanctuary with rock lathe.

In 1953 eleven men volunteered to farm some rented land. The money earned was used to buy an oil furnace and a parsonage. The parsonage was later sold and the money used to help pay for the addition of restrooms, a kitchen, and a fellowship hall. The addition was dedicated in 1966 as the

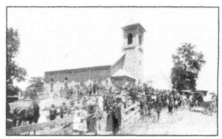

H.B. Beamon Memorial Hall. The Rev. Beamon served Eberhard from 1937 to 1942 and again from 1962 until his retirement in 1969. He continued to supply at the church until 1971.

Eberhard Lutheran Church.

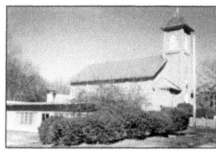

In 1977, lay minister Wayne Hapner was called and served full time for seven years, Pastors came and went during the following years until the Rev. Paul Hunteman and Chaplins John Peterson and Peter Kolch began sharing duties in 1986. Finally, the current pastor, Alice E.W. Smith was called in 2001. The church is currently refurbishing the building and experiencing growth.

Eberhard Lutheran Church, 2360 W Keiser Road, Columbia City.

The first recorded officers of the church were J.J. Litchenwalter, Daniel Heinbach, George Eberhard Sr., Jacob Heinbach, John Wolfe, George Bentz, Henry B. Sell, and John Eberhard.

OAK GROVE CHURCH OF GOD

The Oak Grove Church of God, formerly known as the Compton Church or Oak Grove Bethel, is located at 2426 South Raber Road. As one of the first established churches, records reveal that religious services were held in the nearby community as early as 1850 when Mr. James Compton, an influential citizen, began conducting services at the Compton School.

The church was formally organized March 3, 1857. As the church grew in numbers and strength, the congregation desired to build an edifice dedicated to God. A site just to the east of the Compton School was selected, the location of the present church at the intersection of Keiser and Raber Roads. The land was purchased from Charles and Nannie Seymoure for $85.00.

Construction began in 1878 on a brick structure 34 feet by 46 feet with a steep Gothic style roof. Total cost was $1,750.00 and the church was debt free at completion. Dedication services for the new building were on July 12, 1879, with the Rev. W.W. Lovett delivering the sermon. At this time the church name was changed from Compton Church to Oak Grove Bethel due to the many beautiful oak trees which surrounded the building.

Less than four years after the completion of the church building it was completely destroyed by a tornado on May 18, 1883. The cyclone destroyed in a few seconds that which required years of patient toil to accumulate. Construction was begun immediately on a new building at the same location and dedicated in December 1883 by Rev. R.H. Bolton. The Bible from the former church was repaired and placed in the new church where it remained in constant use until 1890.

In 1937 a balcony was built in the rear of the auditorium and two small rooms were added on the main floor. The interior was redecorated and electric wiring suitable for 110-volt service was installed.

On April 7, 1957, groundbreaking ceremonies were held for a major building expansion. Lyman Schrader, life-long attendee and honorary

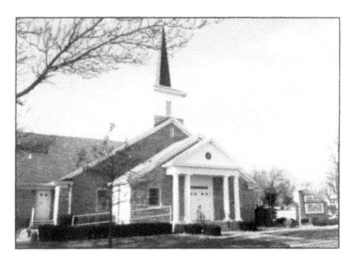

trustee, turned the first shovel of dirt. A memorial cornerstone was placed in the southeast corner of the building to be opened in October 2007.

In 1966 the church acquired 10-1/2 acres of additional land south of the church to construct a cement block fellowship hall. The 1980s brought the addition of an expanded entrance and the construction of an educational wing on the south side of the church. In 1990 eight more classrooms were added along with rest rooms and a large nursery area.

From its charter membership of 25 in 1857 to its present membership of over 200, the church has sought sound Biblical teaching, while remaining firm in its convictions to the unerring Word of God and the desire to reach the community with the gospel message through a variety of ministries.

SATURN CHRISTIAN CHURCH

Some time before the year 1858, Mrs. Rhoda Swayne invited some of the older settlers of Jefferson Township to come to her home (a log cabin) and there organized a Sunday School and Bible Study. However, Saturn was first organized as a congregation on August 2, 1858, while meeting at the Red School House located at the corner of county roads 700E and 900S. At this location, under the leadership of Elder William Dowling, 22 charter members elected officers and thus became a congregation based upon "the principles that the Bible and the Bible alone is sufficient for our rule of faith and practice in church government and the exercise of love, charity and fellowship toward all that love and obey our Lord and Savior Jesus Christ." Those 22 members were:

Samuel Braden	Margaret Braden
William T. Jeffries	Mariah Jeffries
James Putman Sr.	Daniel Putman
Nehemiah Gaskill	James Putman Jr.
Elizabeth Putman	Perminta Hasty
Malissa Smith	Matilda Ann Wallace
Julie Ann Smith	Dency Ayers
Susan C. Byall	C.J. Ayers
George Kincaid	Elizabeth Kincaid
H.W. Zents	R. Hankins
Margaret Ann Broxon	James Broxon

In 1874 Saturn moved into their own church building on Road 800S, a quarter mile west of Road 700E (our present location). The ground was donated by James Broxon, as were much of the timber and labor for erecting the building. L.L. Carpenter of Wabash was called to dedicate the building to Christian worship and service to Jesus Christ.

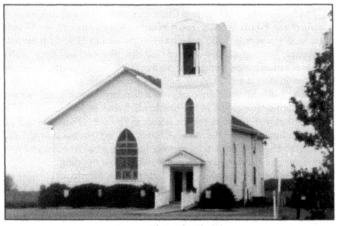

Saturn Christian Church

Saturn Church is governed by a church board, members of which are elected by the congregation. Saturn is an independent Christian Church and not affiliated with any formal denomination. Our current pastor is Russell D. Riley. He and his wife, Carolyn, have ministered at Saturn since December of 1990. Our youth pastor is Alison Enos-Shepherd and she has been with us since May of 2003.

The church has seen several pastors over the years and the building has been remodeled and updated and is currently in the process of building a fellowship hall, but our goal to serve Christ Jesus has remained the same as our mission statement declares, "Our mission is to live the teachings of Christ, to declare God's glory among the nations, to share the good news of salvation through Jesus Christ and to serve through the power of the Holy Spirit."

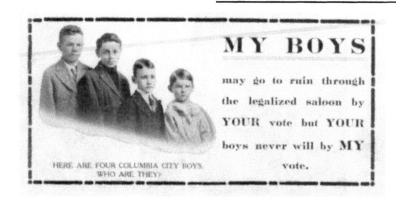

MY BOYS

may go to ruin through the legalized saloon by YOUR vote but YOUR boys never will by MY vote.

HERE ARE FOUR COLUMBIA CITY BOYS. WHO ARE THEY?

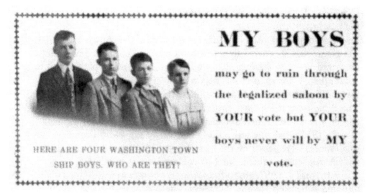

MY BOYS

may go to ruin through the legalized saloon by YOUR vote but YOUR boys never will by MY vote.

HERE ARE FOUR WASHINGTON TOWNSHIP BOYS. WHO ARE THEY?

BLUE RIVER, INC.

Low-Cost Housing For Senior Citizens

Recognizing a community need for low-cost senior housing, Dr. Frank Thompson, a local physician, called together a group of concerned citizens to investigate the need. A not-for-profit corporation was formed and named Blue River, Inc. Dr. Thompson was elected president. Others serving on the Board of Directors were James Fleck, Kenneth Wright, Margaret Rosentrader, Ullyses Groves and Clark Waterfall. The year was 1969.

Three years later, 1972, the board was granted a low-interest loan from a Federal Government Agency, Farm Home Rural Development and an apartment building housing 10 one-bedroom units were constructed and immediately filled with tenets. It was six more years before the corporation could convince the federal government of the community's great need and in 1978 the Housing Urban Development Agency granted a second low-interest loan to construct 30 more units.

Immediately another long waiting list of people needing low-cost housing prompted the corporation to seek more government funding. This time it was 26 years before success was to be obtained. Twenty more units are now under construction and should be ready for occupancy in April 2005. HUD again is the funding agency.

Others to have served on the Board of Directors, in addition to the original members, are Kenneth Helmer, David Walter, Richard Haworth, Robert Cornmesser, Bill Overdeer, Kathleen Heuer, Gene Heckman, Sharon Beckman, Darcy Shafer, and Marjorie Warnick.

Blue River Apartments are located at 904 Blue River Drive, Columbia City, IN. Phone 248-2254. The original site manager was Clemetine Cleland. The present manager is Mindy Muchow.

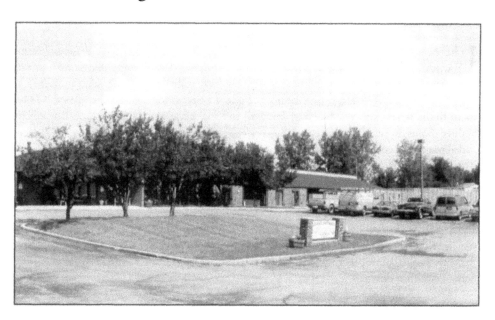

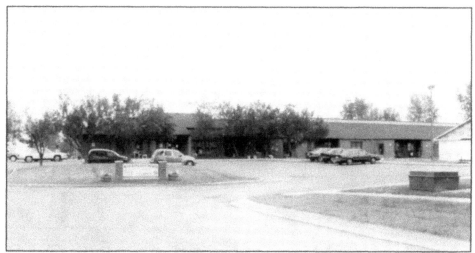

COLUMBIA TWP. CLASS 1953-61
FRIENDSHIPS FOR 50 YEARS

It has been 50 years since we started our education at Columbia Township School. Columbia Township School was built in 1941 and was called Columbia Centralized School. The first addition in 1951 added a cafeteria and two rooms, including a first grade room to the west end of the building. In 1957 an equal addition of three rooms for the junior high was added to the east end of the building. Both additions were added to accommodate our big class and those that followed us. Three more additions were added in 1966, 1979 and 1985. At the end of the school year in 1996 the school was closed. In May 2002 Columbia Township School was torn down.

The Columbia Township "Blazers" basketball team played the other grade school teams in Whitley County. There was a county-wide tournament at the end of the season. The Whitley County grade schools were Coesse, Columbia Township, Etna Troy, Jefferson Center, Thorncreek Township, Washington Center, Churubusco, Larwill and South Whitley.

Columbia Twp. School in 2002 before it was torn down.

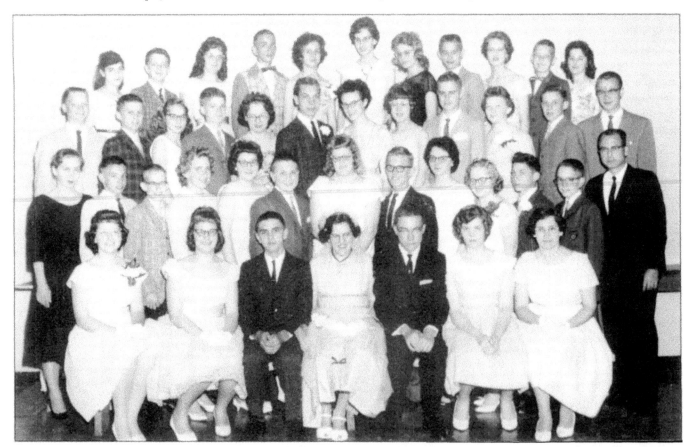

Columbia Twp. 1961 8th Grade Graduation. 8th Grade Graduates of Columbia Township School, 1961. **Front row:** *Judy Winkler Garrison, Becky Killian May, Greg Hammel, Jean Schaefer Erne, Dick Gondek, Carolyn Krider Schrader, Cheri Pressler Ruhlman.* **Row two:** *Mrs. Elizabeth Phend Thompson, Mike Fahl, Stan Mosher, Karen Smith Sandlin, Wanda Brown Sitts, Melvin Nix, Jerine Bockleman, Lynn Weirick, Jane Sievers Miller, Margaret Pepple Miller, Dick Gross, Randy Trout, Mr. Howard Youngblood.* **Row three:** *Roger Pittenger, John Vance, Linda Zumbrun, Bob Brase, Linda Keirn Harris, Kerry Geist, Susanne Simmons Sites, Marcia Geyer Clark, Bob Kauffman, Edwinia Kincaid Mosher, Bob Ballard, Roger Fenker.* **Back row:** *Roberta Smith Ruppert, Tim Langohr, Barb Orr Boyd, Allen Farmer, Jane Geiger Niemeier, Peggy Trimmer Hawkins, Vicky Klopfenstein Mitchell, Ray Sheeler, Bonnie Miller Wolfe, Denny Tripcony, Lynda Meier Mix. Seven year classmate, Steve Method, is not in picture.*

PASSAGES, INC./WHITLEY CROSSINGS NEIGHBORHOOD CORPORATION

Mary Holloway had a dream - that children with developmental disabilities like her son, could go to school. And she made sure that happened with the support of Dr. Warren Niccum, Attorney Edward Meyers and other parents. Original incorporators of the Whitley County Council for the Retarded were William H. Ulrich, Doris Hoover, Attorney Edward Myers, Marie Tom, Dr. Warren Niccum and Max Holloway on October 27, 1954.

As Sharon DeBolt, one of the early students remembers it, the original school was at 201 E. Ellsworth and Mary was the teacher. Later, teaching occurred in a house on N. Line St. In 1966 a kick-off dinner was held to raise funds for the new school building to be built across from the high school on N. Whitley St. in 1969.

In 1972 the public schools assumed responsibility for special education and the Opportunity Center, a sheltered workshop for adults, began as a satellite. There were 13 clients and three staff members. By 1974 the workshop had grown and was moved to S. Line St. (Pence's Cleaners). Renovation was donated by Paul Anders, Dave Walter and Clarence Kreider. Meantime, a preschool was started in the N. Whitley St. building.

The Stop 'n Shop (now Second Time Around), was added in the 1970s along with social services, speech and adult education and homebound services. By 1979 job placement in community jobs began with one person's insistence that he could and would get a job in the community. He's still employed by Scott's Grocery. Three group homes each housing eight adults were started in the 1980s along with supported living.

In 1989 a name change occurred, to Passages, Inc. Since then Passages has built Towerview Industries and two new group homes. Offices moved to Marshall Community Center in 1998. The Healthy Families program was added to serve mothers and children. Mary's dream has really blossomed; today, Passages serves over 400 infants and adults who are living, learning, working and playing in the community.

Seeing the need for affordable housing among the people Passages, Inc. serves, the Board of Directors decided to create a separate not for profit tax organization called Whitley Crossings Neighborhood Corporation. Its mission is to create affordable housing for low to moderate income families. The organization began investigating the feasibility of building apartments just off E. Hanna Street when it was approached by People Preserving History to renovate the Clugston Hotel for senior housing.

Although the project looked formidable because of the building's deplorable condition, the board agreed to tackle the project. The City Council agreed to let the project proceed after seeing the view from the courthouse if the building were torn down. Board members involved were Aileen Meier, Dr. Clark Waterfall, Larry Reynolds, Dan Nelson, John Cowan,

Grace Lotter, Dick Buchanan and Sharon DeBolt. Helen Beatty and Jan Hammer lent their expertise from People Preserving History. Kay Fleck, David Lehman and Trudy Burman were involved from Whitley Crossings staff.

Cardinal Development owned by Lisa Gilman assisted with the grant applications which eventually raised over $2 million for renovation of the building into 22 units of housing for people over 55. The Whitley County Community Foundation participated with a generous donation from the local foundation and the Lilly Endowment. The city granted the project $181,000, money that was set aside to raze the building along with some redevelopment funds. Architect Greg Kil from South Bend worked with the State Historic Architect to assure the historic integrity was kept to the extent possible. Since its opening in March, 2001, many seniors have lived comfortably at the Clugston.

In 2003 Whitley Crossings broke ground on its original project, Whitley Meadows.

These 21 apartments will house low to moderate income families.

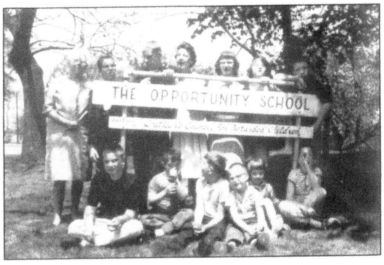

Peabody Public Library

Then and Now

The institution known today as the Peabody Public Library had its beginnings in 1901 under the benefaction of Leigh Smith J. Hunt, a former resident who had made his fortune in the newspaper business. His contribution made possible the original concept of a library for Columbia City, a concept incorporated in 1903 as the "People's Free Library of Whitley County."

The original site of the library occupied four rooms on the second floor of the Raupfer Building on the corner of West Van Buren and Line Streets.

By 1917, board member and lumberman Simon J. Peabody came forward as benefactor for a new building, which was built on a North Main Street property adjacent to his own. This building opened in 1919, and was expanded in the late 1960s

By the early 1990s, it was clear that both community growth and changes in library service and technology had made the present building unacceptable for the future. After much consideration, the Board of Trustees decided to build a new facility on land donated by the city. The new building opened to the community in June of 1999.

Dedication Dates
July 18, 1901 - Original Opening
May 31, 1919 - Building on Main Street
June 27, 1999 - Building on Highway 205

Peabody Public Library on the second floor of the Raufer Building on the corner of West Van Buren and Line Streets.

Peabody Public Library, Main Street.

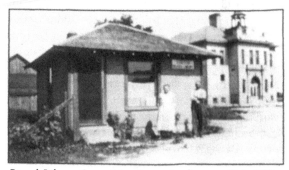

Branch Library-Coesse, Mrs. Shrayer, in charge and Mr. Miller.

Peabody Public Library, Highway 205.

Branch Library-Larvill

Whitley County Community Foundation

The new home of the Whitley County Community Foundation at 400 North Whitley Street stands in solid symmetry and mid-19th century composure. Its red-brick walls, more than a foot thick, were built to last, and its several occupants have had lasting influence, too, on the life of Columbia City and Whitley County, Indiana. Construction of the historic house began in turbulent pre-Civil War times of 1860. When war broke out, carpenters left one room undone and hastened to join the fray, thinking, as everyone did, that it would all be over in six weeks. Neither the room nor the war would be finished for years.

Builder, James S. Collins

As construction waxed and waned, the builder of the homestead was serving a term as Senator in the Indiana General Assembly. He was James S. Collins, deeply rooted in the public affairs of Whitley County, one of its first lawyers, in fact, admitted to the practice of law in 1845.

James and his wife, Eliza Jane, married in 1849, lived at first in a frame house in "Collins Orchard" on what was then the outskirts of Columbia City. Their property holdings included grounds of the present-day high school, land along Main Street where the Zion Lutheran and Nazarene churches are located, and the Columbia Shores residential area. Today, the little lane that connected the Collins homesteads is known as Maple Street.

"Aunt Jennie" Collins

Jane, the eldest Collins daughter, was an especially beloved, long-lived figure who contributed greatly to the rising culture of the city and county. Known as Aunt Jennie to family and friends, she was the first librarian of the Columbia City Library when it opened on the second floor of the Raupfer Building in 1901, and she remained a member of the Library Board all her life.

Then, in 1926, James Dupont Adams, and his wife, Clarice, moved into the home and began modernizing it with water, electricity, and heat. "This house was designed for convenience, and any changes which had to be made in its modernization were amazingly minor." The Adamses made it their home for 30 years.

James Dupont Adams

Continuing the newspapering tradition of his father, James Dupont Adams was owner and publisher of *The Post* and *The Commercial Mail* from 1925 to 1951, when he sold the two editorially distinct papers to his brother, John Quincy Adams. James's other interests embraced business and civic enterprises. He founded Whitley Products, which had auto parts manufacturing plants in Columbia City and Pierceton. He was also instrumental in forming the Whitley County REMC, was president of the first telephone exchange in the county, founded and was president of the Citizens State Bank, and built movie theatres in both Columbia City and Huntington. Active in Democratic Party politics, he was state highway commission chairman for terms under Governors Paul V. McNutt and Henry F. Schricker.

In 1956 the well-seasoned home was sold, and its character was dramatically altered. Upholstery, beds, and dressers were

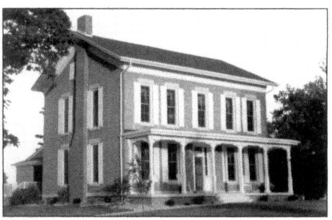

Home of the Whitley County Community Foundation.

replaced by file cabinets and desks; utilitarian paneling covered the walls. The family dwelling took on a business like atmosphere as it was converted to the Whitley County Consolidated Schools (WCCS) Administration Building; the surrounding 40 acres of property became the site of the new Columbia City Joint High School.

Ralph Bailey

The school administration honored one of its own by naming the building for one of the most important occupants, Ralph Bailey. His outstanding career as an educator included 23 years as superintendent of Columbia City schools and the Columbia City Joint High School. His status is such that, even though he "retired" in 1989, he continues to be sought-after to fill interim positions in area public schools.

In 1997, WCCS administrative offices were moved to the Marshall Community Center as the school corporation considered the fate of the historic home. In January 2000, the decision was made to give the home to the Whitley County Community Foundation. Something of a newcomer to the local scene, the Foundation was established in 1991, its mission to be "a responsible solicitor and manager of our county's philanthropic resources." Buoyed by grants from Lilly Endowment that have been successfully matched by local donors, the Foundation has grown tremendously, its management of funds helping donors achieve personal financial goals and boost worthy public causes.

It is, indeed, on the strength of the latest Lilly Endowment challenge grant that the Foundation has accomplished the present renovation of the Collins-Adams home. With the oversight of Foundation Board member John Lefever, builders Larry and Orvill Grable have taken a historically sensitive approach, preserving and restoring even as they have updated heating and electrical systems and added air conditioning and handicapped accessible features. And the traditions of James S. Collins, Aunt Jennie Collins, James Dupont Adams, and Ralph Bailey are being preserved, too, as occupants of this place continue to influence community affairs. Time will enshrine those donors and volunteers giving generously of time and monetary resources for the benefit of Whitley County. *Written by Rosemary Steiner, Whitley County Community Foundation Board of Directors.*

80/20 INC.

80/20 Inc., 1701 South 400 East, Columbia City

Not very often does a successful company evolve out of the mind of a single man from a rural area. Even less often does that company exist because of an attitude, and a positive one at that. But for Don Wood, creator of 80/20 Inc., that is exactly how it was done. In less than a decade, 80/20 has taken over the T-slotted, aluminum framing market, and become one of Whitley County's fastest-growing businesses.

In 1989, Don Wood was a toolmaker with a vision. His desire was to create better machine framing, to "See beyond the obvious and act on it." Along with his sons John and Doug, Don created a product in the T-slotted market to meet customer's exact needs for machine framing and guarding. 80/20 was born. A small, 3,000 sq. foot space in Ft. Wayne became the first home of The Industrial Erector Set(R), where it flourished and in less than ten years moved to its own 115,000 sq. foot warehouse, and they're not done yet.

Space is not the only area of expansion, however. The heart of 80/20 lies in its desire to meet customer's needs, and provide the market with quality, modular, T-slotted aluminum framing. The company that first provided a simple, three-profile line, has now grown into the distributor of over 5,500 components world-wide, and a fleet of Demonstration Vans to send directly to customers.

The framing industry isn't the only area noticing the accomplishments of 80/20. In June of 2003, *Business People Magazine* turned its head and took notice of the Wood family and their labors, writing an article on the logistics of creating and cultivating a family-owned business. 80/20 has also caught the eye of other area publications, including *The Journal Gazette* and *The News Sentinel.*

Creator, manufacturer and distributor of the Industrial Erector Set(R), 80/20 prides itself on offering unmatched service and selection, making it the framing industry's perfect one-stop shop, and a brilliant addition to Whitley County.

AG PLUS, LP

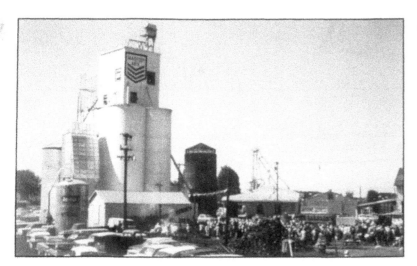

Ag Plus, LP

Aerial view of Ag Plus, LP, August 2000. Photo by Blue Sky Aerial.

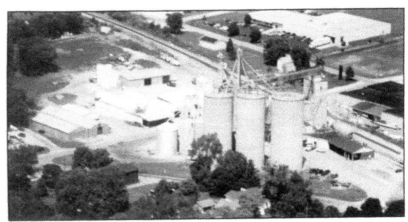

Ag Plus, LP was formed in July 1, 2001 through a merger voted on by the stockholders of Allen County Cooperative Association, established in 1930, and Farmers Elevator Company of South Whitley, established in 1912. The combination of the two companies was an easy transition, as both offered similar services and products to the Allen and Whitley county areas.

Fire struck Farmers Elevator Company on February 15, 1951 destroying most of the facility. Within two days, the board of directors met and voted to immediately start rebuilding for business. On December 1, 1951 several patrons attended an open house for the company with the slogan " a better place to trade." The management had the foresight to build a feed mill in which the basic principles of the mill are still in existence today. The original grain storage facility handled 35,000 bushel in 11 different bins. Today, the facility handles 1.4 million bushel of storage with the use of two-grain dumps. Six patrons with the intention of acquiring and purchasing coal established Farmers Elevator Company in 1912 in South Whitley, IN. Allen County Cooperative Association was formed under the same principles, to offer agricultural products and services at an economical cost to the patrons. That business grew and started to include livestock feed, supplies and grain handling. In the first years, you were required to be a member to do business with the company. Today, that company has grown to 1,763 members through acquisitions, mergers and name changes to include services and products in grain, feed, farm supply, fertilizer, chemical, seed, petroleum, and lawn and garden. Also, the philosophy of the company has changed so that patrons are not required to be a member but may as an agricultural producer join the organization.

As the original founders of both Farmers Elevator Company and Allen County Coop Association believed in building a business for its patrons, Ag Plus plans to carry on that tradition in making sound decisions for Ag Plus as a company and its patrons. The mission statement of Ag Plus reflects this philosophy: "We are a customer-driven and profitable cooperative that is committed to providing our patrons with premium value through our products and services."

C & A TOOL ENGINEERING

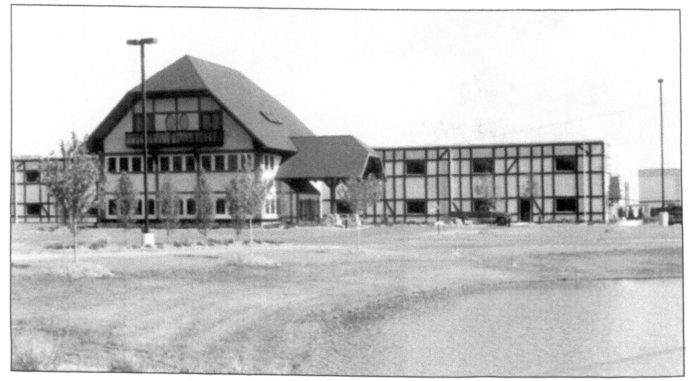

C & A Tool Engineering

C & A Tool Engineering was founded in 1969 by Richard Conrow in Churubusco, IN. Initially housed in Mr. Conrow's garage, the company started as a mold shop providing plastic and rubber molds predominately for the shaft seal industry.

The company continued to advance into many traditional tool making markets and moved into vacant downtown storefronts renovating and restoring these buildings along the way, continuing a core policy of maintaining a strong commitment to the community in which it proudly resides. A Bavarian architecture was selected for C & A facilities not only to reflect area German and Swiss ancestry but also to promote the concept of "Old World Craftsmanship" which is a rich part of the toolmaker's tradition and high standard of quality.

As the company's reputation for high precision component development gained recognition, opportunities developed in offering C & A Tool customers the ability to proceed with production work immediately following the prototype development stage. This insures that the finished product performs as exactly as intended and shortens the "drawing board to market" time lapse to the minimum possible.

The unparalleled success in this effort spawned a new 110,000 sq. ft. facility in 1999 utilizing state of the art machining equipment that focuses toward higher volume production of precision components for the automotive, aerospace, medical, and fuel system markets.

Currently C & A Tool employs 275 people collectively focused on customer satisfaction and continued growth. The company continues to rely on its apprenticeship program as the foundation of advancing skill development to meet and be ahead of the demands for technical expertise in an ever changing world. Enjoying a world-wide reputation for technical excellence, C & A aggressively pursues opportunities in both the domestic and international markets. With a strong commitment to people and the tool making profession, the finest metalworking equipment in the world is, as always, utilized to complement the continuously increasing skill and craftsmanship of the members of C & A Tool.

CAROL'S CORNER

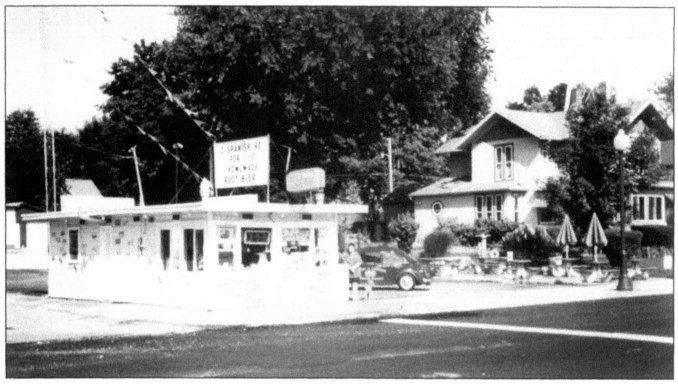

Carol's Corner

The northwest corner of State and Columbia Street in South Whitley has been the home of many businesses in the town's 150-year history, but Carol's Corner Drive-In will be the latest remembered.

The popular drive-in was built on its present site in 1951 by Foy Eisaman and Ken Hostler. Mr. Eisaman ran the restaurant for the first five years. It was then sold to Juanita Newell. It was fondly called "Spec's" from Mrs. Newell's nickname.

During her ownership, Mrs. Newell added five feet to the rear of the building. It stayed nearly the same until Carol Eberly purchased it in 1970. It was then called "Carol's Corner." Carol's Corner has been one of the most popular summer spots for the last 34 years. Many local teenagers have received their first taste of work at the local eatery, and many a hot dog and ice cream cone have made its way through the drive-in's door.

The corner was first the home of the Grimes building. The Grimes building was a saloon and billiard parlor. When the saloon closed, the Church of God used the first floor of the building until 1920. Various fraternal groups also used the upstairs.

The corner was then a gas station owned first by Vance Green and then Esta Arnold before becoming the current day drive-in.

In January 1986, Carol Eberly purchased the adjoining business, The Ideal Dress Shop. It was razed to expand the parking area. A spacious picnic area was built with patio tables and a play area for children. During these improvements various old medicine and liquor bottles and old car parts were uncovered.

The Ideal Dress Shop building was built in 1930 by Harmon Warner. Mary Louise Heuer ran the brick building from 1953 to 1970. It was purchased by Juanita Newell in 1970 and sold to Rosemary Piebenga in 1972. It remained the Ideal Dress Shop until 1986 when Carol Eberly purchased it for the expansion of Carol's Corner.

The dress shop building had been the home of the liquor store from 1934 to 1936. Over the years Dr. G. Latham DDS, Dr. Warren Purkey DDS, and Dr. Ernest Wilkin MD occupied it. It was also the site of Steve Michael's Barber Shop. From 1950 to 1952 it was the home of Joy Electric Shop owned by Rod Peabody.

Carol recently purchased an old vacant building behind Carol's Corner for further expansion of her parking lot. The demolished old building was once home to the Lloyd Warner Garage that sold Model T's, and later Dodges and Willis until the Big Depression in 1930. Mr. Bayman in the 40s operated a meet locker/grocery store and it remained meat locker well into the late 1900s.

Both Carol's Corner and the Ideal Dress Shop location have added much to the history of South Whitley and carry many fond memories for us all.

COLUMBIA CITY AUTOMOTIVE SUPPLY, INC. (NAPA)

Noel Phegley and his father B.J. Phegley established Columbia City Automotive Supply, Inc. (NAPA) and on February 5, 1975 opened its doors in the current Quik Mart location on East Chicago Street. This was continuing family tradition as B.J. owned and operated two other NAPA Stores in Bluffton and Decatur. The family tradition continued as Noel's brother Mark joined the Columbia City operation in May 1977 to learn the business ropes. Noel's wife Gloria joined the business in late 1975 and took over the bookkeeping. Both of Noel's daughters, Abby English and Jamie Peppler, have and continue to work in the family business assisting with computer work and the accounting. Mark Phegley moved to Decatur in 1989 to take over the family business there. His son Drew now works with him in sales at that location. The traditional small business is a part of the Phegley lifeline. The Phegley family strives to uphold the old business ethic of a gentleman's handshake.

NAPA is a national organization established in 1925 under the name of Genuine Parts Company (GPC). A young man, Carlyle Fraser from West Virginia, purchased the Motor Parts Depot in Atlanta, Georgia for $40,000. As GPC conglomerate began to grow NAPA became one of its many subsidiaries. The company was founded to meet America's growing need for a world-class auto parts distribution system. By providing excellent customer service for more than 70 years, NAPA has become the industry leader. NAPA's strength is unrivaled, with 6,000 NAPA stores, sixty-nine Distribution Centers, over 12,000 affiliated NAPA AutoCare facilities, 200,000 parts in inventory, and more ASE-Certified Parts Professionals than anyone in the industry.

NAPA Store, Noel Phebley, owner.

Grand Opening at 201 East Chicago Street with Mayor Leland Williams cutting the ribbon. Front left: Jim Fidewa, NAPA representative from Fort Wayne; Noel Phegley, owner-manager; Gloria Pease; Robert DeMoney, president of CC Area Chamber of Commerce; B.J. Phegley, the owner's father; Mayor Williams.

Noel Phebley, owner

Over the years many part-time employees have assisted in the daily operation of the local Columbia City business. Several students from the ICE program at CCHS have worked during the school year. Three of these young men have gone on to work in automotive related jobs. Our staff performs many different duties during the business day. The knowledge needed by our staff today in part application has become much more complicated with the addition of so many makes and models not only in the automotive end of the business but also the industrial and agricultural segments of the business. Currently, Daniel Barnhart is the store manager.

NAPA was just beginning the use of computers in the 70s. Each day all sales were punched into a small keyboard and then transmitted over the telephone receiver and stock was replenished several days later. Columbia City NAPA has seen several computer systems come and go in the last 30 years. Turn around time is much quicker today. The current computer system has made availability of parts for the customer and accessibility to sixty-nine warehouses across the nation almost instant. The local store can also access the manufacturer of each line to check their inventory. The present system also offers technical assistance and part photo identification. Prior to the move to Columbia City, the ordering of parts was done on a card system and handwritten ledger sheets were used for each charge customer. Today parts are ordered over the computer with internet access and all accounts are updated instantly on the computer.

The business location changed in May of 1978. The business was moved to its current location at 513 South Main Street. The Phillips 66 location was purchased from United Oil of Bluffton. A 4,200 square foot pole structure was constructed on the site. In January of 2001, the Weling

property adjacent to the store was purchased. The house was demolished for additional parking. The garage still remains.

Local competition has changed several times in the last thirty years. NAPA has seen new business move to town and some leave. Pricing and availability are now the name of the game. Because we have become such a mobile society, customers are most interested in the best price and the fastest turn around time. Again computers have made this service possible.

Our clientele has remained steadfast in the last 30 years. Of course, many new accounts have been added to our accounts receivable roster. The agriculture and dealership trade have always been strong accounts. As the business began to grow municipalities and industry joined the list of consumers. Many small garages have been constant in purchasing the traditional car and truck repair parts. We also service clients who need parts for marine application or small engine repair. As vehicles have become computerized part application has become much more complex.

Columbia City NAPA has always been a service-oriented business. Delivery is an important element of the daily operation. Today, two trips are made to the Fort Wayne Distribution Center to pick up parts. We also receive overnight delivery from the Fort Wayne Distribution Center and Indianapolis Distribution Center. This makes service and turn around time much quicker for all our retail and wholesale customers. A new facet of the system is the NAPA Auto Care Center. Currently, in Whitley County there are three Auto Care Centers, which are serviced by the Columbia City store. These businesses use NAPA parts and honor all NAPA warranties.

In recent years, technical assistance has become as close as the phone. Each manufacturer is available to support the local store with questions about specific parts and their application. This is a helpful tool as many individuals do repairs on their own.

As the parts industry continues to grow, Columbia City NAPA will continue to expand to meet the consumers' needs.

COLUMBIA CITY VETERINARY HOSPITAL

One hundred fourteen years ago the Columbia City Veterinary Clinic and Hospital was founded. Its first location was in a livery stable next to the Columbia City First Baptist Church on West Van Buren Street. The year was 1890, the founder, Dr. John W. Clark.

In 1904, the business was moved back of the Clark home at 110 W. Jackson Street into the summer kitchen and small barn. In 1905, John's son, George LeRoy, was graduated from the Ontario Veterinary College and joined his father in the practice.

Through the years, in addition to the two Drs. Clark, Drs. Ben Blood, Nathan Turner, J.M. Hilsheimer, M.M. Coble, Clark Waterfall (a grandson to John Clark), Joe Klopfenstein, Carol Blandford, Robert Hott and Don Richey serviced the practice.

In 1988, Dr. Richey purchased the practice and moved it to its present location at 636 North State Road 9. Dr. Colleen Quinn joined the practice in 1992. In 2004, Dr. Jill Kitson was added to the staff.

At present, Dr. Quinn has purchased the business, retaining Dr. Richey on the staff.

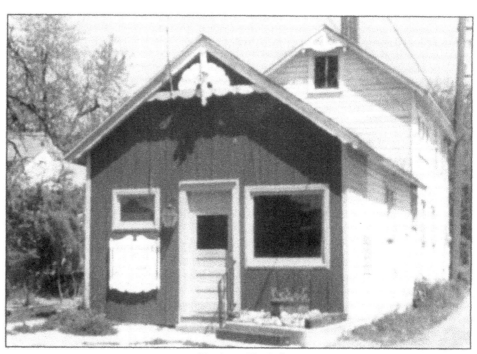

Veterinary Hospital

In addition to the twelve Doctors of Veterinary Medicine who have served the community, the staff have fostered six employees who have made Veterinary Medicine their careers, three as graduate DVMs and three as graduate Veterinary Technicians, all taking their advance training at Purdue University.

The present Columbia City Veterinary Hospital.

YONTZ GROCERY 1900-1964
FABRIC CENTER 1964-1991
COLUMBIA HOUSE INTERIORS 1976-PRESENT

Customers Hold Yontz - Freeman Store in Fond Memory

In 1900 Sam Yontz and Arnie Hallauer (Mary Grant Trier's grandfather) bought the store - then a grocery from Wes Magley. In 1926 Fred Yontz became a partner with his father and in 1942 Robert Yontz joined his father Fred to run the grocery.

The store remained Yontz and Son Grocers until 1964 when Fred retired and Ned and Alma Freeman and George and Nellie Freeman, Ned's parents, purchased the business. George Freeman had a career as a merchant and manufacturer's representative, textiles being his favorite along with Ned's wife Alma - hence the family tradition of department stores changed and the Fabric Center was born in September 1964.

Freeman's purchased the building from Richard Morsches who had moved to New York City with the metropolitan Museum of Art.

In 1969 the tragic sudden death of Nellie due to a freak automobile accident created a major loss to the business. Soon thereafter George Freeman left the business and moved to Arizona.

The fabric Center was a complete home sewer's dream. Sewing classes, craft classes kept pace with the current trends. The 70s brought back to our culture needle arts and crafts of all kinds with the major style fad of sewing with double knits.

Annually a juried and judged quilt show was held at the Fabric Center. A bus trip was organized to the national quilt show one year.

In 1976 an expansion onto the second floor of the building added "Columbia House Interiors" which included furniture, wallcoverings, accessories and expanded window treatments and bed treatment. Interior decorating classes were held with capacity participation. A ten-week session ended with a bus trip to Chicago's Merchandise Mart.

A drapery workroom has been housed in the building since the store opened in 1964, with several seamstresses employed. The workroom has continued as a vital part of the store allowing us to control the quality of the work and provide assurance of customer satisfaction.

Long term employees have included Freeda Zumbrun, May Wappes, Clementine Cleland, and currently Kathi Roman is celebrating 23 years as a faithful employee. Much credit goes to employees for the success of the business.

In 1976 an art department was added with original and limited edition art. Feature artist P. Buckley Moss was added in 1981. Many remember the personal appearances of Ms. Moss and the long lines waiting outside the store to meet her and have a piece of art signed. The Freeman grandchildren were outdoor hostesses serving hot drinks and pastry as the shows were always in November. Each show was dedicated to a benefit of local needs.

Custom picture framing is also a major part of Columbia House. Ned Freeman offers standard and conservation framing as well as needlework and canvas framing.

1991 brought to a close the Fabric Center, and since the entire building has been dedicated to interiors, allowing major expansion for accessories, complete areas for framing selections, and window shades vignettes.

If Columbia House cannot complete an interior with local selections the customer is taken to Chicago or elsewhere to attain the best selections possible for the job. The logo of the store - "Beautiful Interiors Budgeted to Your Needs" allows the customer to understand all projects are carefully budgeted.

Customers shop at Columbia House from as far as Indianapolis, Michigan, Ohio, and Illinois.

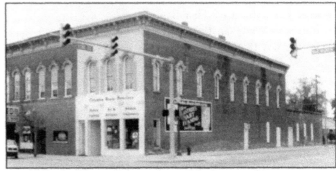

Columbia House Interiors, corner of Van Buren and Line streets.

The Fabric Center's 1984 Quilt Show; Emma Lou Zeigler, Josephine Hibbs, Mary Harshbarger and Alma Freeman.

Antiques are now a vital part at Columbia House, specializing in unique European antiques at reasonable and affordable prices,

The Freeman's travel extensively attaining the antiques as far as England and other parts of Europe. Currently their antiques are also in a shop in Zionsville, Indiana.

2004 is the golden anniversary of 50 years in business for Ned and Alma Freeman, the first 10 years being department stores.

40 years here in Columbia City have been a real blessing to our family.

God has given us the opportunity to serve and be a blessing to many people. Our wonderful employees are the best, and without the faithful customers we would not be celebrating 50 years in business.

Thank you to our employees and customers.

The Fabric Center ribbon cutting, September 11, 1964, G.W. Freeman, Alma Freeman and Ned Freeman.

Ned and Alma Freeman and Family

CULLIGAN

In June of 1946, Paul F. Martin formed a partnership with his parents-in-law to be, Arnold and Opal Schipper, to purchase the Culligan franchise for Whitley County from Culligan International Company. On August 14, 1946 Culligan Soft Water Service opened for business on East Van Buren Street offering a new concept in providing soft water with portable exchange tank service delivered to the home. The first exchange tank rental service was established.

Paul Martin and Colleen Schipper were married on September 1, 1946 in Wabash, Indiana and moved to Columbia City.

In 1952 a new building was constructed at 515 Golden Avenue for plant and office operations. The first fully automatic water softeners became available in 1956 thus expanding the business into the sale and rental of water softeners along with salt delivery for homes and businesses.

Paul and Colleen Martin became sole owners of the operation in 1958. Colleen became active in the business in 1961 when Paul was recalled to active duty with the Air National Guard and spent the next eleven months in France. This was during the Berlin Wall Crisis.

In 1963, an addition was added to the building for office and sales area and in 1973 a warehouse was built for additional salt storage. In 1972 the business was incorporated, Frederick "Fritz" and Bryan Martin joined their parents in the operation and assumed ownership in 1982 when their father retired.

With the growing concern for high quality drinking water, the business has expanded into bottled water and in-home drinking water systems which have become an important part of the business as well as commercial and industrial water treatment.

The business further expanded with the purchase of the W.J. Glass building at 675 East Business 30 for office and sales facilities opening in January of 1995.

On August 14, 1996, Culligan of Columbia City celebrated fifty years of operation under Martin family ownership. The entire family is proud to have been a part of the community and appreciate the opportunities provided them in their business and personal lives.

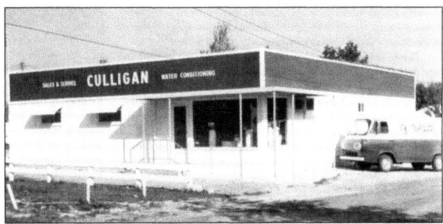

1962 Culligan

1995 Culligan

1952 Culligan

2005 Culligan

DeMoney-Grimes Funeral Home

DeMoney-Grimes Countryside Park Funeral Home began in 1915 in a storefront building on West Van Buren Street and in 1923 moved to the corner of Van Buren and Washington Streets. A fire in March 1983 destroyed that building and the new facility was opened at 600 Countryside Drive on January 4, 1984. DeMoney-Grimes Countryside Park Funeral Home is a full service funeral home providing complete facilities and services for funeral and memorial ceremonies, interments and cremations. They also provide monument designing and installation through Countryside Monuments located at the funeral home location. They also provide funeral pre-arrangements with post service counseling for families' continued care. DeMoney-Grimes is also Whitley County's only member, by invitation, of the prestigious Selected Independent Funeral Homes of independent funeral homes.

Randy L. Grimes started working at a funeral home in 1972 and then went to mortuary school at the Indiana College of Mortuary Science in Indianapolis. In 1976 he went to work with Bob and Ginnie DeMoney at the funeral home. After three years, Randy bought the funeral home. Since that time Randy has worked hard to supply the community with extended services and care.

Bob DeMoney continued the tradition of complete care started by his father and mother, J.A. and Effie DeMoney. J.A. graduated from the Spring 1917 Class of The Askin Training School for Embalmers. Bob started in the funeral profession working with his father as early as age 10 working around the family funeral parlor. At age 17, Bob went to mortuary school and graduated in 1938, then went on to Indiana University. Bob worked as a funeral director in Philadelphia and also in Indianapolis and came back to work with his father in the family business in 1942. When Bob's wife, Ginnie, became ill he retired from the funeral profession and began a rewarding career as a Whitley County volunteer. He is often seen taking meals to shut-ins or driving many to doctor's appointments or the grocery store.

Virginia Grimes joined the firm during the construction of the new funeral home on Countryside Drive working part time. Following the death of Virginia's husband, Franklin, she joined the staff full time. Virginia takes great pride in caring for the funeral home's families and is known for taking that extra step to help other widows. Now mostly retired she is content to oversee the many mailings the funeral home does to keep the community informed about happenings at the funeral home.

Greeters that assist families and friends during visitation include Curt Johnson, Ellie Lambert, Bonnie Johnson, Carolyn Bills and Bev Harrold. Rev. John Cummings, pastor of Community Bible Church, assists with removals and often steps in to help when a family has no church connection. Other support staff includes Carla Blakley, personal assistant to Randy L. Grimes and Tim Cunningham, Director of Marketing.

Evelyn Stemen has worked since 1980 for DeMoney-Grimes as staff organist and has made the beautiful music that adds so much to the services. Evelyn has been instrumental in keeping the funeral home's organ in good repair so that visiting musicians do not have to struggle with broken notes or pedals. In 2003, Randy purchased a digital keyboard in order to provide a greater variety of musical styles to the families.

Sarah and Bob Howard who moved to Columbia City in 1993 have become a valued part of the team. Sarah and Bob take care of cleaning with Laura Snyder who joined the staff during the 2004 addition, doing repairs and seeing that the funeral home is in top shape at all times. Sarah also takes care of payroll and accounts payable and receivable.

Marti Schrader joined the staff in 1998 to expand the Grief Support offerings of the funeral home. Tapestries, a free grief support group of DeMoney-Grimes, meets twice a month February through May and then again from July to October, and provides survivors with coping skills to deal with grief issues. In 2002, Compassionate Friends, an organization

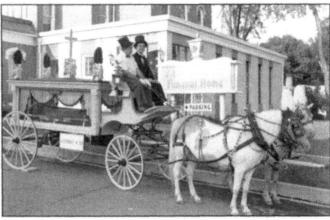

Horse drawn hearse.

for grieving parents, became a part of the DeMoney-Grimes family of grief support. In addition to her duties as grief facilitator, Marti, plans the Annual Holiday Helps program which takes place in the month of November, and the Annual Memorial Service to help the families in the community deal with their losses through the holidays. All families in the community are invited. As of this writing the Annual Holiday Memorial Service will be in its 13th year and nearly 400 people attend the two

Early DeMoney Funeral Home on the corner of VanBuren and Washington Streets.

services. Marti also has developed a grief library at the funeral home and Peabody Library and has programs in place for children and teens.

Kevin Nicodemus joined the staff in 2000 as Pre-Need and Post-Service Counselor. Kevin's main duties include helping people pre-plan funerals for themselves or a loved one. He also offers options on payment plans. Kevin is also responsible for helping with permanent monuments.

In 1996, an expansion of the building included a Community Room. Families often use this room for before or after funeral dinners. Joyce Kessie is the hostess for the Community Room. An expansion in 2004 included a new chapel, reception area, and office space. A new sound system expanded the capabilities of the building with the ability to play CDs, cassettes, and record services. Large movie screens make it possible for all attending the funeral to view video Tributes, a DeMoney-Grimes exclusive.

Randy Grimes and the entire DeMoney-Grimes family want to express to the community that they pride themselves in caring for the family's total needs and are proud of what they have accomplished over the past 90 years they have been in business. Thus the tradition of caring and sharing, started long ago by J.A. DeMoney, continues with a new generation serving area families with a complete full-service, handicapped accessible, facility. DeMoney-Grimes Funeral Home has received the National Funeral Director Association's Pursuit of Excellence Eagle Award since 2001 achieving a Golden Eagle Award in 2004. This is the NFDA's most prestigious and coveted award. Only three funeral homes in Indiana received the award in 2003.

EAGLES LODGE – 1906

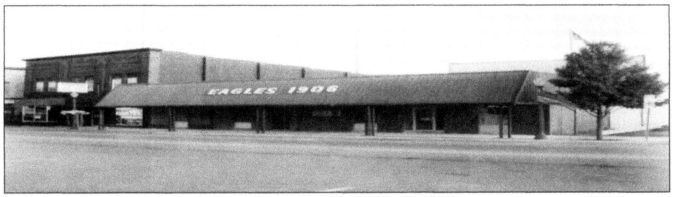

Eagles Lodge Aerie 1906, W. Van Buren St., Columbia City.

The Fraternal Order of Eagles Lodge Aerie 1906 was formed October 20, 1909 and was issued its charter on December 24, 1909. The lodge, consisting of 54 charter members, voted and agreed to the GAR Hall (which was located above the Bamboo Lounge)(Haisley's) as their permanent meeting place. The annual cost of membership was $10.00. The lodge continued to grow in membership and warranted a new meeting place. In 1924, the Eagles Lodge purchased the building they currently occupy for $8,000. The building was expanded in 1950 creating space for a ballroom downstairs while the Eagles Lodge and its auxiliary continued meeting upstairs. On the night of December 13, 1976, a fire completely destroyed the adjacent building and quickly spread to the lodge. The front portion of the lodge was damaged beyond repair. After many lengthy discussions and deliberations, it was decided to rebuild the lodge. Bids were received and the following companies were selected for the rebuilding: D&C Construction, Whetstone Electric, and Redman Plumbing and Heating. During the reconstruction, Aeire 1906 weekly meetings were held at the Moose Lodge in Columbia City. On January 1, 1978, the building was completed, passed inspection, and re-opened for business. The grand opening was held on April 15 and 16 with a ribbon cutting ceremony. Mayor Robert Walker performed the ribbon cutting honors with Ivan Blaugh, Worthy President of the local club, as master of ceremonies. A program followed in the ballroom with

Past Grand Worthy President Lewis Reed of Milwaukee, Wisconsin as the guest speaker. Persons traveled from many parts of northern Indiana to attend the Columbia City Eagles Lodge two day celebration. In 1979, the Eagles Lodge was contacted by Paul Redman (the owner of the fire ravished vacant lot) and asked if they would be interested in purchasing the land. The Eagles agreed to purchase the lot at a price of $15,000. A $10,000 down payment was made and the rest of the money was borrowed. The loan was paid ahead of schedule with only $92.00 accrued interest. Several updates and improvements have been made to the facility over the years which has added an atmosphere for a good family-oriented service club.

The local club has been involved with Eagles Grand Aerie projects on a national level, such as: Eagles Jimmy Durante Children's Fund; Eagles Spinal Cord Injury Fund; Art Ehrmann Cancer Fund. Money and services are provided for local organizations, as well.

The local club has numerous projects to raise funds for the many worthwhile projects. Perhaps the one that is the most popular is the Bingo nights which occur on Friday and Saturday.

Entertainment is also provided on Saturday nights, after Bingo. Local bands provide good music for dancing or just for your listening pleasure. The membership of the club has grown in excess of 700 since its inception.

EAGLE'S NEST EVENT CENTER

125 S. Eagle Glen Tri Columbia Center
Phone 260/248-2563
Stanley and Doris Horne, Owners

Eagle's Nest Event Center

The Eagle's Nest opened for business in 1996. Since that time Stan and Doris and their staff have served thousands and thousands of guests. They host over three hundred parties and events each year. During the busy seasons they have up to three events going at one time. It is overlooking the water and Eagle Glen Golf Course; a beautiful event center catering to organizations, clubs, church groups parties and receptions. The building is owned by the Eagle Glen Golf Course and leased by the Hornes. They are the owners of Eagles Nest.

ESTLICK-GIRVIN & LEFEVER, INC. INSURANCE

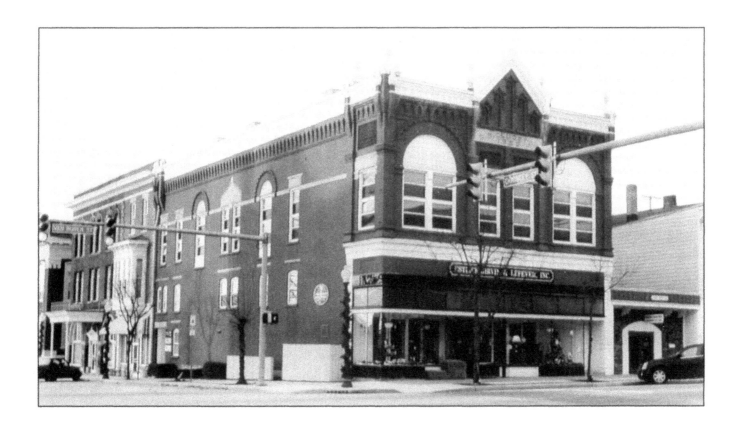

Through a series of purchases and mergers, the history of Estlick-Girvin & Lefever, Inc. dates back to 1894. The main office is located in Columbia City with branches in South Whitley, Churubusco, Ligonier, Ft. Wayne, Huntington, Warren, Bluffton and Marion. A brief summary follows:

In 1894, John and Benton Gates were appointed as agents for the Ohio Farmers Insurance Company. In 1910, Elmer Bump and Ralph Ferry opened an agency. In 1916, Charles Estlick started an agency and sold mostly fire and wind insurance. Scott Holderbaum opened an agency in 1932 in Columbia City and Pat Isay started an agency in Churubusco in 1934. Near the same time, Phil Glassley took over an agency in South Whitley that had been started by his grandfather. Bob Estlick purchased his grandfathers agency in 1939. Everett Jones and Joe McGuire each opened separate agencies in Churubusco in 1941. Ed Pugh took over the Gates Agency in Columbia City. Ford Goble and his son Willis opened another agency in 1950, Chuck Jones joined his father in 1963 and Bob McGuire joined his father in the late 60s. Jim Brock opened his agency in 1975 and Lee Girvin purchased the Estlick Agency in 1979. John Lefever joined Girvin in 1981. The Estlick-Girvin & Lefever, Inc. Insurance Agency was founded that year.

Additional transactions expanded the business base. Ed Spicer had purchased the Holderbaum Agency and that agency was purchased by the group in 1985. The Glassley Agency was purchased in 1990 from Mark Glassley who had taken over the

business run by his father. Todd Jones, son of Chuck and grandson of Everett, joined the firm and runs the South Whitley office. Starting in 1993, Estlick-Girvin & Lefever, Inc. branched out and purchased the Scott Agency in Ligonier and also purchased Odyssey Travel that year. Over the next 10 years, additional locations have been added in Ft. Wayne, Huntington, Warren, Bluffton and Marion. Starting in 2004, Developmental Concepts, Inc. was started as a marketing company. It is also located in Columbia City and is operated by David Lefever and Kelley Kemp.

Some background information regarding insurance is as follows:

In 1941, the State Legislature passed the Financial Responsibility law requiring that everyone carry liability insurance on their autos. A typical semi-annual rate for $5,000 per person/ $10,000 per accident Bodily Injury with $5,000 Property Damage was $12.50. The annual rate per $1,000 worth of residential property was $4.00. Real estate was probably valued at about 5% of today's valuation.

Insurance has gone from insuring just fire exposures to covering about any risk one wants to insure. It is not atypical for a family to have three or four cars, a home, a boat, a lake home and other recreational, type vehicles. In addition, people routinely purchase life insurance, health insurance, medi-care supplements, long term care insurance and disability insurance. It would not be unusual today for a family to spend 15% of their income on insurance.

FOX PRODUCTS CORPORATION

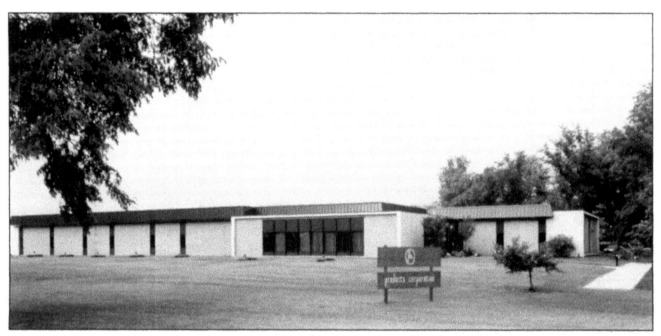

Fox Products Corporation

The concept of the Fox Bassoon Company, now Fox Products Corporation, began in Hugo Fox's imagination sometime between 1922 and 1949, years when he was principal bassoonist of the Chicago Symphony Orchestra. He founded Fox Products Corporation in South Whitley, Indiana, during the summer of 1949 and the first bassoon was completed in November 1951. During the first production year, twelve instruments were finished and delivered.

The business included bassoon reed manufacturing, which Mr. Fox had started during the late 1930s. The 1950s saw the addition of oboe reed manufacturing to the product line, as well as continual additions to machines and tools and modest expansion of bassoon manufacturing. The last year of the decade saw the production of 60 instruments, along with 5,000 bassoon reeds and 10,000 oboe reeds.

Mr. Fox's failing health threatened to end the young company as the 50s drew to a close. In the fall of 1960, Hugo's son, Alan, decided to give up his chemical engineering career and take over the family business, with his father supervising the assembly and tuning of the instruments. By 1964, however, the elder Fox was no longer able to continue, so the company began to rely on part-time bassoonists for tuning and on a group of prominent American bassoonists and repairmen for technical guidance.

Under the guidance of the American bassoonists, the instruments began to improve. The company began to grow and the 60s and 70s saw the beginning of the recruitment of highly talented people. Despite a fire in September 1974, which destroyed the reed business and the instrument wood shop, the company grew enough, both in artistic stature and in production capacity,

to allow development of a contrabassoon and a domestically oriented oboe, and began the export of serious instruments to Europe and Asia.

Initially, there were objections to the tone quality of Fox bassoons by many of the European players, so subtle changes were made in the designs to make them appeal to their tastes. The Asians had problems with widely spread keys, so the mechanism became more compact. The evolution continued throughout the 80s, and the 90s began to see worldwide acceptance of this "new" American maker.

Throughout its history, Fox has sought technical expertise and has been receptive to modifying its instruments to suit the needs and tastes of its customers. It supplies a broad base of bassoonists around the world, and an increasing group of oboists in North America. It is becoming recognized as a standard in each of the fields it serves, and has the people and the desire to preserve a long-term commitment to double reed musicians.

GENE REEG MOTOR SALES

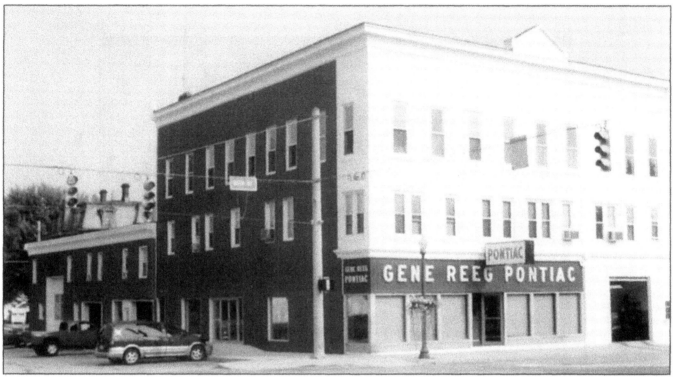

Gene Reeg Motor Sales

When the farmhouse of Gene (Leonard Eugene) and Georgia Reeg burned in 1947 near South Whitley, Gene decided to go into the used car business with his brother, Dale. They started out at 600 South Main Street in Columbia City. On February 17, 1949, Gene went into partnership with Gene Simmonds and Dale Reeg for the Pontiac franchise and on September 23, 1949, he became sole owner. The dealership has always been located at 201 South Main St. when the Dare Harness Shop moved out. In 1954, the 600 South Main Street car lot land was purchased from Rome and Meryle Repp and additional outlots behind were purchased from Arthur W. and Irene Trier in 1961. In 1962 the 201 South Main Street building was purchased from Hazel Hancock and in 1963 extensive remodeling was begun and expansion was made into the rear section of the building formerly occupied by Magin Sewing Machine Shop and Russel Wolfe's Garage.

In 1990 Georgia Reeg purchased the old Whitley County jail at 116 East Market Street and a parking lot was added along the west side of the jail lot. Since 1993 the old jail has been used for a haunted jail each Halloween.

Georgia Reeg started working in the business on a part-time basis in 1950. After Gene died in 1969, Georgia became one of the first female General Motors dealers in the country when she received the Pontiac and GMC franchises.

In 1952 the Frigidaire appliance franchise was purchased from Thomson's Farm Store and Georgia's brother, Forrest "Si" Menzie, worked in that area until his retirement in 1992.

Gene and Georgia had three children: Brenda, Jana and Melvin. Jana and Melvin started working in the family business as teenagers as did Jana's daughter Denise Reeg Pequignot. The family-

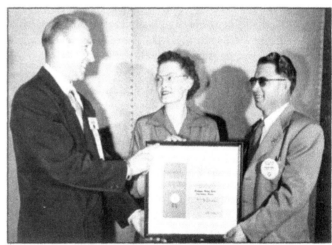

Left: Bart Main of Chicago Motor Club. Center: Georgia (Menzie) Reeg. Right: L. Eugene Reeg. Circa 1954.

operated business has had three generations working together successfully on a daily basis since Denise started in 1989.

Gene Reeg Motor Sales, Inc., credits a large part of their success to their loyal employees. Roger Groves has been manager of sales since 1971 and Bonnie Pfeiffer has worked with him in sales since 2000. Melvin Reeg manages the service and parts departments. Service technicians are Randall Hinen who started in 1979, Scott Kyler in 1986, and Jeremy Pequignot in 1999. All service department employees started while they were high school students. Jana Reeg is the general manager and is assisted by her daughter Denise.

Harold Copp Farms, Inc.

The Copp Farm, Columbia Township.

The year 1947 was a year of beginnings for the Harold and Miriam Copp family. Miriam and Harold began both a marriage and the business of Copp Farm Supply. The subsequent years would lead to both a growing family of five children and numerous farm and farm supply endeavors. In 1957 the family moved to the Wilkswood Stock Farm in Columbia City, IN. The Peadbody farm as many had called it, was rich in history. Deeded originally by President Arthur, the property was at one time part of the Indian Beaver Reserve. In the late 1800s and early 1900s, the farm was owned and operated by S.J. Peabody, a lumberman whose reputation became world-wide as a supplier of fine hardwood lumber. The current Holmes Lumber Company was originally started by Mr. Peabody. It was during this time that the property was turned into a horse farm complete with race track, grandstand, multiple supporting structures as well as reportedly, the first concrete swimming pool in the state. Wilkswood who was a world champion trotter, was the horse for whom the farm was named. The original sign, now owned by Dale and Jean Shively, hangs in the restored mare barn that the Copp Family call Change of Heart.

Interim owners were Grant Munson of Fort Wayne, and Wilson Frank. The Copp family has engaged in numerous enterprises since purchasing the property that included multiple hog operations, one of which was the BS&B Bacon Bins, a cow/calf herd, sheep and chicken operations and a large ultra modern dairy operation called Copp Cow Palace, which was a state of the art dairy that included equipment used for the very first time. Although profitable, those operations were eventually phased out in response to the growing farm supply business and its specific demands of time and labor. The grain farm operation has continued and grown with the passing of time. The original 858 acre farm has expanded with numerous acquisitions.

Harold's career passion was business. He loved to sell. Although, being a depression child whose business philosophy was "You Have to Make a Profit," he endeavored to offer his customers quality products at an ex-

Harold "Bud" Copp (1921-1999).

tremely competitive price. Harold had a very organized business, of course those who knew him, knew that organization was locked only inside his mind, not well aligned showcases or filing cabinets. Numerous stories were told of his unconventional way of doing things that included parts piled in the weeds, cigar boxes full of unbilled customer invoices allowing them to "hold onto their money a little longer," and an absolute obsession to help out a customer even if it meant scavenging the entire farm to find parts when no other dealer would have them.

The business was incorporated in 1979 and is called Harold Copp Farms, Inc. Today the operation focuses on it's grain farming and the growing farm supply.

KILLIAN AUTO SALVAGE

Killian Auto Salvage. Inset photo: Ralph Killian.

A gallon of regular gasoline cost 21 cents. A new entertainment concept called television was introduced. And a young animator named Walt Disney created a new cartoon character that he named Mickey Mouse. The year was 1928.

In February of 1928, brothers, Ralph and Jake Killian, each put up $1.25 and, along with another $5 they borrowed from their father, Jacob, opened Killian Auto Salvage in Columbia City, IN.

The brothers weren't interested in selling used parts. They simply bought broken down cars and set them on fire. After the wood and upholstery burned away, what was left were crumpled piles of copper, tin and aluminum. The metal was then sold to the Menefee Foundry. Twenty hours of work yielded a profit of $12. It was a fantastic income, considering that workers at the foundry were earning around $9 a week.

In 1933, Ralph bought out his brother's interest in the business for $125. The business moved to its current 24-acre site, which was purchased for $2,000. This was about the time Ralph's son, Richard, started hanging around.

"I can remember, as a young boy, sitting around the pot-bellied stove and listening to my dad talk about the scrap business. What an education that was," Richard recalled. The youngster's role in the business soon increased.

"When I was 16, we went out with the wrecker scouting for old cars we could buy. Most of the time, we didn't come home until we bought two - one hanging from the wrecker boom and the other tied to the back, which I had to sit inside and steer back to the yard," Richard said.

After graduating from college in 1965, Richard reluctantly joined his father in business and a family feud soon ensued.

"I saw some of the yards around Ft. Wayne, and they were doing real well selling parts, but dad never believed in late-model salvage," Richard recalled.

Ralph passed away in February of 1980, almost 52 years to the day after starting the business. Richard then assumed the day-to-day responsibilities of running the business. In less than 10 years, it was a full-scale, late-model recycling business, complete with a computerized inventory.

Richard Killian, left, and Eric Killian have played a significant role in the success of a company which started as a $7.50 investment.

Equipment and buildings were expanded and updated. Today, the operation employs seven and processes about 800 vehicles each year. They maintain an 800-vehicle inventory, mostly domestic, from 1994 to current models.

Richard's son, Eric, started working for the company in 1998 and is the third generation to contribute to its growth. Eric's expertise lies in computers, and he has upgraded their system to Hollander's Powertink. A new 5,000 square-foot teardown building was added last year, and the existing buildings were given an exterior refurbishing.

Richard recently celebrated his 60th birthday, and he is preparing Eric to take over. As far as advice, Richard reverts to his own roots.

"We should never lose sight of what first made us successful. When times got a little tough, I could walk out back and always find money," he said. The foundry is still in business and still buys scrap metal.

MORCHES LUMBER, INC.

Morsches Lumber, Inc. was originally started as a partnership of Paul J. Morsches and Ralph (Bud) Grant. These men, who had both worked for the S.J. Peabody Lumber Company for many years, decided in 1939 to separate the retail lumber business from the hardwood sawmill division which was operated by Fred and Julius Morsches from 1931 to 1939 when they retired. Fred and Julius had managed the company for S.J. Peabody for many years after Mr. Peabody moved to Daytona Beach, FL. The S.J. Peabody Company had been a nationally prominent band mill operation started in 1871 to manufacture the high quality hardwoods of the Indiana region. At one time, they had 10 mills running in Indiana.

Ralph Grant sold his share of the company to Paul Morsches during the war years. Soon after, a fire destroyed the offices of the company, and the present office building was built at East Terminal Market Street in 1946.

Paul Morsches Jr. joined his father as a partner in 1954. The firm was incorporated in 1959.

The firm expanded to South Whitley in 1955 by purchasing the Lee Lumber Company located on Front Street.

Ralph Grant returned to work in the company and took over as manager of the South Whitley yard.

In 1962 Paul Morsches Jr. started to expand the operations to other communities. The expansion yards were incorporated individually as they were built. The first yard was built in Warsaw, IN. Soon it was decided to close the South Whitley yard and move it to a new location at Huntington. Five years later a new yard was built at Goshen, IN in 1973.

In 1988 the company started Builders Mart of Wabash at Wabash, IN.

All of the yards in 1995 operated under the name of Builders Mart.

Some of the important managers of divisions of the company in its earlier years were Paul Morsches, Bud Grant, Alton Braddock, Jack Mettler, Delbert Chew, Jack Shipley, Betty Zumbrun and Paul Morsches Jr., who retired in 1995 after working for the company for 42 years.

The current management team of the company are Franz Morsches, Les Krider, Mike Lemon, Steven Lemmon, Scott Reed, Rod Henry and Terry Smith.

Paul Morsches Sr.

The company primarily sells lumber, plywood, building materials, millwork and hardware used in the construction business. The primary customers of the company are professional builders located in northern Indiana. The lumber products are shipped into the various yards from British Columbia and the southern pine regions of Arkansas, Texas, Mississippi, Louisiana and Georgia.

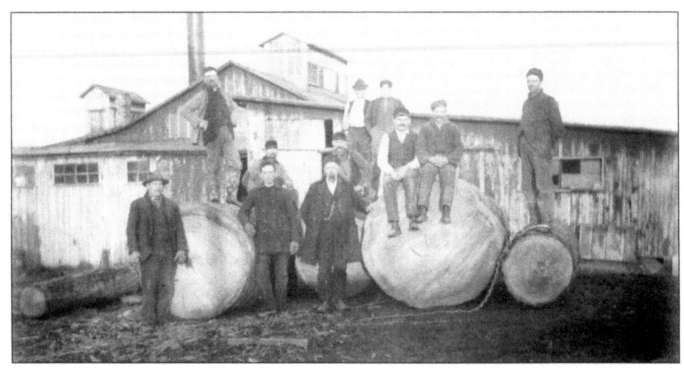

Sycamore Log – 1600 feet, ca. 1895. Pictured from l-r front row: Langohr Sawyer, Ernest Woodhadler, Fred Morsches, David Geiger, Ross Western, John Shaw, Charles Trout (back row) Harve Seavers, Henry Burkholder; Jesse Gibson, Edward Langohr.

NATIONAL CITY BANK

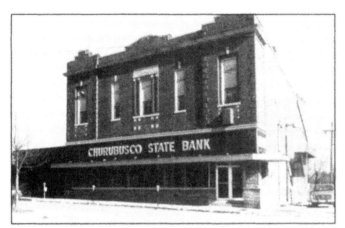

Churubusco State Bank

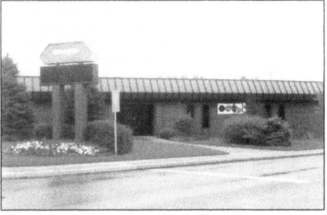

National City Bank

The Churubusco State Bank was organized in 1928 so Churubusco could have banking facilities. This need came with the closing of Churubusco's two banks - The Farmer's State Bank in 1926 and The Exchange Bank in 1927, which were among hundreds that closed during the early Depression period of 1926-1931.

The pace was accelerated by the stock market crash of 1929. During this period the number of banks throughout the country dwindled from some 30,000 to 16,000.

The new Churubusco State Bank was spearheaded by Joseph Luckey, who, with the help of businessmen, farmers, and other citizens of the area, sold stock of the new bank to raise $25,000 capital and $5,000 surplus needed to get it chartered.

The new bank was chartered on January 12, 1928. At the end of the first year, the bank's assets totaled $330,000, but as the Depression deepened, they hit a low of $150,000 in 1934. The only solution for Churubusco State Bank was to qualify for deposit insurance from the newly formed Federal Deposit Insurance Corporation.

Because of deposit insurance, the bank's assets began a slow but steady climb. They topped the million-dollar mark in June 1943.

Everett Jones was elected president of the bank in 1968 and remained in that position until he retired in 1988 after 60 years of dedicated service.

In 1978, a decision was made to build a new building. The ground floor area would cover 6,728 square feet with a full basement. The new building opened for business on November 15, 1979.

On July 11, 1985, Churubusco announced plans to merge with Fort Wayne National Corporation. In this agreement, Churubusco State Bank was to be operated as its own entity, retaining its own board of directors, officers, and staff.

In November 1998, Churubusco State Bank merged with National City Bank of Indiana. This merger brought a wealth of resources to pull from in order to continually improve the services provided by the bank. The Churubusco Office of National City Bank currently operates as a $15.36 million total branch asset bank, and $40 million total branch deposit bank. National City Bank, formerly known as Churubusco State Bank, is a proud leader in the community of Churubusco, Indiana. If you would like to see any further history of our bank please stop in and see us at the northeast corner of State Road 205 and Highway 33.

REELCRAFT INDUSTRIES

In the later months of 1969 Dresser Industries sold their hose reel division to Mr. Richard Schaller and Mr. Stan Penn. At the time of this change in ownership the company was renamed to Reelcraft Industries. Reelcraft purchased all the tooling, fixtures, drawings and inventory.

Following Mr. Schaller's retirement in 1981, Stan Penn Jr. became the sole owner of Reelcraft and the president. Four years later, in 1985, a new 44,000 square foot manufacturing plant with 4,000 square feet of office space was built at 2842 E. Business 30.

In March 1989 Reelcraft built an 8,000 square foot state of the art powder coating painting facility. Each manufactured part is individually subjected to a 5-stage phosphosizing cleaning system and then is powder coated. Powder coating is a process of electrostatically applying polyurethane powder to the surface and then heating it until it is melted into a smooth coating. This technique provides the customer with a high quality, chip resistant finish that fights weathering. Unlike many painting processes, polyurethane powder coating does not create sludge, hazardous waste or air pollution, which makes it environmentally safe.

In 1991 Reelcraft International Incorporated was formed and a distribution center was opened in Veenendaal, Netherlands, at that time. Additional distribution centers have since been established in Santa Fe Springs, California; Mississauga, Canada; the Philippines and Columbia City, Indiana. This network of distribution centers has allowed Reelcraft to significantly reduce lead-time and provide worldwide sales and service. Currently Reelcraft has 36 independent manufacturer representatives, more than 4,000 distributors in the United States and more than 225 distributors in 160 countries.

During this same period, Mr. Penn purchased Nordic Systems of Mississauga, Canada. Nordic manufacturers specialty fire, fuel and custom design reels and related fire petroleum OEM equipment. Nordic also is the primary source of Reelcraft reels for the Canadian market. Nordic's capacity to supply the larger fuel dispensing reels for the US and Canadian commercial and military applications have further expanded the range of hose reel products throughout the world. The acquisition of Nordic allowed Reelcraft to quote the specialty reels for the OEM market, foam fire fighting apparatus and fuel delivery.

In September of 1995 Reelcraft purchased a neighboring 31,200 square foot building with 1,800 square feet of office space for the purposes of housing some sub assembly operations, machining center and to warehouse finished products. The offices were recently refurbished into a modern training center for further education of our staff, and our manufacturer representatives.

In January 2002 Reelcraft acquired Transmotion Industries which was located in Simi Valley, California, and incorporated their line of hose reels into Reelcraft's line which gives Reelcraft a

Reelcraft

strong offering in the stackable reels as well as expansion of Reelcraft's line of welding reels. Their production was moved to Columbia City at that time.

Reelcraft is continually committed to customer service through its dedication to on time delivery, continuous product improvement, and enhancement of product quality, while remaining price competitive with both domestic and foreign markets. This has been accomplished by the implementation of lean manufacturing concepts which utilize manufacturing cells. In manufacturing cells, equipment and workstations are arranged in a sequence that supports a smooth flow of materials and components through the process with minimal transport of materials or delay.

In order to remain competitive and offer top quality products Reelcraft has continually invested in new equipment, education of employees and programs. As an example Reelcraft is ISO 9001:2000 certified and further backs its commitment to quality through the implementation of its Six-Sigma program. The company uses a state of the art MRP system which provides better planning, quicker scheduling changes, better inventory control and quicker customer service, as well as timely information on production operations. Reelcraft also utilizes state of the art IDEAS CAD/CAM software for design and verification of future products. This has allowed the company to reduce the design time it takes to bring a new product to market. The latest example is the ReelTek reel, which utilizes fewer parts than the traditional reel and is designed to compete with off shore products in terms of price and provide excellent quality and service.

In summary Reelcraft is committed to aggressively pursuing engineering technology, advances in design, manufacturing improvements in cost and quality in order to provide our customer with a durable product of maximum performance and long life at a reasonable cost. The company was built on customer service and the customer continues to be the focus of the company's activities each and every day.

The Schrader Real Estate & Auction Co., Inc. was founded by Denzil Schrader when he began in 1944 as an auctioneer in Columbia City, Indiana. Denzil was soon joined by his brother, LaVern. The recognition of the Schrader name was built as the auction business grew—selling farms, farm equipment, and livestock throughout Indiana and Michigan.

Expansion accelerated beginning in 1967 as a strategic plan was implemented to add Schrader representatives throughout the Midwest. Growth in the 1970's included selling land by arranging tax-deferred exchanges for many Midwestern landowners moving operations to other regions of the United States.

The Maximum Marketing Method, now know as M3 was also developed in the 1970's to maximize the sale price of large land tracts at auctions. This innovative method, energized by an experienced Schrader team, resulted in numerous strategic joint-venture auction companies being formed by Schrader.

The Schrader company has now reached over 30 states marketing large holdings of farms, ranches and timberland, as well as commercial and industrial portfolios.

As a full-service auction company, Schrader can professionally market all real estate and personal property. Over time, though, the focus has centered on several key markets. With prolonged focus comes a high level of experience in the marketing of farmland, timberland, recreational land, commercial properties, farm equipment, fertilizer equipment and antiques.

Schrader has won over 90 advertising awards, including 9 NAA 2004 and 8 NAA 2003 national first-place awards and 24 IAA awards in that same time—winning best of Website Design, Photography, and Brochure Design.

Schrader also was awarded the Auction of the Year Award in 2004 for a 4000 acre auction in Morgan County, Indiana.

And the tradition continues as Rex's son, R. D. Schrader II (Rex) joined the company in 1995 specializing in the marketing of large land parcels anywhere in the United States.

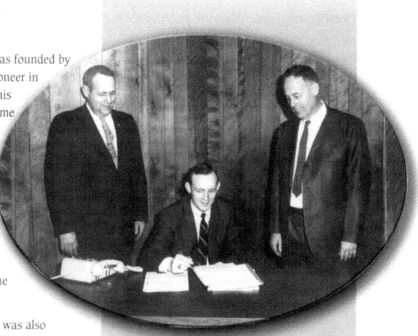

Shown here from left to right, LaVern Schrader, Rex Schrader and Denzil Schrader opening up their office as Schrader Real Estate and Auction Co., Inc. in 1967, when Rex Schrader joined the firm.

Shown here is Rex Schrader and R.D. Schrader II enjoying a few of the awards won at the 2004 National Auctioneer's Association Convention in Madison, Wisconsin.

SCHRADER
Real Estate & Auction Co., Inc.

THE SHEETS FUNERAL HOME

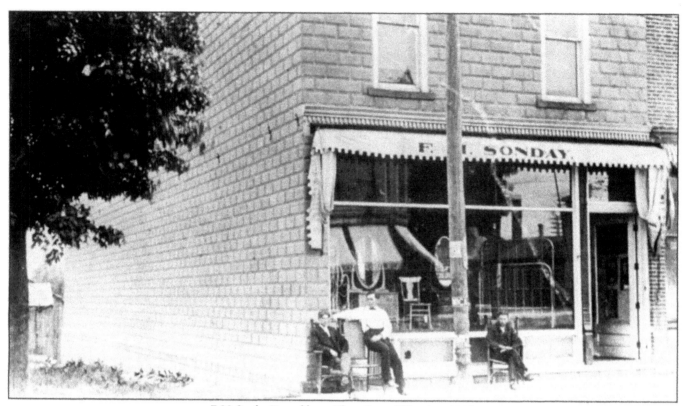

F. M. Sonday Funeral home (Sheets Funeral Home) ca. 1906.

The Sheets Funeral Home is the oldest continuing business in Churubusco, dating back to 1872 when Samuel Barr became Churubusco's first "undertaker." In. 1880 he sold to J.W. and W.C. Smith who operated their business for 18 years, selling it to Ed Briggs in 1898. In 1902 Lucas Welsheimer bought half interest in the firm, and purchased the entire business in 1905 when Mr. Briggs became a partner with Harley Warren in Columbia City.

The long established and widely known Francis M. Sonday purchased the firm on April 15, 1906. A few years before his death in 1951, Stuart Smith of Columbia City was made a partner in the Sonday Funeral Home, assisting Mr. Sonday and his wife Daisy Kichler Sonday. Lester K. Sheets became the firm's resident embalmer and funeral director in 1951, shortly before the death of F.M. Sonday.

Following the death of Mrs. Sonday in 1960, Lester and Doris Sheets purchased the funeral home. They expanded the funeral home's facilities, and became widely known for expert and efficient ambulance service, and outstanding professional care. The firm was known as Sonday and Sheets Funeral Home for many years, and later became The Sheets Funeral Home. On June 1, 1986, Mr. and Mrs. Sheets engaged C. Gregory Childs, a licensed embalmer and funeral director, to assist them in the operation of the business.

The Sheets Funeral Home

Mr. and Mrs. Sheets announced their retirement on January 2, 1990, and sold the business at that time to their associate Gregory Childs and his wife Jeannie, the present owners and operators of the funeral home. Mr. and Mrs. Childs reside in the funeral home's living quarters along with their three sons, and continue to strive to uphold the enviable reputation that The Sheets Funeral Home, has been widely known for.

SMITH FUNERAL HOME

Smith Funeral Home

Smith and Sons Funeral Home, 207 North Main Street, Columbia City, and 208 North Maple Street, South Whitley, was founded in 1851 by Henry S. Smith (1807-1870), undertaker, cabinet and furniture maker. The original business was located in South Whitley.

Following the Civil War, Henry S. Smith moved the business to Larwill, a fast growing town on the main line of the Pennsylvania Railroad. Rail transportation had become of increasing importance to the funeral service. The furniture store and undertaking establishment was located on the property now occupied by the Larwill Town Hall. His son, Winfield Scott Smith (1848-1935), later joined him in the business.

Charles S. Smith (1885-1960) became the third generation to join the business and in 1924 he moved the business to Columbia City, locating the first funeral home in the brick house on the southwest corner of West Market and South Line Streets. Charles Smith also was involved with the operation of the Hood & Smith Furniture Store located on the east side of the courthouse.

In 1935 Charles S. Smith purchased the North Main Street estate of the late S.J. Peabody, pioneer lumberman and philanthropist who died in 1933. The mansion, with its nineteen rooms and eleven closets, was built by Peabody in 1892. Eight varieties of wood were used in its construction. The stairway is of white oak, the subsiding and shingled, yellow poplar; the interior trim was of wild cherry, curly maple, quarter-sawed oak, sycamore, maple and native walnut; parquet floors of walnut, oak and maple.

There were five fireplaces in the house and one in the hostler's quarters in the carriage house. Every door and window was wired to a burglar alarm and the lawn had an underground sprinkling system. In 1935 there were nineteen trees on the quarter block: elm, maple, swamp maple. The last original tree blew down in 1975. A twelve feet by eighteen feet stall in the carriage house was home to Mr. Peabody's prized racehorse Wilkswood.

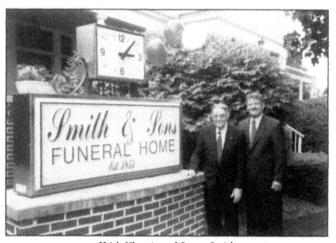

Keith Kleespie and Stuart Smith

The home was soon converted to one of the most modern funeral home in the area. Stuart D. and Boyce B. joined their father, Charles S. Smith in the operation of the business after the opening of the North Main Street facility. In 1975, C. Taron Smith, the son of Stuart D. and Ada Keiser Smith, became the fifth generation in the family to assume ownership of the family business.

In January 1982 C. Taron Smith and his wife Gloria A. Smith purchased the Miller Funeral Home at 208 North Maple Street in South Whitley. It is operated at the Smith and Sons Miller Chapel. The Miller firm was founded in 1886 by Robert Fisher and Roy Miller. Following the death of Mr. Miller in 1949, his son-in-law William A. Striggle operated the home. Taron W. Smith and Scott A. Smith, sons of C. Taron and Gloria Smith, have become the sixth generation of the Smith family to be licensed embalmers and funeral directors, making Smith and Sons one of the oldest continuous, family owned funeral home in the country.

STAR FINANCIAL BANK

The forerunner to STAR Financial Bank was Citizens State Bank which was chartered on November 9, 1929 with total assets of $139,036. James D. Adams served as its first president until 1954. Forest Orr succeeded James Adams and served as president until the bank was sold in January 1964. Kenneth A. Wright was elected the new president and served in that position until 1990. In 1966 the bank became a national bank and was renamed Citizens National Bank of Whitley County. In 1967, the Citizens State Bank building was demolished as the Citizens National Bank of Whitley County building was erected across the street where STAR Financial Bank presently stands. R. Alson Smith served as President from 1990 until 2003. Today the Columbia City region has total assets of $119,419,472.

The development and formation of STAR Financial Group in 1986 was initiated so the seven original banks could remain a major force in the increasingly competitive financial industry. This formation was facilitated by the Indiana Banking Structure Reform Act of 1985, which permitted bank holding companies to own or control more than one bank in the state of Indiana. The Boards of Directors of the original seven banks which formed STAR Financial Group viewed the new legislation permitting the formation of multi-bank holding companies as a favorable development for the group. Citizens National Bank of Whitley County, located in Columbia City, was one of the original banks.

As the state banking regulations changed, so did Citizens National Bank. In 1990 the bank's name changed to STAR Financial Bank, but the owners and directors remained the same as did their mission; to provide the citizens of Columbia City and Whitley County with the best technology, products, and service available. Our community will succeed, as well as the bank, when we both work together.

Today, STAR Financial Bank is a wholly owned subsidiary of STAR Financial Group, Inc. with over $1.3 billion in total assets. STAR Financial Bank operates 44 offices, from Angola to Indianapolis primarily following the I-69 corridor, with four locations in Whitley County, they are: 102 West Van Buren Street, Columbia City; 105 Frontage Road, Columbia City; 207 South State Street, South Whitley; and 717 South Main Street, Churubusco.

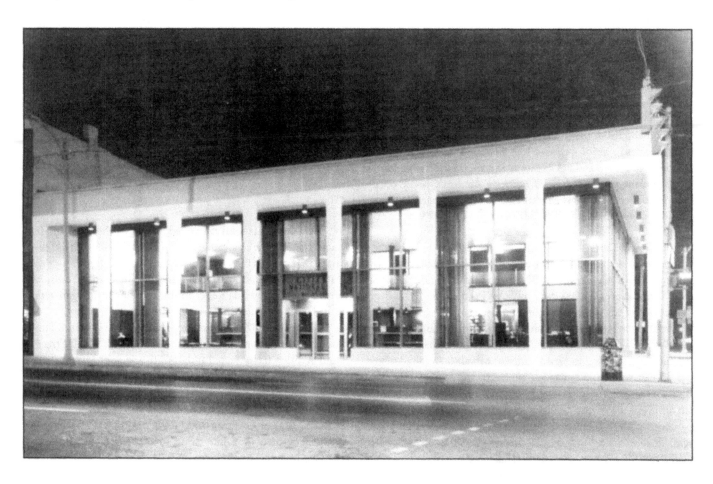

BLOOM GATES SIGLER & WHITELEATHER, LLP HISTORY

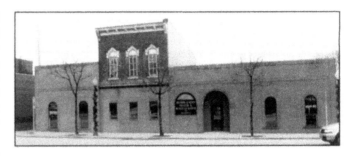

The firm of Bloom Gates Sigler & Whiteleather LLP is distinguished by a unique history. The firm traces its beginnings to 1894, when David V. Whiteleather began the practice of law in Columbia City. Shortly thereafter, in 1908, Benton J. Bloom followed suit. Well-known in northeastern Indiana as skilled trial attorneys and active participants in politics and civic affairs, the two established the law firm of Whiteleather & Bloom in 1922. Their initial partnership was made on the second floor of the Central Building on the north side of the Whitley County Courthouse Square.

In 1937, however, the firm dissolved when Whiteleather's son, John, and Bloom's son, Benton W., graduated from law school and returned to Columbia City to practice law with their respective fathers. After the dissolution, William Bloom also came back to the family practice, joining his father and brother. It was then that the separate partnerships of Whiteleather & Whiteleather and Bloom & Bloom, were established. The Bloom law firm practiced in the Central Building until 1964 when Benton and Bill purchased and remodeled the former Salvation Army Building at 111 W. Market Street. Whiteleather & Whiteleather maintained its office above the Strouse Men's Store at the northwest corner of Chauncey and Main Street until 1966 when they relocated to the present 119 S. Main Street address.

The Bloom law office would continue as a successful family affair for the next six decades. William's son, John S. Bloom, joined the firm in 1973 and Benton's son, Timothy J. Bloom, signed on in 1978. From 1972 until 1990 the firm was known as Bloom, Bloom & Fleck when current Columbia City Mayor, James R. Fleck, was actively involved in the practice of law. Benton Bloom, following a long and distinguished career, passed away in September of 1990. William Bloom, a distinguished member of the Indiana Bar for more than 50 years including serving two terms as county prosecutor, passed away in January of 2004.

John Whiteleather Sr. was joined by his son in 1965 and in 1970, the junior Whiteleather was elected to the first of eight terms as Whitley County prosecutor. John Whiteleather Sr., a community stalwart and highly respected member of the Bar, died in 1984 at the age of 80. The firm then continued under the name of the Whiteleather Law Firm.

On January 1, 1993, John Whiteleather Jr., John Bloom and Timothy Bloom created a new law firm, much like the one their grandfathers had forged 80 years before in the shadow of the Whitley County Courthouse.

Another noted Whitley County attorney, Richard Gates, joined the firm in 1994. Sadly, Dick passed away in 1997, leaving behind a wonderful family and numerous friends. Despite spending just a few short years with the firm, his singular contributions to the firm will never be forgotten. Dick continues to be an important and valued part of our history.

In 1998, at the conclusion of his fifth and final term as prosecutor, Dan joined Bloom Gates & Whiteleather bringing with him a wealth of litigation experience and a thriving private practice. The firm's father-and-son tradition continued in 2001, when Dan's son, D.J., joined us as a new associate.

At present, the firm consists of three partners, John W. Whiteleather Jr., Timothy J. Bloom and Daniel J. Sigler, and two associates, D.J. Sigler and Lindsey A. Carter, who joined the firm in September of 2002. The firm has the experience, tradition and dedication to excellence to continue serving the legal needs of families and business in Whitley County for generations to come.

BONAR INSURANCE

David Bonar started Bonar Insurance in January 1982 working out of his home in Churubusco. He later opened an office on South Main Street. With the business growing and a need to expand, he then purchased the building at 203 North Main Street and moved the business to this location and it is still being operated at this location today.

With being an independent agency, Bonar Insurance is able to represent numerous companies. To date, the agency currently represents 10 insurance companies. The largest amount of business is written through Allstate Insurance. Years ago, Allstate Insurance was only written through captive Allstate agencies. Over the years they have found success in contracting with independent agencies.

The agency currently employs two full time, David Bonar and Dee Dee McCoy, and one part time, Connie Bair, employees.

Even though the agency has grown in the business sense, David still likes to maintain the small, friendly service that was started many years ago.

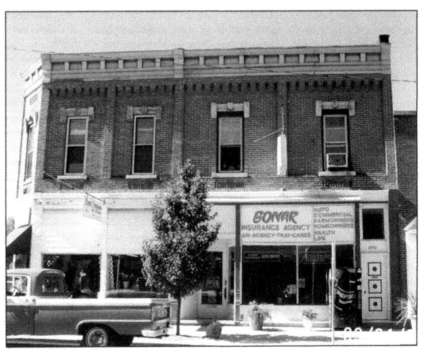

CHURUBUSCO WOODWORKING

Churubusco Woodworking celebrates 50th anniversary

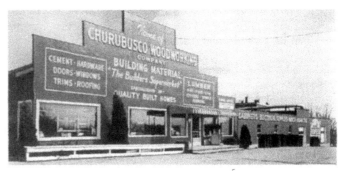

Churubusco Woodworking, located on U.S. 33 just south of Churubusco, opened in 1949. At that time it was owned by William or "Charles" Shively, and his sons, C. Allen Shively and Paul B. Shively.

John Ford started working for Churubusco Woodworking and the Shively Brothers when he was still a student at Churubusco High School in 1949.

In 1964 Ford began buying an interest in the business and soon bought the business outright from the Shively brothers.

His son, J.R., started working at the company in "some form or another" in 1966. He began working full time for his father in 1977.

In 1950, the company added a retail lumber business and a hardware and building store to the sawmill and hardwood lumber mill that already existed.

Later, in 1990, the company underwent a major remodeling and renovation and added an extensive line of supplies for the home do-it yourselfer.

The store is open six days a week and offers a complete line of builders hardware, paint, electrical supplies, lighting fixtures, plumbing fixtures, cabinets, vanities, floor coverings, doors and windows, roofing supplies, ceiling tiles, and more.

Whether you are a do-it-yourselfer or a professional builder, Churubusco Woodworking has the supplies and know-how to help get the job done as quickly and accurately as possible.

Churubusco Woodworking employs several full time and part time employees, including long time employee, Michele Elias, who has been a familiar face at Churubusco Woodworking since 1985.

The company offers free estimates and free deliveries. They also provide service installed sales, meaning when they sell a customer a product, they will also install it if the customer so desires.

J.R. is an active member of the Churubusco Chamber of Commerce and Churubusco Rotary and says the company will continue to be a part of the many projects his father was involved in, such as Habitat for Humanity of Whitley County.

"We have always been very community-minded and supportive of community organizations and projects," Ford said. The community has given to us for 50 years and its our way of saying thank you, our way of giving back."

CROOKED LAKE GOLF COURSE

In the summer of 1924 Argyle Luckenbill and some of his friends became interested in having someplace to play golf in Columbia City. Several people around town were making trips to Wawasee Golf Course to play at this time. A seven-hole course was laid out on an L-shaped plot of ground to the west and north of the Luckenbill residence about a quarter of a mile east of Columbia City on present State Road 205. The greens were simply round patches of pastureland mowed and rolled. The course was very crude, the fairways, due to the limited space, crisscrossed and the players really risked their lives in playing. There was only one major casualty when L.M. (Pinkey) Meiser got a very black eye when hit by a golf ball. Membership in the club sold for $5.00 for the season.

Enough enthusiasm was generated so that in the summer of 1926 a group of golfers decided that Columbia City needed a better golf course. An organization was formed, 40 acres of land purchased from the Crooked Lake Development Co., and applications for the purchase of stock in the Crooked Lake Realty Corp. were solicited. The group was incorporated and 42 shares were issued at $50.00 per share dated November 1, 1926. The first board of directors were A.E. Hancock, Edmund C. Lindsay, Shinzo Ohki, Merle Fisher, E.J. Strouse, Fred F. Morsches and George O. Compton.

The building of the course was planned and supervised by A.E. Hancock and Dewitt Monroe. Their idea of a golf course was that all greens and tees should be elevated. As a result most all the greens had to be approached by shooting up a steep bank. Later on the approaches were lowered by filling in and enlarging the greens and tees in order to simplify the mowing and maintenance problem. In those early days a box of sand was kept at each tee to provide material for making tees to set the ball on for driving off the tee. There were no wooden tees in those days.

In 1954 the barn, which stood on the south side of the road leading

in to the golf club, collapsed in a windstorm. A cement block building was erected on the north side of the road and later converted into a clubhouse. In 1958 the caddy house back of Number 1 tee was repaired and later the ladies league was given permission to use it as a clubhouse. They furnished it and, served coffee and doughnuts to their members on their league day.

Much argument took place over the proposal to build an outhouse on the course behind Number 5 tee in 1965. Mr. Bob Brennan got disgusted over the argument and exclaimed, "Hell, I'll pay for it myself." Accordingly the outhouse was built and the directors discussed in fun the idea of putting his name on it, but they never got around to it.

At a meeting of the stockholders in April 1969, it was decided to sell the golf course and all equipment to John Schumaker for $100,000, possession to be given January 1970. Included in the contract was a clause stating that Mr. Schumaker would issue a life membership to the 28 stockholders.

Under the ownership of Mr. Schumaker the barn was converted into a weather conditioned clubhouse serving sandwiches and drinks and offering golf merchandise, a pond was created in the low spot between Number 2 and 3 greens and tees which catches an estimated 500 balls a season and many trees were planted between fairways over the course. Presently, John's son Bill Schumaker owns Crooked Lake Golf Course.

IGA

J. Frank Grimes founded IGA, Independent Grocers Alliance in 1926. The association was formed to help provide smaller independent grocers with the ability to be supplied with low cost goods for their customers, by providing the larger volume buying power. Today IGA Worldwide has over 4,000 stores in the United States and 30 foreign countries. There are over 37 distribution centers for distributing groceries to stores both large and small. IGA has over 20 billion dollars in sales annually, making it the largest voluntary supermarket network.

IGA has operated continuously in Churubusco for 76 years. In 1929, A. Drew opened the first IGA in Churubusco at the corner of North Main and Washington Streets, formerly occupied by the Gandy Mercantile and auto dealership. Mr. Drew operated the store until 1941.

In 1941, Honest John Shelton purchased the store from Mr. Drew and operated the store until 1966. In 1954, Mr. Shelton purchased the other half of the Gandy Building, occupied by Mayberry Furniture Store, doubling the space to about 3,000 square feet.

In 1966, Bob and Betty Egolf purchased the business and operated at the same location until 1982, when the present store was constructed and they continue to serve their customers today. Mr. Egolf had worked for Mr. Shelton during his high school years. The current store has over 10,000 square feet of space Mr. and Mrs. Egolf have operated the store continuously for 38 years.

The success of Egolf's IGA has been by retaining very good employees (between the owner, Mr. Egolf, his store manager, and meat manager, they have over 120 years of combined service) and especially the loyalty of their valued customers. Egolf's IGA provides an old fashioned meat

IGA in the 1950s.

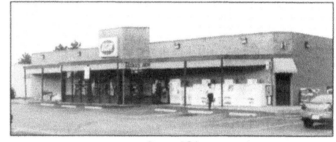

Present IGA

case, fresh bakery, fresh quality produce, personalized service, good prices, and Hometown Pride. Egolf's IGA located at 609 S. Main Street, is open 7 days a week from 7:00 a.m to 10:00 p.m.

FARMERS MUTUAL INSURANCE ASSN. OF WHITLEY COUNTY

Farmers Mutual Fire Insurance Association of Whitley County was organized on June 26, 1884. The admit date to the Department of Insurance was January 1, 1900. It was elected to come under Chapter 145, Acts 1919 on September 24, 1924.

In the 1940s the Mutual wrote insurance on cars and trucks. In 1957 the name was changed to Farmers Mutual Insurance Assn. of Whitley County. The reason for this was that in 1957 the Mutual started writing wind and multiple peril insurance.

In 1945, the office was in the Production Credit Association Building on the east side of the courthouse.

The members of this association are all that hold a policy with the company.

The corporate powers of the Company shall be vested in a Board of five directors who will be elected at the annual meeting. These board of directors have a term of three years and must be policy holders of the Company. Each director represents specified townships of Whitley County.

Farmers Mutual can only write insurance in the state of Indiana. In the

past the insurance could not be written in a town that was Incorporated. In July 2003, the law was changed and the mutual could write insurance in towns.

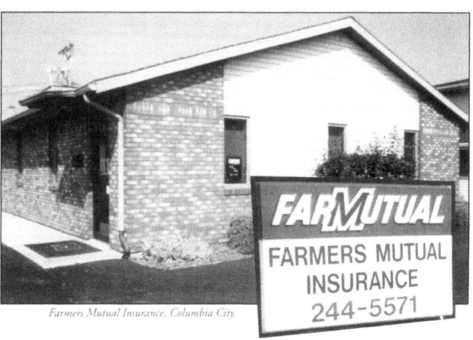

Farmers Mutual Insurance, Columbia City.

J & J Insurance

J&J Insurance was established in February of 1990. The agency was previously owned by Richard D. Kiester and was known by Rick Kiester Insurance. June Keiser, a long time employee in the Kiester agency along with Jacie Worrick of Whitley County purchased the Kiester Agency and renamed the agency to J&J Insurance Solutions, Inc. Keiser and Worrick, brought over 40 years of experience in the insurance field to their business, which offers coverage in the areas of auto, home, farm, business and life. The present agency is located at 155 Diplomat Drive in Columbia City, IN. For insurance questions J&J has the solutions! The agency is an independent agency and represents several different companies. To fine tune their knowledge, both Keiser and Worrick are involved in continuing education on an ongoing basis.

Line Street Vet Hospital

Michael E. Mawhorter, DVM

Dr. Michael Mawhorter is a 1982 graduate of Purdue University's School of Veterinary Medicine. After graduation he returned to his hometown of Albion, Indiana and worked in a mixed animal practice for nine years. In March of 1991 he purchased the brick house on the corner of Line Street and Diplomat Drive, and Line Street Veterinary Hospital was formed.

Initially, Dr. Mawhorter treated farm animals and companion animals in an effort to build up the young practice. Eventually in 1996, he decided to concentrate totally on dogs and cats.

The practice has grown very rapidly since that time and Dr. Mawhorter's dream of a high quality practice with an outstanding support staff continues to progress. Construction of the new hospital was completed in April of 2000. Certification of the practice by the American Animal Hospital Association was achieved in November of 2001.

The American Animal Hospital Association provides the guidelines for excellence in veterinary practice. These guidelines provide direction as Line Street Veterinary Hospital continues to grow and mature into a compassionate, caring and highly competent hospital.

Adam Ferguson, DVM

Dr. Ferguson is a 2001 graduate of Ohio State University. He worked as a small animal veterinarian at another AAHA hospital in northwestern Ohio prior to arriving in Indiana. Currently he resides in Columbia City with his wife, Kristen, and their son, Brice. They are controlled by a black Labrador, a cocker spaniel, and a calico cat.

A Caring Staff

The staff of Line Street Veterinary Hospital includes two Doctors of Veterinary Medicine (DVM), four Registered Veterinary Technicians (RVT), several Veterinary Assistants, and one Office Manager.

Our RVT's are legally permitted to perform similar procedures as the doctors, except diagnose diseases, prescribe medications, or perform surgeries.

Our Veterinary Assistants admit patients to the rooms, take histories, help hold your pets during examinations, and perform numerous other tasks which help to make your pet's experience, as well as yours, as quick and enjoyable as possible.

The staff of Line Street Veterinary Hospital is not confined to the building on North Line Street. We work in very close association with board-certified specialists in the areas of dermatology, ophthalmology, internal medicine, and surgery, in an effort to offer your pet the highest quality of care possible.

THE MAGIC WAND

The Magic Wand restaurant located at 602 South Main Street in Churubusco has been owned by Max and Judy Myers since 1964. Max was about to graduate from Indiana University school of business when his father Stanley Myers (owner of Myers Food Center and later Super Valu in Churubusco) called and told them of a small restaurant for lease. Max and Judy leased the business with the understanding that they would operate it for five years. They purchased the restaurant from Orlo McCoy a few years later and after 40 years are still happily running it today.

When the "Wand" first opened it was seasonal with a counter, five booths and an outside bathroom. In 1979, the Myers' added on to the building, expanding seating capacity to 106 people.

Today, the Magic Wand is a year round restaurant serving breakfast, lunch and dinner seven days a week. Daily home cooked specials and soft serve ice cream are featured items.

The Myers' have witnessed many changes in Churubusco, over the years, including being taken into the city limits, new

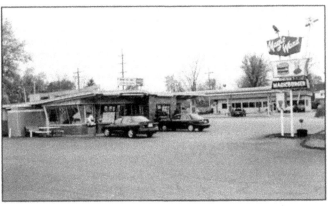

Magic Wand Restaurant

businesses coming and going and changing hands. They've owned and operated a business longer than any current one in town. Countless high school students have worked at the Magic Wand through the years providing valuable work experience for their lives and now they also have inside restrooms.

NORTHSIDE GRILL

VanBuren St. Columbia City

If the walls of this three story brick building housing the Northside Grill could talk, what tales might they tell. Located on the east side of the alley on W. VanBuren street directly across from the north entrance of the Whitley County Courthouse, all businesses there have furnished food and refreshments for surrounding community peoples since the late 1880s.

Perhaps since walls do not talk the resident ghost, Charley, might tell you the stories. Watch for him when the front door opens and you can't see anyone there or when the sound system turns on and off without anyone in sight. At one time, the second floor hosted a gaming parlor, the third floor a brothel, both active, it is said, before, during and after the prohibition era. The owner of the Northside Grill is Deborah Law.

WHITLEY COUNTY MOTOR SALES

Whitley County Motor Sales, also known as Thomson's, is presently located on U.S. 30 East, in Columbia City. It has been owned and operated continuously for more than 75 years by the Thomson family. It all happened like this:

William C. Thomson Sr. "Charley", born in Richland Township, Whitley County, in 1891, first was involved in the automobile business when he worked for Mel "Big Daddy" Miller Ford in Columbia City in about 1917. Shortly thereafter, with his brother-in-law, George Walter, Charley opened the West End Garage at 222 West Van Buren Street. In 1919 Charley built the 66 feet by 150 feet brick building located at 309 West Van Buren Street that now houses Redman Plumbing and Heating. The bricks came from the East Ward School in Columbia City that had just been razed. With the new building came a new car franchise with Studebaker and this marked the birth of Whitley County Motor Sales.

In 1921, the Studebaker franchise was dropped and replaced with Chevrolet and Thomson became the first (and to date, only) Chevrolet dealer in Columbia City. Other GM lines were acquired by Whitley County Motor Sales in the 1930s: Buick, 1934; Oldsmobile, 1936; and Cadillac, 1939. For a brief period, Charley Thomson had the Pontiac franchise under the name Hoosier Motor Sales. Following World War II, the franchises for Frigidaire appliances and Ford tractors were acquired and operated out of what was known as "the farm store" at the corner of Main and Jackson Streets. During the "sit down" strikes in the late 30s when Chevrolets were unavailable, Whitley County Motor Sales sold Packards until the labor dispute was resolved.

William C. Thomson Jr. "Bill", born in 1916, joined his father in the business and took on many of the day-to-day management functions. By 1963 the transfer of ownership was complete.

In 1968, on 80 acres of land east of Columbia City, Whitley County Motor Sales opened a large, state-of-the-art facility with a showroom capacity of eighteen cars. This move transformed Thomson's from a local to a regional dealership.

Timothy N. Thomson "Tim," born in 1944, joined the family business and after several years mastering the intricacies of the service, parts and body repair operations, moved directly into management, and began a long and successful partnership with his father.

In 1995, Whitley County Motor Sales completed a total renovation of its physical facility with an eye toward the 21st century and another 75 years of marketing and servicing quality GM products to and for the residents of northeast Indiana.

MURPHY JEWELERS

Mr. and Mrs. Harold C. (Wilma C. Byfield) Murphy moved to Columbia City from Winamac, IN in early 1950. On May 1, 1950, Mr. Murphy purchased a small watch repair business from the late Martin Binder, consisting of one workbench and one showcase in the front window of the Melody Gift Shop, located at 110 W. Van Buren Street (present location of Star Financial Bank). When the Bert Baileys relocated the gift shop to 217 W. Van Buren Street as the Garden Gift Shop, Mr. Murphy expanded into the entire store (at 110 W. Van Buren) and began to build his inventory into a fully stocked retail jewelry store with full-service watch and jewelry repair, most of which he did himself; Murphy Jewelers was established.

In March 1959, Mr. Murphy relocated the business to its present location, 103 S. Main Street, which had been the Osborn Jewelry Store. In January 1988, Mr. Murphy sold the business to his daughter, Marilyn K. Murphy, who continues to operate it as a retail watch, jewelry and gift sales, and full-service repair business.

Full and part-time employees through the years have included Mrs. Herbert (Ruth Ann Scott) Fry, Mrs. David (Nell) Spence, Miss Addie Trout, Mrs. Nicholas (Laurel Carlson) Steill, Mrs. Barbara (Berwert) Walters, Mrs. Gregory (Ruth Ann Staley) Woodham, and current manager, Mrs. Gary (Amy Fry) Carlisle. Other recent part-time employees have been Dan and Colin Clifford.

Mr. Murphy died on December 26, 1988, and Mrs. Murphy died on January 7, 1995.

R & D MOTORSPORTS

US 30 West
260-248-8522

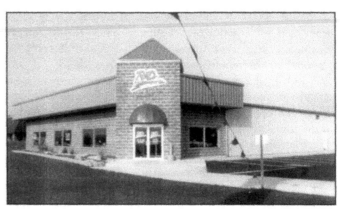

Randy Bills founded R&D Motorsports in November 1981. Rob Arms purchased the business in November 2001 and relocated to a new facility on US 30 West in November 2003. Products available include motorcycles, ATVs, scooters, snowmobiles and wave runners. They offer a full service repair facility as well as a store with accessories and clothing.

INDEX

135

136

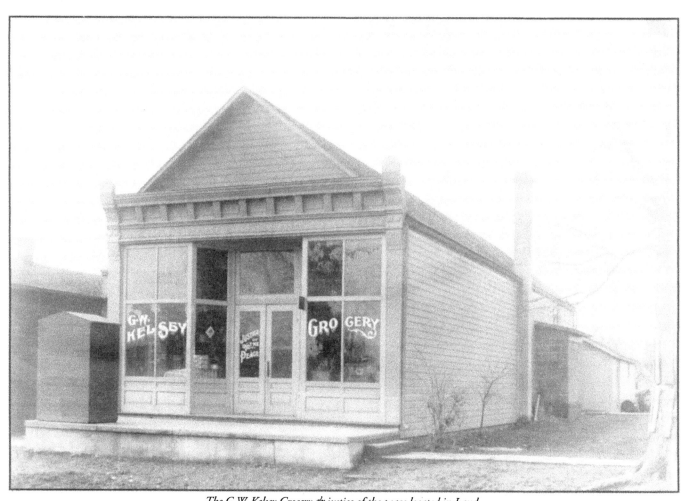

The G. W. Kelsey Grocery & justice of the peace located in Laud.

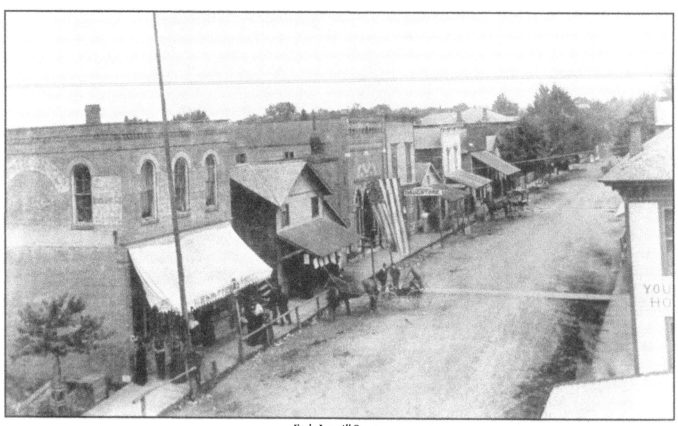

Early Larwill Street

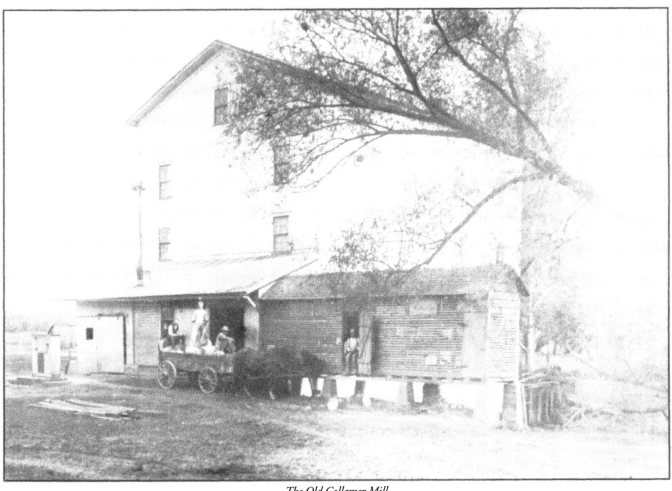

The Old Collamer Mill.

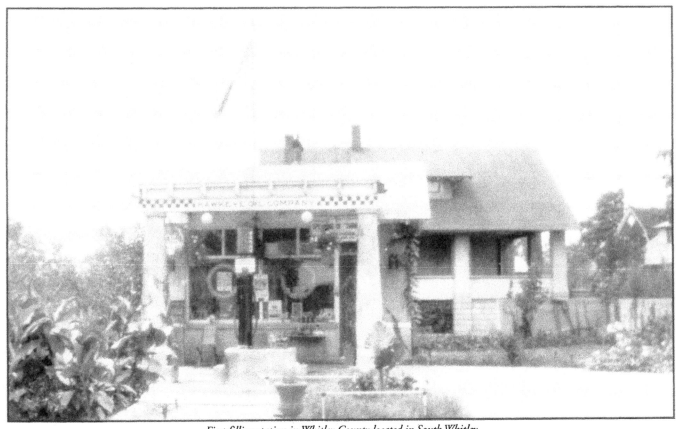

First filling station in Whitley County located in South Whitley.

Printed in the USA
CPSIA information can be obtained
at www.ICGtesting.com
JSHW060054150824
68134JS00032B/2735

9 781681 624488